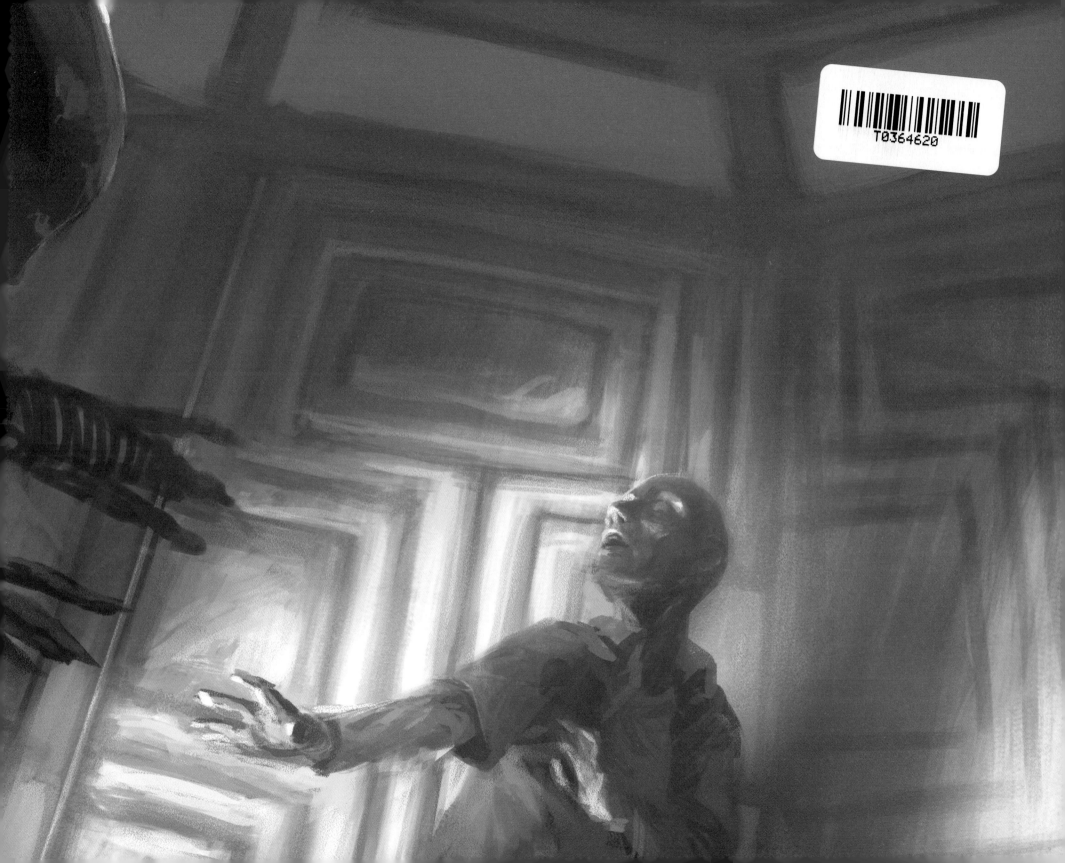

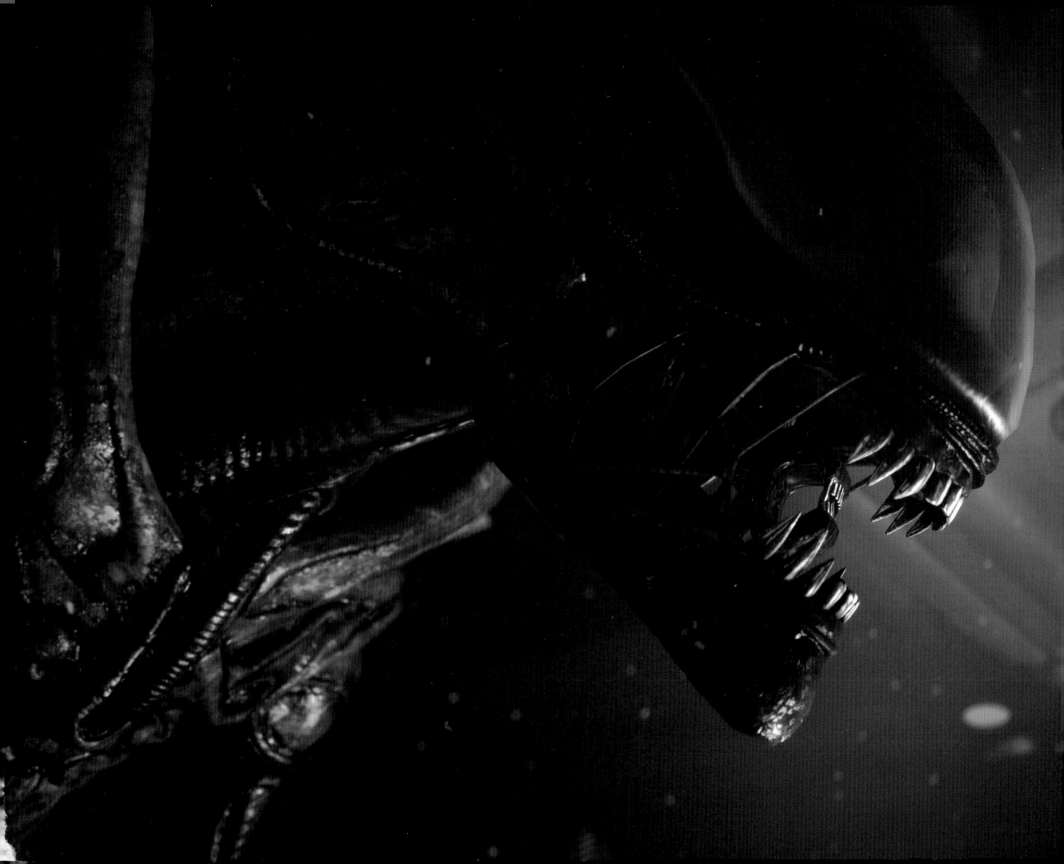

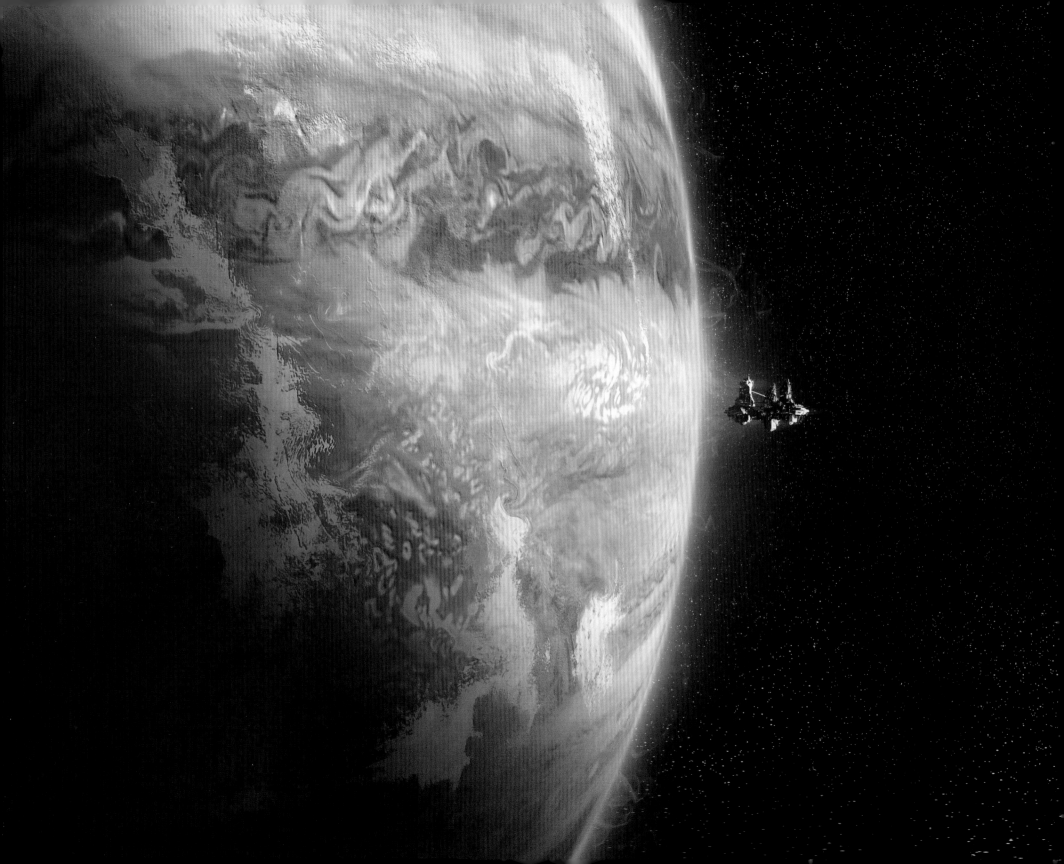

THE ART OF
ALIEN™
ISOLATION

ANDY McVITTIE

FOREWORD BY
JUDE BOND

TITAN BOOKS

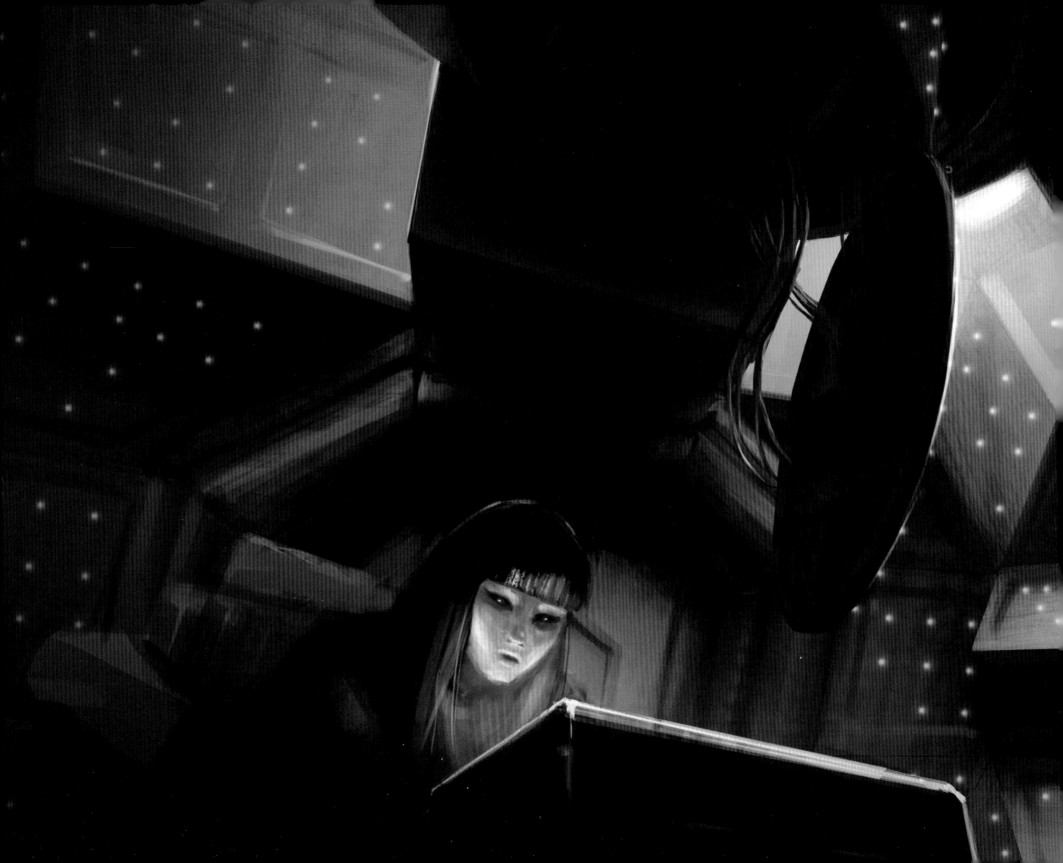

CH000 / CONTENTS

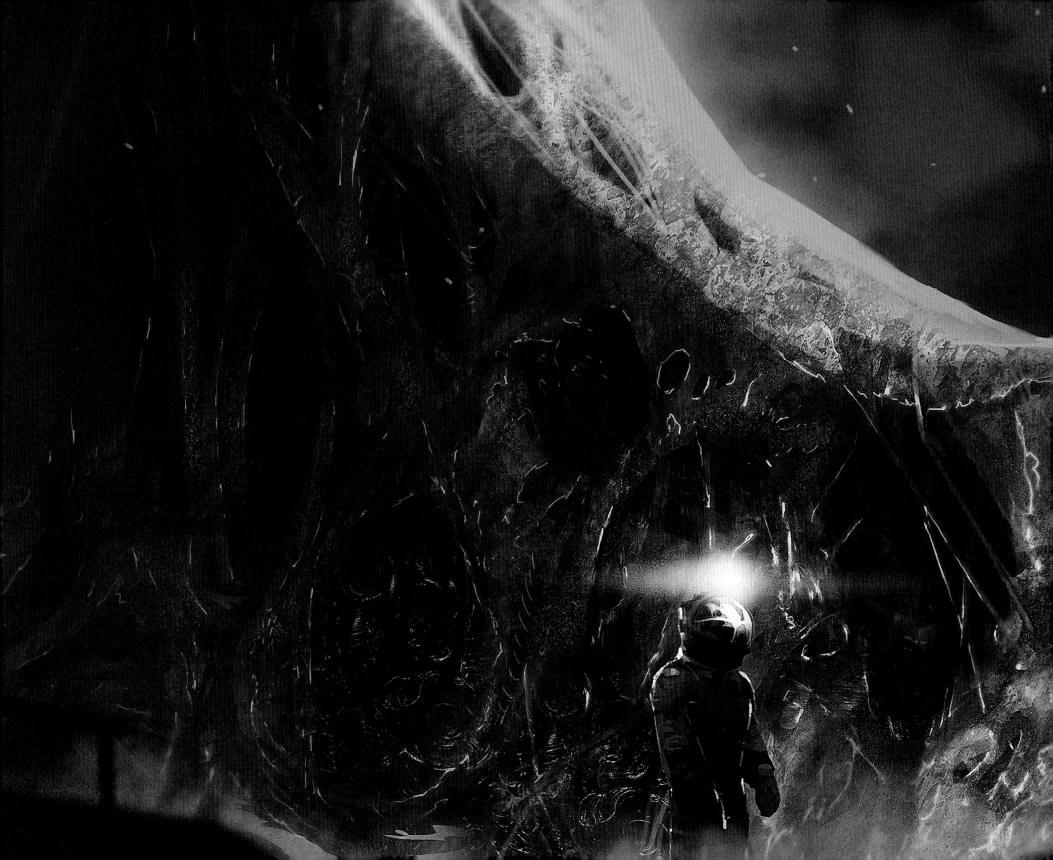

CH000 / FOREWORD

// by JUDE BOND //
LEAD ARTIST

THE PAGES OF this book contain a small selection of production materials from our art department, ranging from concept art to storyboards and pre-visualisation images. The quality of these images is testament to the hard work of the artists on the team and their dedication. It's been a pleasure working with such a talented bunch of individuals.

As a team we feel very privileged to have had the opportunity to work with such high quality IP and we sincerely hope that we've done justice to the Alien franchise, treating it with the respect that it deserves. We've felt like custodians of a great treasure.

The original film ALIEN was our primary source of inspiration, a haunted house in space. Our central direction has been one of authenticity, to produce game content which looks and feels in keeping with the much loved universe of ALIEN. Taking our principal cues from the pioneering movie, we've attempted to create a believable 'used future' in keeping with the original vision. The choice to reference the 1979 classic has given us a creative platform from which to explore and unfold this highly acclaimed retro-future.

The scope of the game has demanded that we significantly expand on the source materials, building locations far bigger than the original set, new tools and equipment, costumes and characters. Core to our process was an obsessive deconstruction of the movie (and archive materials), from this foundation we've attempted to capture essential root themes, building on them and expanding the content.

The production has been long and hard. I'd like to thank everybody who's stuck it out and gone the distance. Special thanks go out to Al Hope (Creative Lead) for his unwavering faith in us as an art team and Tim Heaton (Studio Manager) for making it all possible. Lastly, it would be wrong not to thank the production crew of the original 1979 movie, it's their work which has inspired us and provided a foundation for the majority of aesthetic choices in *Alien: Isolation*.

We hope that you enjoy the book, not only for the imagery that it contains, but also for the small piece of insight which it may provide into the production of *Alien: Isolation*.

CH001/ THE CHARACTERS

// "It was very important from the start of the project that our characters were grounded and believable. The cast that we put together for the game, although they're our own creation, we wanted them to feel like they could have been in the original movie." //

Lead Artist, Jude Bond.

AMANDA RIPLEY SLIDES into an open locker and eases the door closed. *Quietly now*, as a dark shape hisses ominously, raises its head and uncurls from the opposite corner of the room. Wide-eyed and clear-headed, she barely dares to draw breath, but silently curses the day that she ever allowed curiosity to get the better of her. Ah, but like mother like daughter, as they say. But don't they also say that lightning never strikes twice?

Welcome to Sevastopol Station and a quest for closure that took root 15 years earlier with the disappearance of Amanda's mother, Ellen Ripley. Now aged 26, Amanda is offered the chance to discover her fate. She will encounter a great many characters during her journey onward; some more amiable than others, some with their own desperate agendas to fulfil and all too many not friendly in the slightest. Our own journey begins right here by meeting just a few of them...

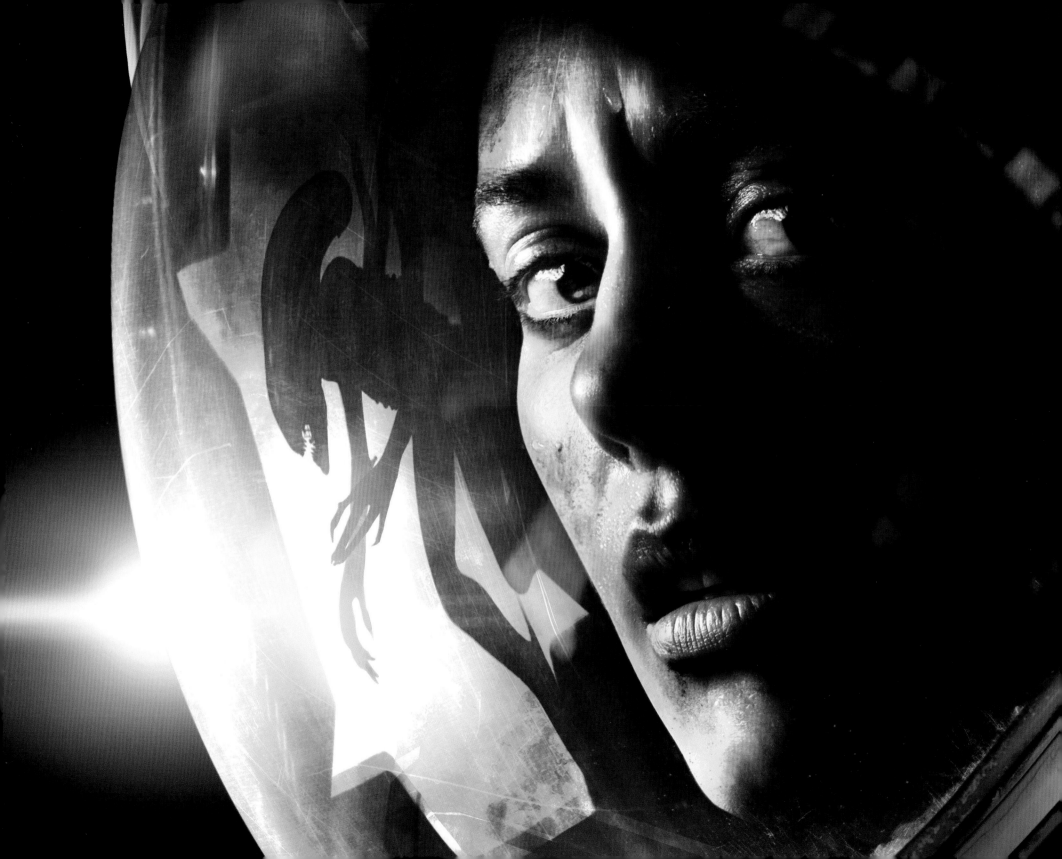

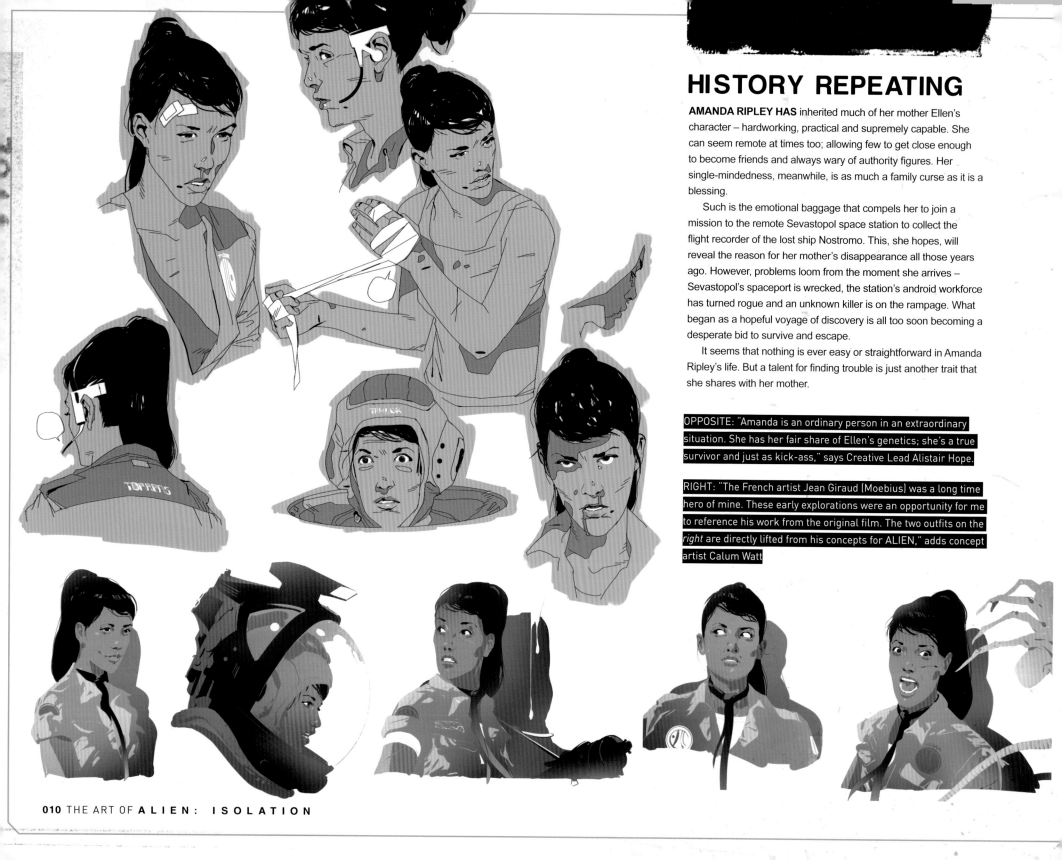

HISTORY REPEATING

AMANDA RIPLEY HAS inherited much of her mother Ellen's character – hardworking, practical and supremely capable. She can seem remote at times too; allowing few to get close enough to become friends and always wary of authority figures. Her single-mindedness, meanwhile, is as much a family curse as it is a blessing.

Such is the emotional baggage that compels her to join a mission to the remote Sevastopol space station to collect the flight recorder of the lost ship Nostromo. This, she hopes, will reveal the reason for her mother's disappearance all those years ago. However, problems loom from the moment she arrives – Sevastopol's spaceport is wrecked, the station's android workforce has turned rogue and an unknown killer is on the rampage. What began as a hopeful voyage of discovery is all too soon becoming a desperate bid to survive and escape.

It seems that nothing is ever easy or straightforward in Amanda Ripley's life. But a talent for finding trouble is just another trait that she shares with her mother.

OPPOSITE: "Amanda is an ordinary person in an extraordinary situation. She has her fair share of Ellen's genetics; she's a true survivor and just as kick-ass," says Creative Lead Alistair Hope.

RIGHT: "The French artist Jean Giraud (Moebius) was a long time hero of mine. These early explorations were an opportunity for me to reference his work from the original film. The two outfits on the right are directly lifted from his concepts for ALIEN," adds concept artist Calum Watt

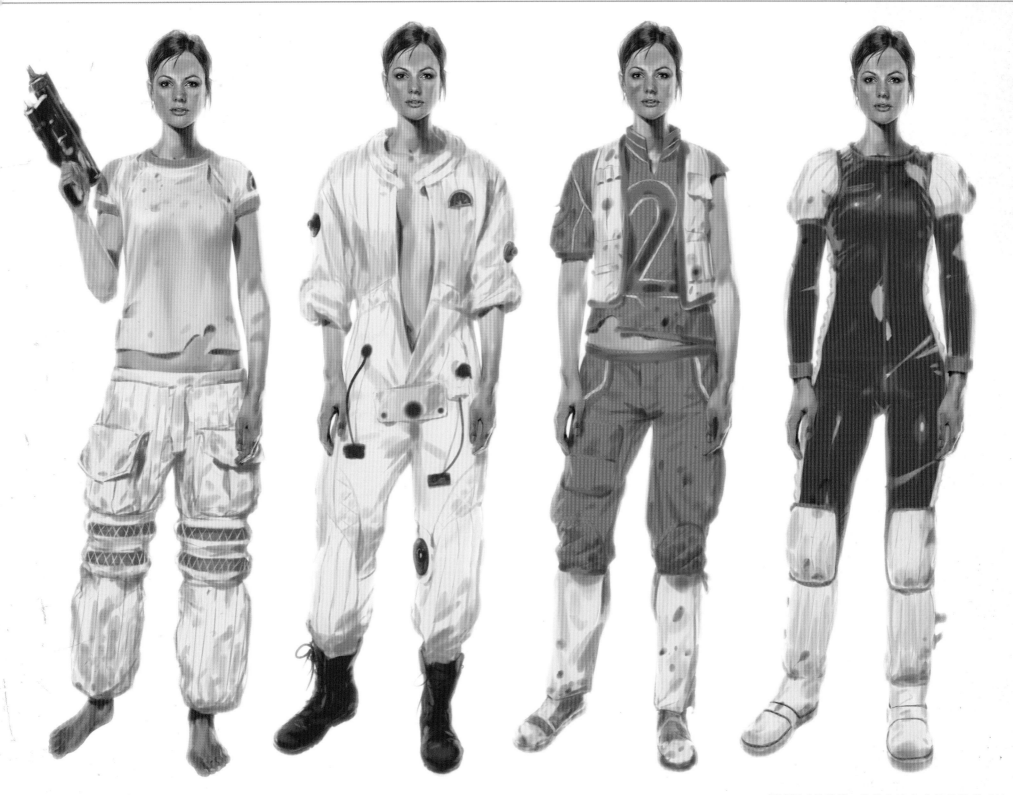

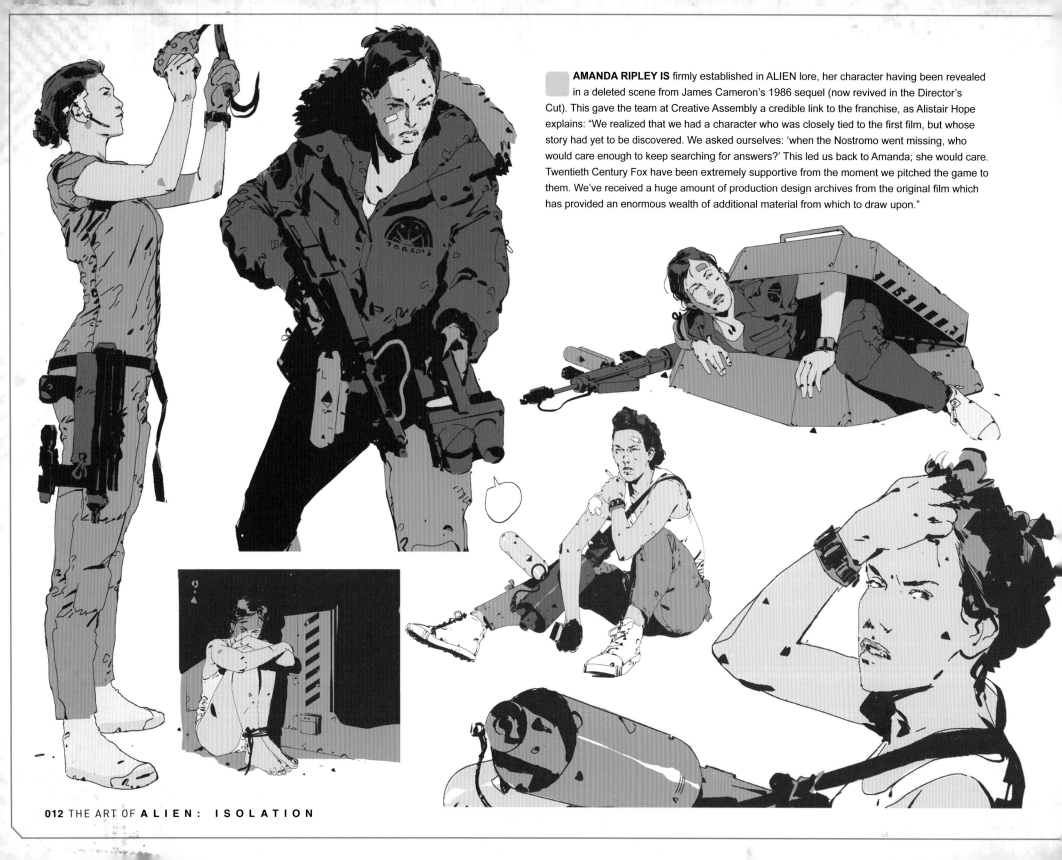

AMANDA RIPLEY IS firmly established in ALIEN lore, her character having been revealed in a deleted scene from James Cameron's 1986 sequel (now revived in the Director's Cut). This gave the team at Creative Assembly a credible link to the franchise, as Alistair Hope explains: "We realized that we had a character who was closely tied to the first film, but whose story had yet to be discovered. We asked ourselves: 'when the Nostromo went missing, who would care enough to keep searching for answers?' This led us back to Amanda; she would care. Twentieth Century Fox have been extremely supportive from the moment we pitched the game to them. We've received a huge amount of production design archives from the original film which has provided an enormous wealth of additional material from which to draw upon."

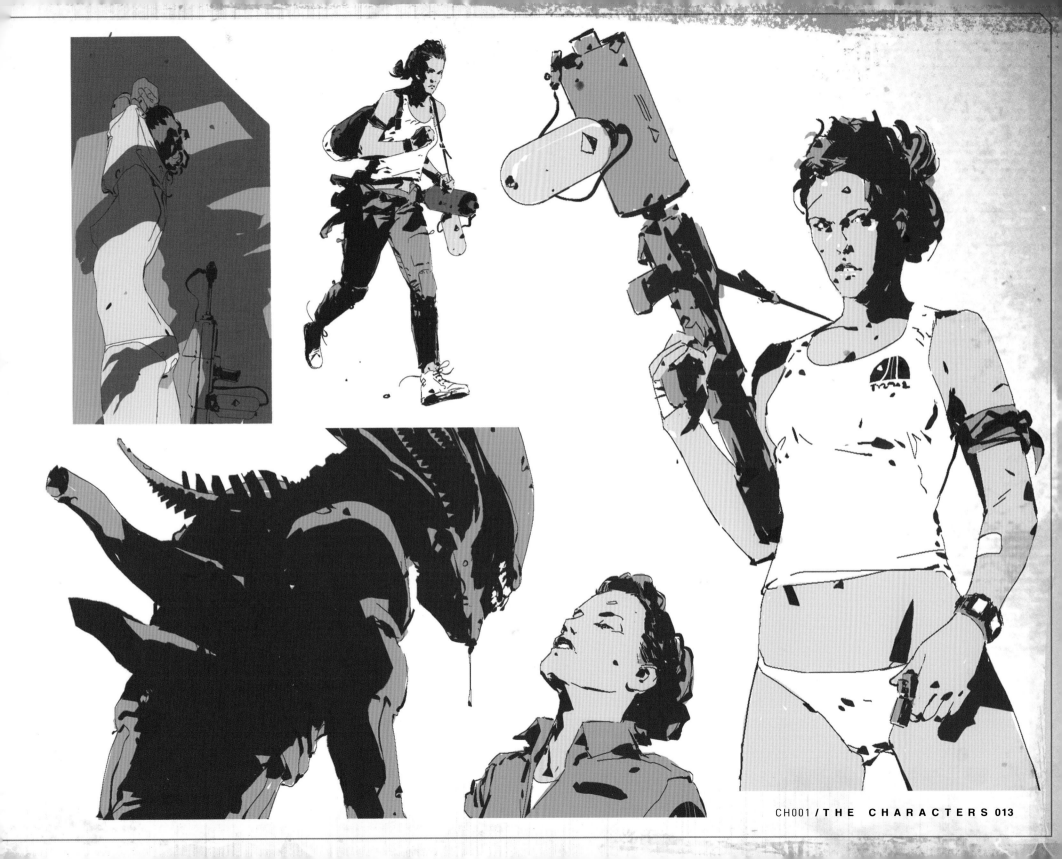

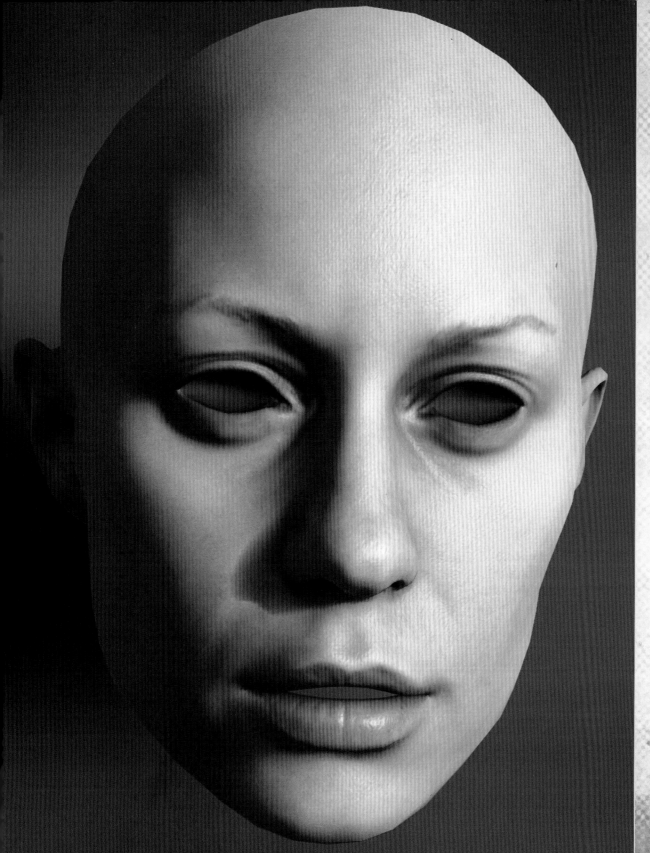

LEFT: This image shows the disembodied and eyeless face of Amanda Ripley, as played in the game by Welsh actress Kezia Burrows. "This was captured during the development of our character's skin," says Jude Bond. "Creating believable skin shading wasn't something we'd looked at before. The image *above* shows the results of this work and was captured in-engine."

ABOVE RIGHT: "Here we have an early animation test, where we were looking at various stances while the character is in three states – unarmed, holding a weapon and aiming a weapon. The weapon itself is a prototype of a large bolt gun and an early revision of the player character in a crude blocked-out form."

LOWER RIGHT: "We built what was essentially a test dummy as a prototype. Although the narrative and cast hadn't been defined at this point, the concept phase was well under way. We were already looking at costumes and developing various elements of the character tech."

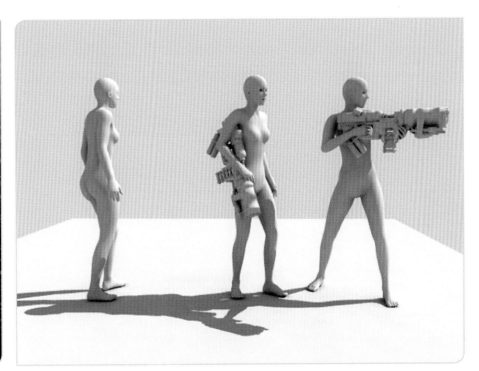

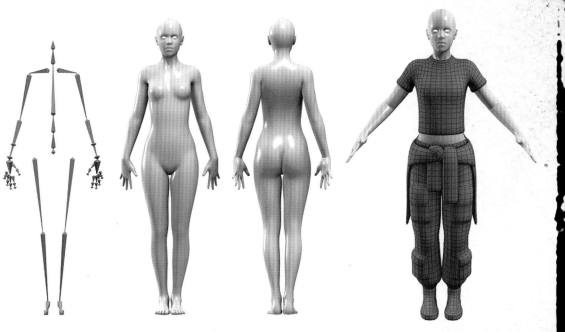

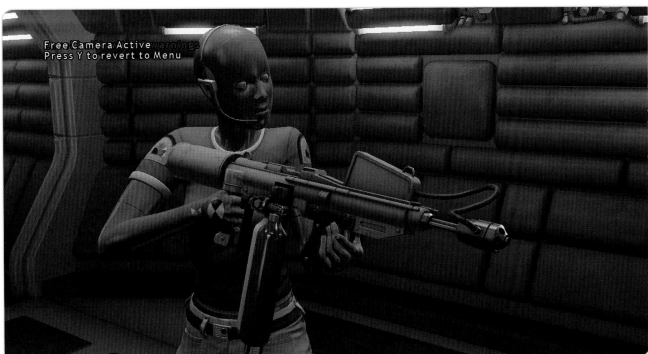

Free Camera Active warnings
Press Y to revert to Menu

Free Camera Active
Press Y to revert to Menu

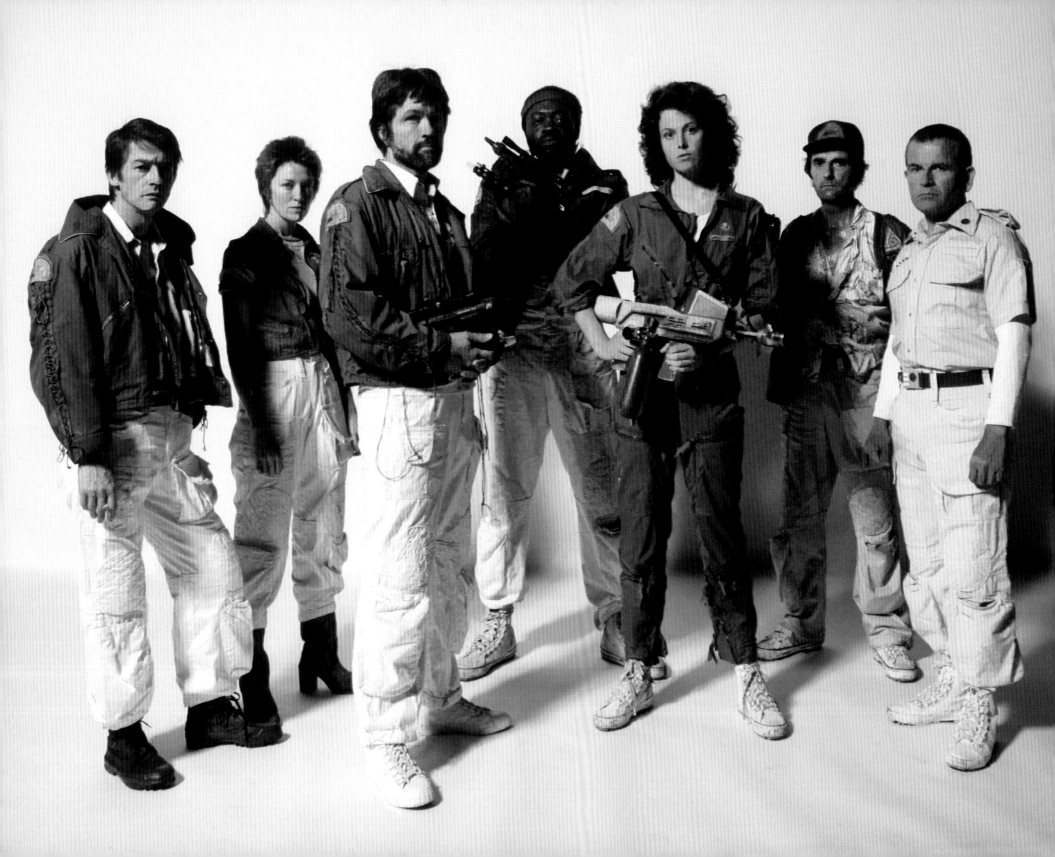

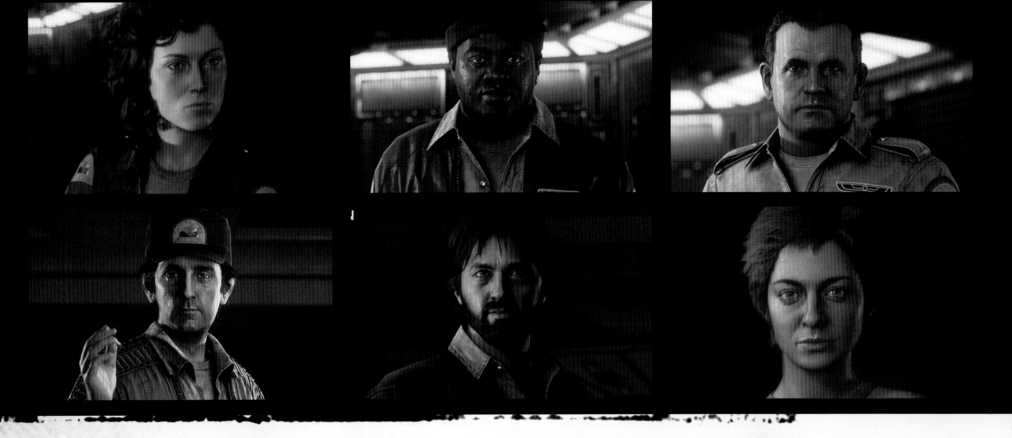

OUT OF THE PAST

"**THE SUBTLE NUANCES** of the costume design fascinated us, seeming to be an extension or expression of the crew's character," says Jude Bond. "The characters wear uniforms, but it's dishevelled and informal, each with their own personal touches – Brett's shirt, Dallas's boots, Parker's headband etc. The costumes were partly responsible for seeding our obsession with the deconstruction of the original film."

TOP: "These images were sculpted by hand and show some early in-engine renders of the original cast. We went through a lot of iteration on these heads."

BOTTOM: "This was an exercise in documenting our journey and completing a set. They're more illustration than concept art, really."

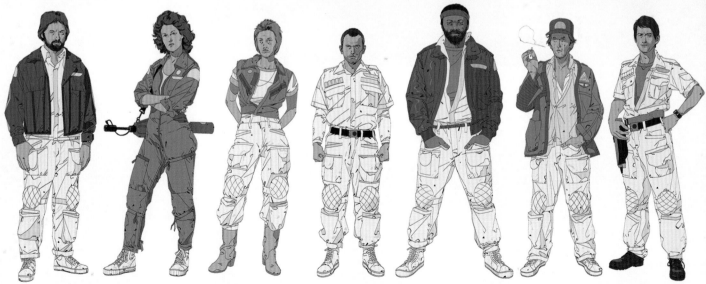

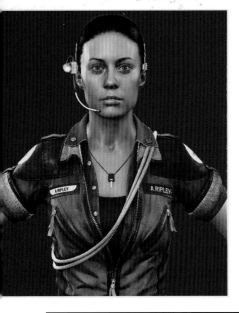
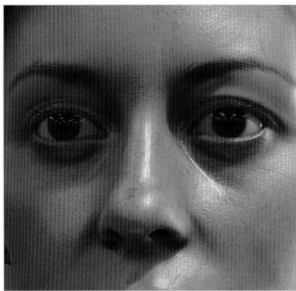
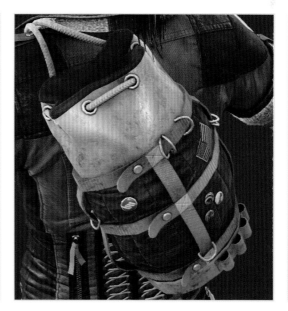

TOP: With Amanda fleshed out the game's artists were able to start focussing on some of the finer details. To the *right*, sights and sounds summarized as Amanda puts on a spacesuit and prepares to move outside of Sevastopol Station.

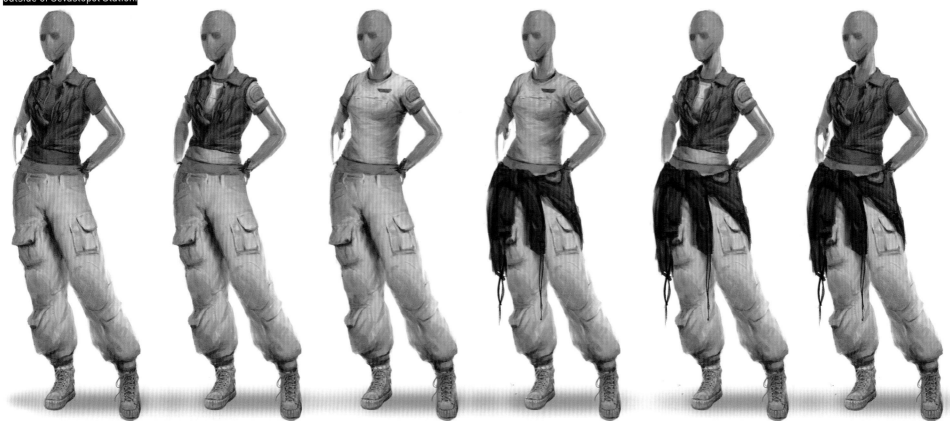

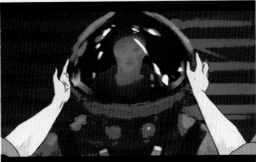
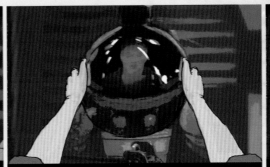
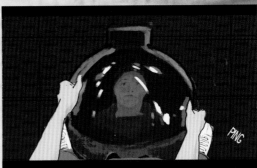
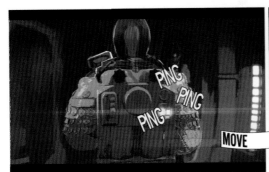

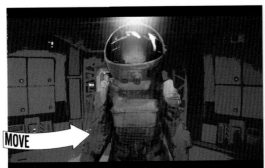

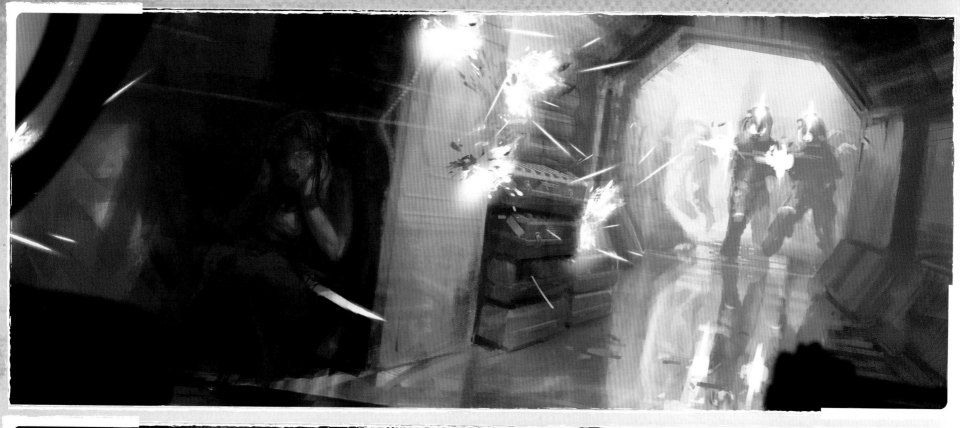

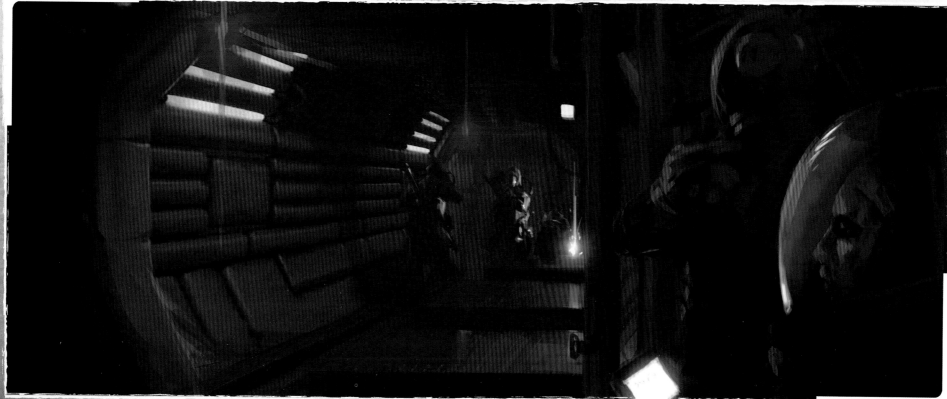

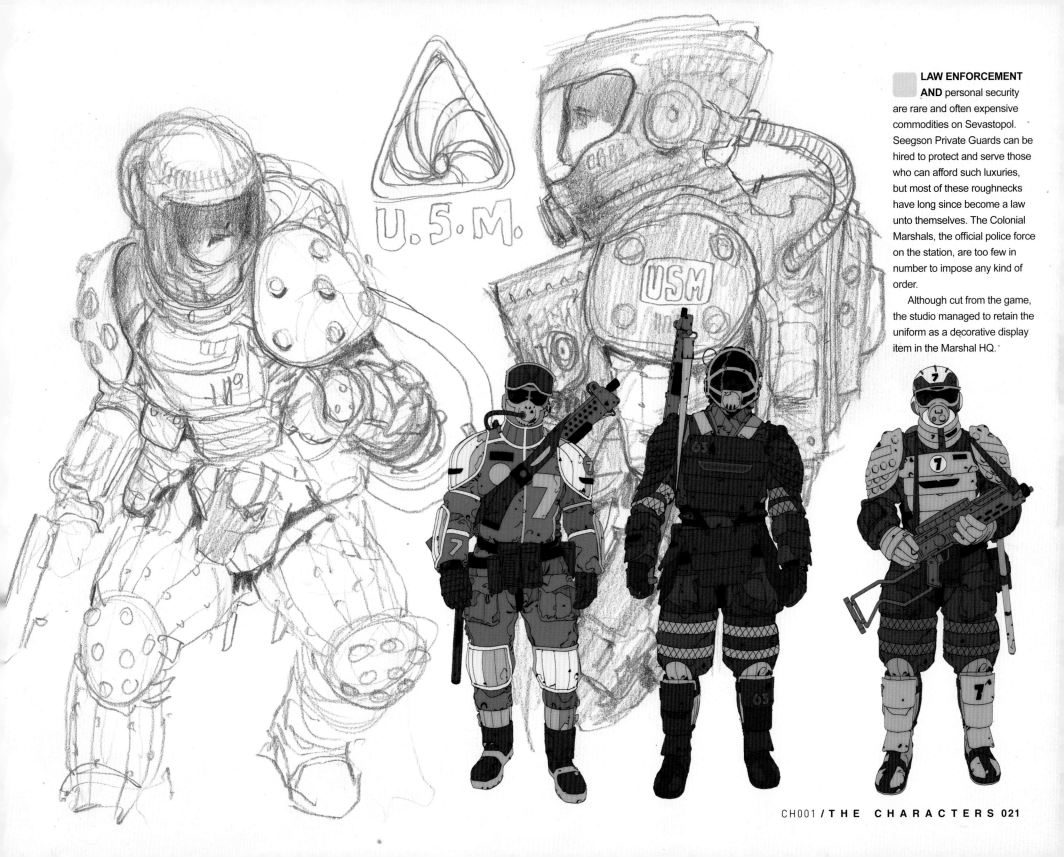

LAW ENFORCEMENT AND personal security are rare and often expensive commodities on Sevastopol. Seegson Private Guards can be hired to protect and serve those who can afford such luxuries, but most of these roughnecks have long since become a law unto themselves. The Colonial Marshals, the official police force on the station, are too few in number to impose any kind of order.

Although cut from the game, the studio managed to retain the uniform as a decorative display item in the Marshal HQ.

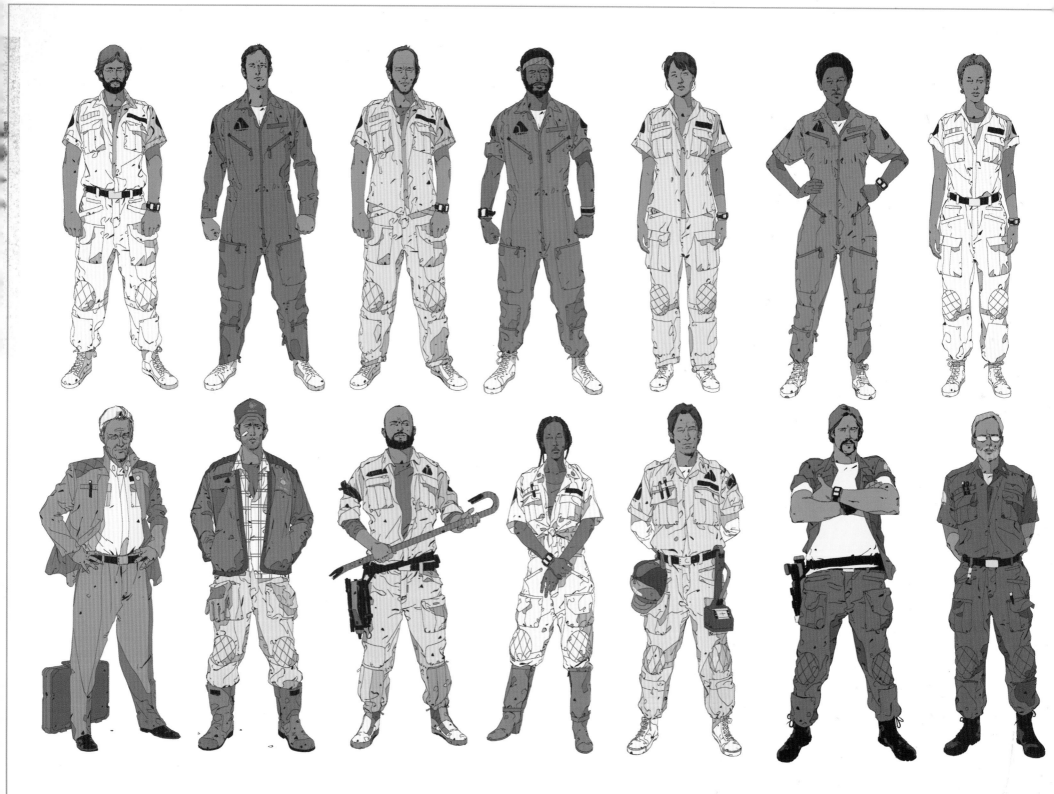

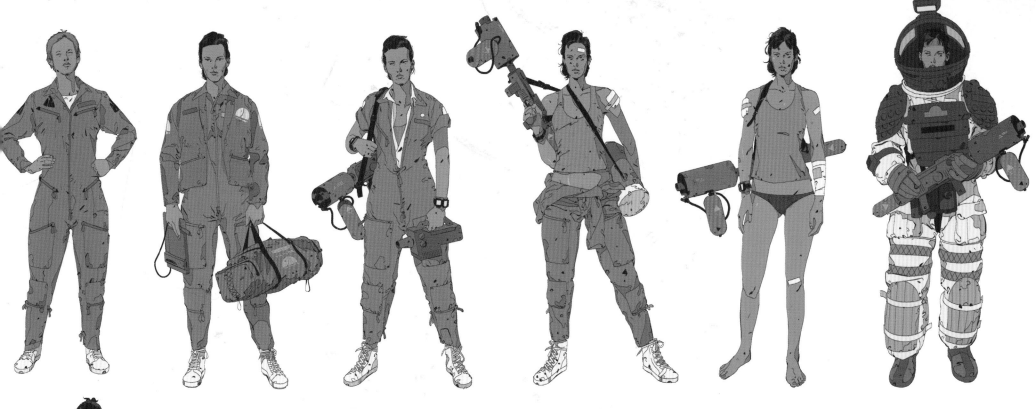

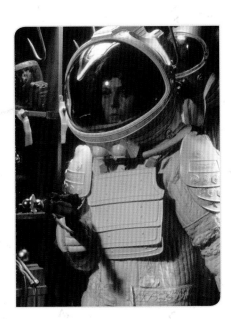

LEFT: A selection of generic and now defunct characters, and numerous uniform iterations. "We took our cues from the original movie and deconstructed the costumes until we understood how they were put together. We then rebuilt them based on what we had learned," says Jude Bond.

ABOVE: Amanda wears a number of outfits throughout the game though only three of these made it to the final build.

RIGHT: John Mollo's spacesuit design was just perfect from the outset. "We just had to get it out there again," adds Jude Bond.

FIRST PRINCIPLES

FIDELITY TO THE original source material has been a crucial consideration during the development of *Alien: Isolation*. This standard has been observed right down to the smallest detail, including the authentic clothes worn by characters throughout the game. The game looks and feels like a natural extension of the ALIEN franchise as a result. But how differently things might have turned out without the input of certain visionary personnel from the 1979 production, as Concept Artist Calum Watt explains: "This early lineup of characters closely follows the work of the costume designer John Mollo and the artist Moebius from the original film. John Mollo's simple utilitarian outfits with the occasional 'personal' item like a jacket, shirt, footwear or accessory have remained timeless and add to the film's classic quality. His costume designs established a harder and more functional approach to sci-fi costuming. Without him we would probably still be designing spacemen wearing spandex!"

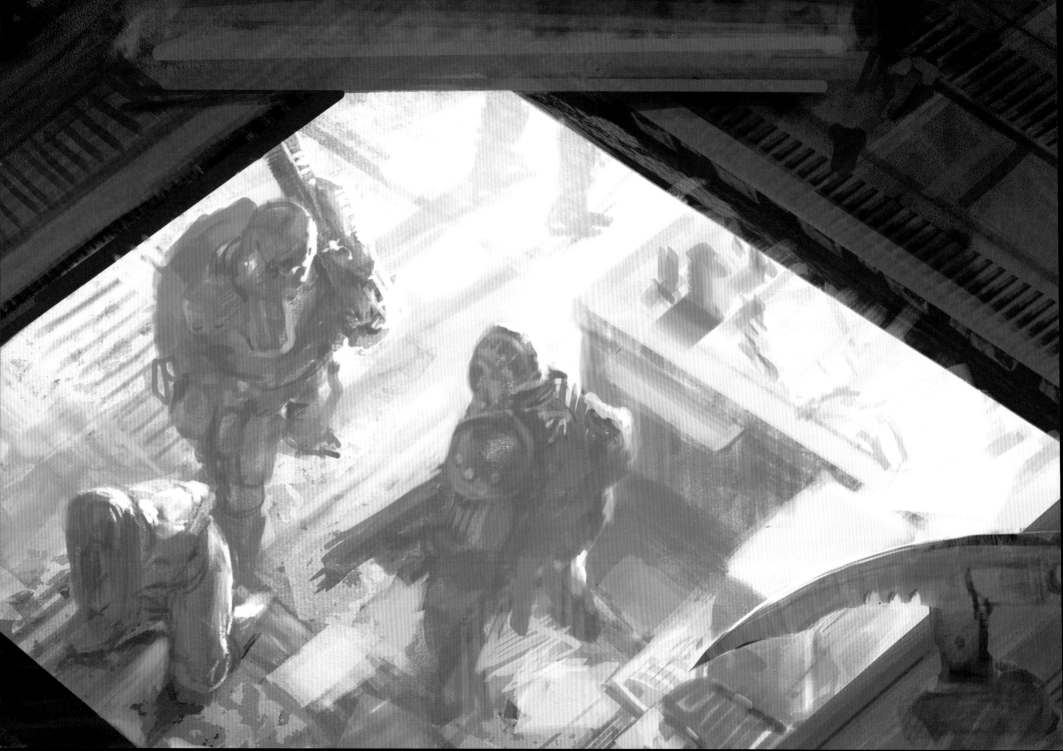

An unpleasant event unfolds below, but this unnamed witness is armed and ready for any consequences. Several other gameplay scenarios in progress on the *right*, although none that made the final build. "We produced quite a lot of these concepts early on in production, just to inspire the designers and give them ideas about what we could do and what would work visually," says Jude Bond.

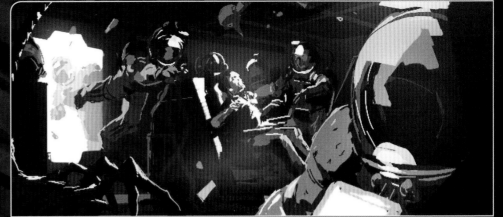

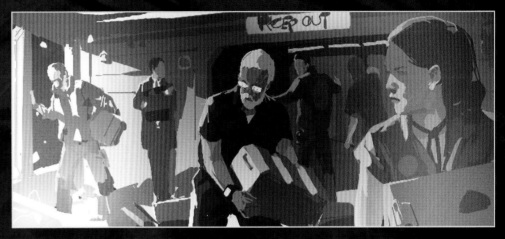

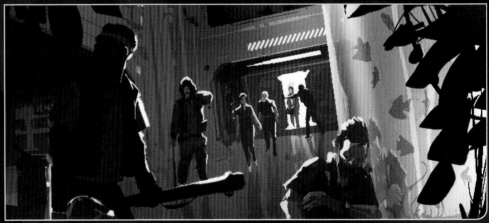

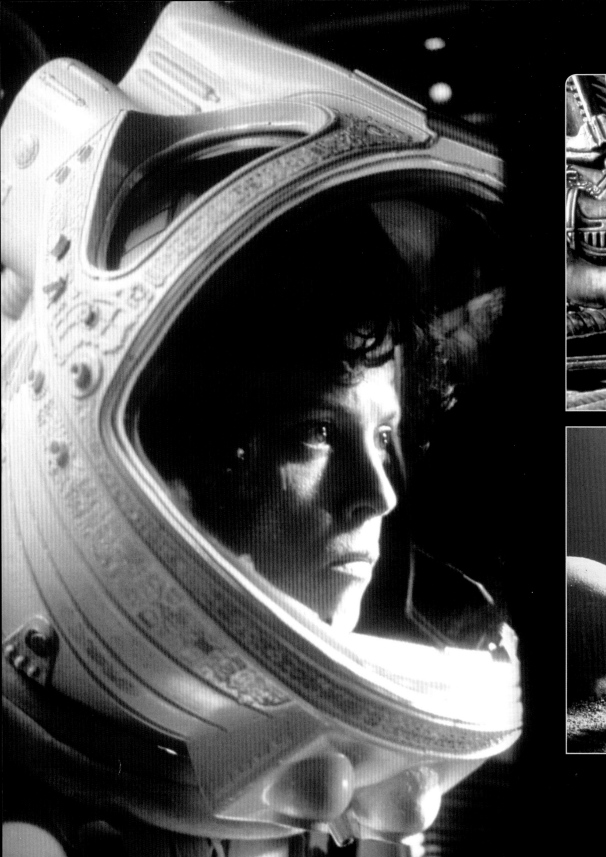
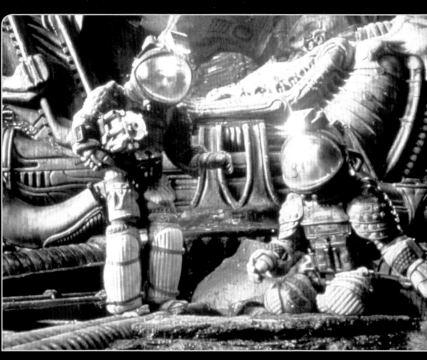
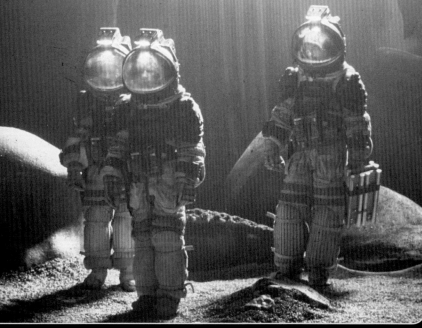

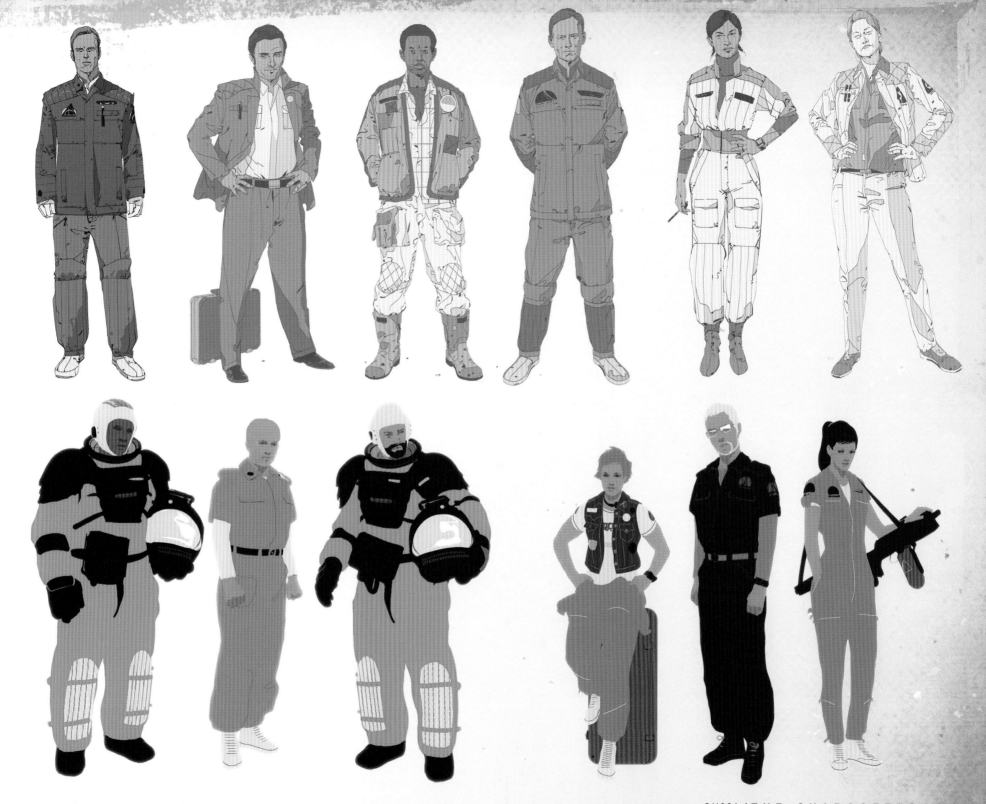

POWER DRESSING

CONCEPT ARTIST CALUM WRIGHT describes how working in one discipline gave him a flavor of another one altogether: "*Alien: Isolation* was the first project I had worked on where we digitally scanned actors to create the in-game cast of characters. Therefore my role was more akin to a costume designer," he begins. "Referencing John Mollo's classic approach to sci-fi costuming, through his work on ALIEN, I was able to give each character the right outfit from a design and period point of view. While the overall 'look' of the character would ultimately be decided by the real world casting, piecing together the costume and giving the character his or her overall attitude was a compelling challenge."

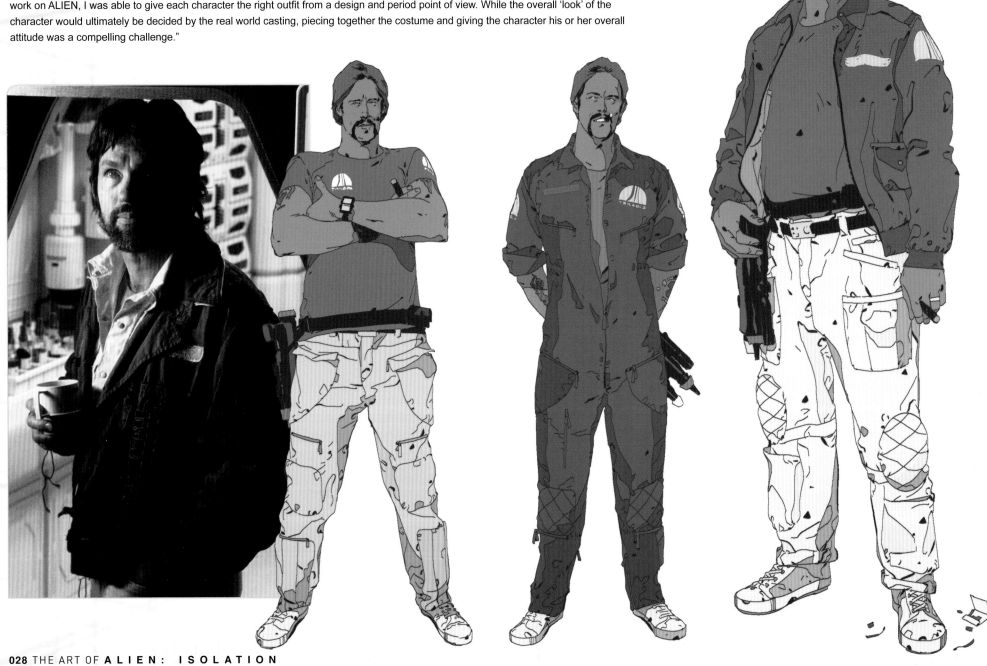

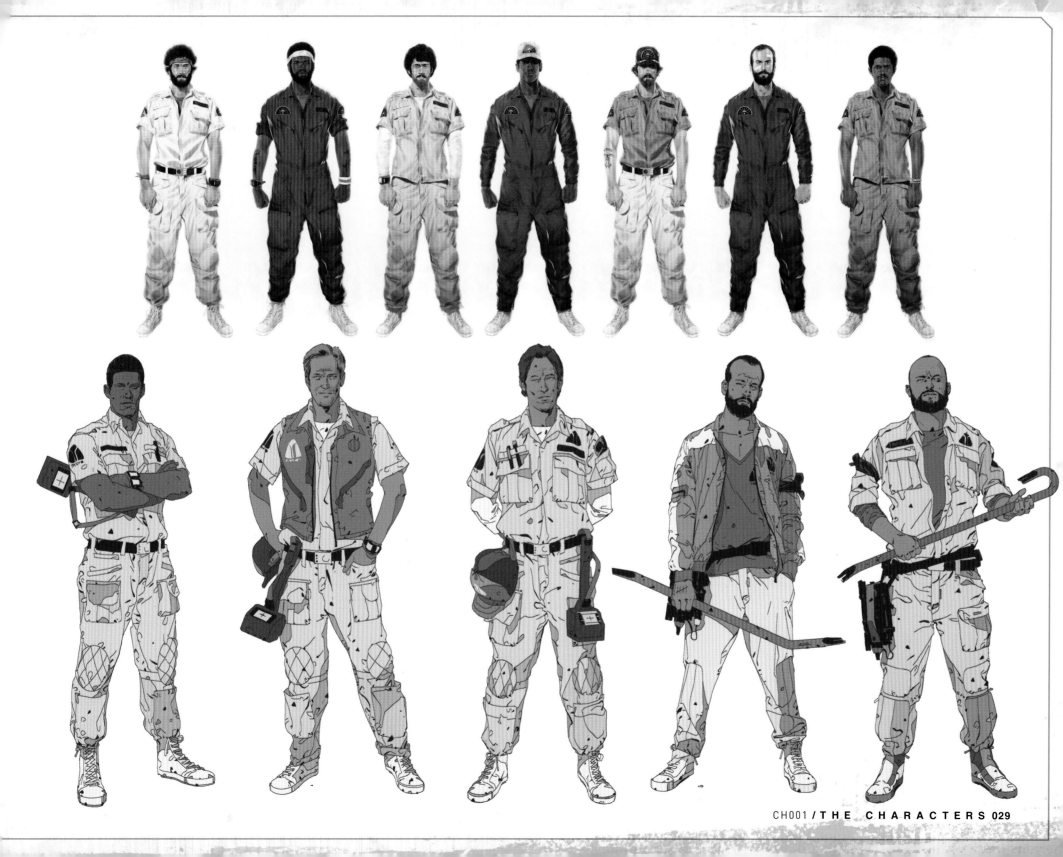

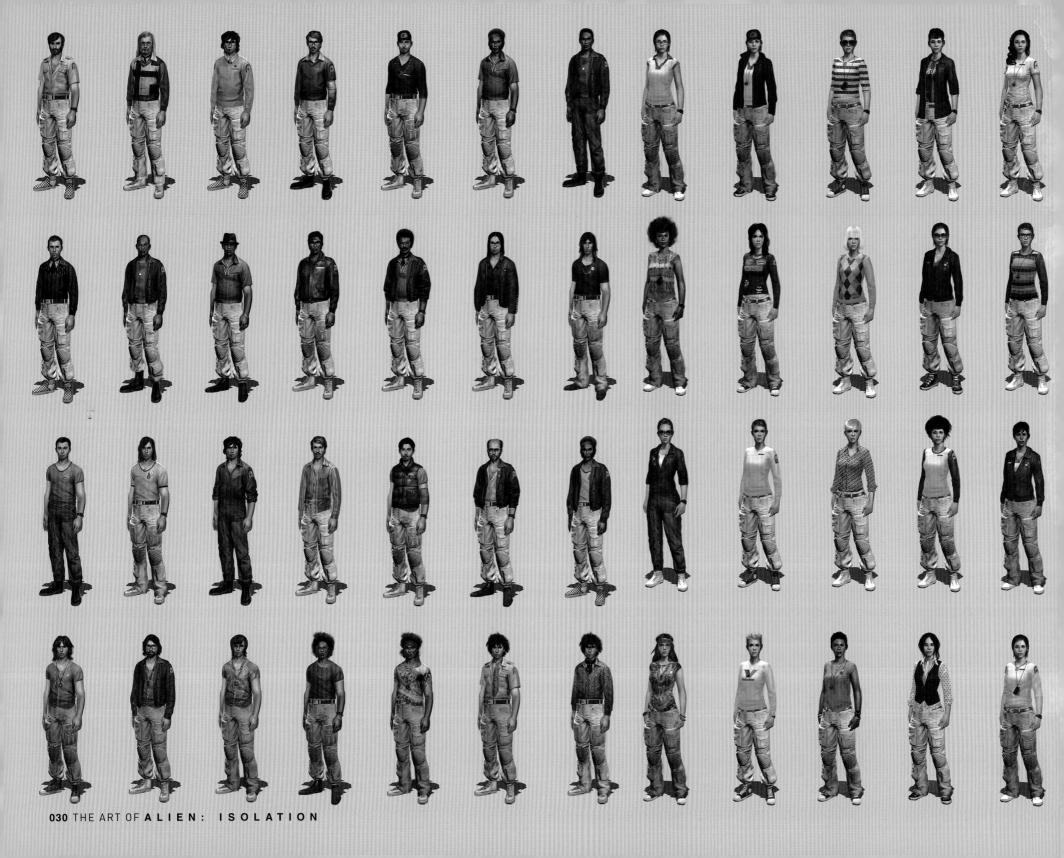

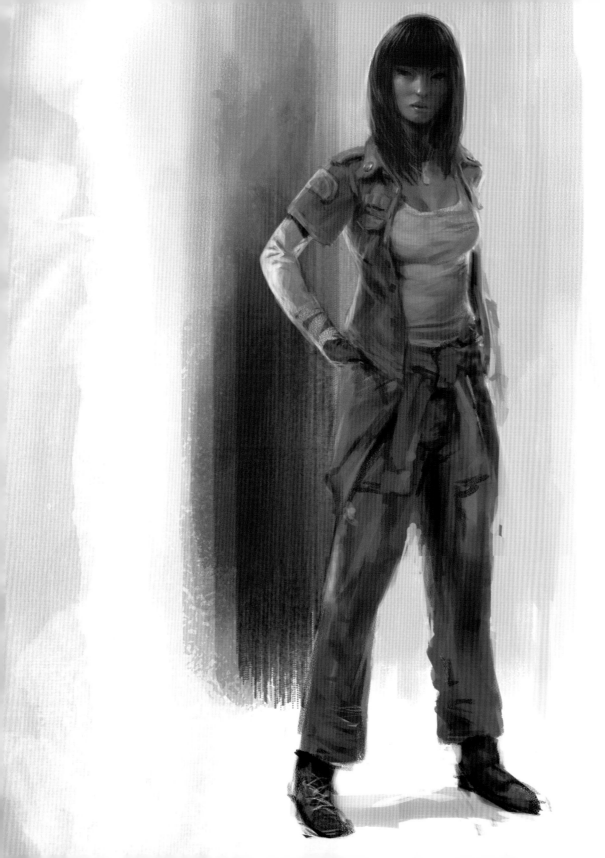

STYLE NEVER GOES out of fashion. However, the clothes designed for the 22nd century setting of the ALIEN movie were firmly locked to the era of their creation. 35 years later and *Alien: Isolation* artists have disinterred the past in order to depict the future, as concept artist Edouard Caplain explains: "In the original film the crew aboard the Nostromo added a few personal touches to their uniforms; something that showed a bit of their character. We tried to go in that direction as well. We browsed through a ton of 1970s photos that we scavenged online and we used bits of their fashion to build characters. I think the end result shows the variety of style there was back then very well. Some look pretty classy and elegant."

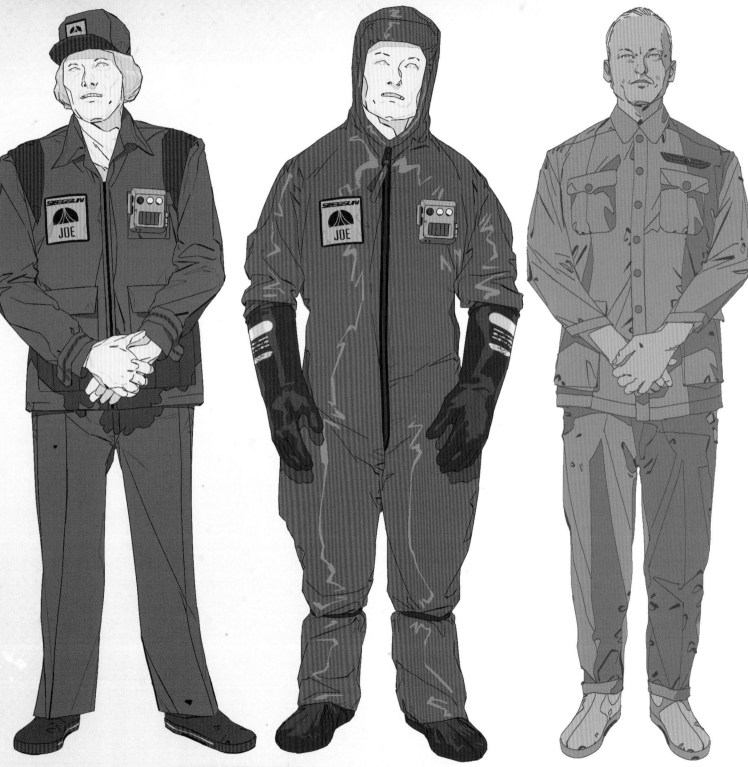

ANDROIDS

THERE IS NO mistaking one of Seegson's 'Working Joe' androids for any of Weyland-Yutani's more sophisticated synthetics. These are machines designed to undertake the everyday functions of Sevastopol Station and to serve its citizens as required. Their subservient role is underlined by a rudimentary appearance (inspired by 1970s resuscitation dummies) and a limited verbal repertoire. Working Joes have operated without incident for the most part. However, they have recently started attacking the human population without any kind of provocation. Those who survive an assault report that the robots maintain their usual responses throughout; many merely informing their victims that they are 'trespassing'. It appears that all Working Joes are afflicted in this way, but does this suggest interference at a much higher level?

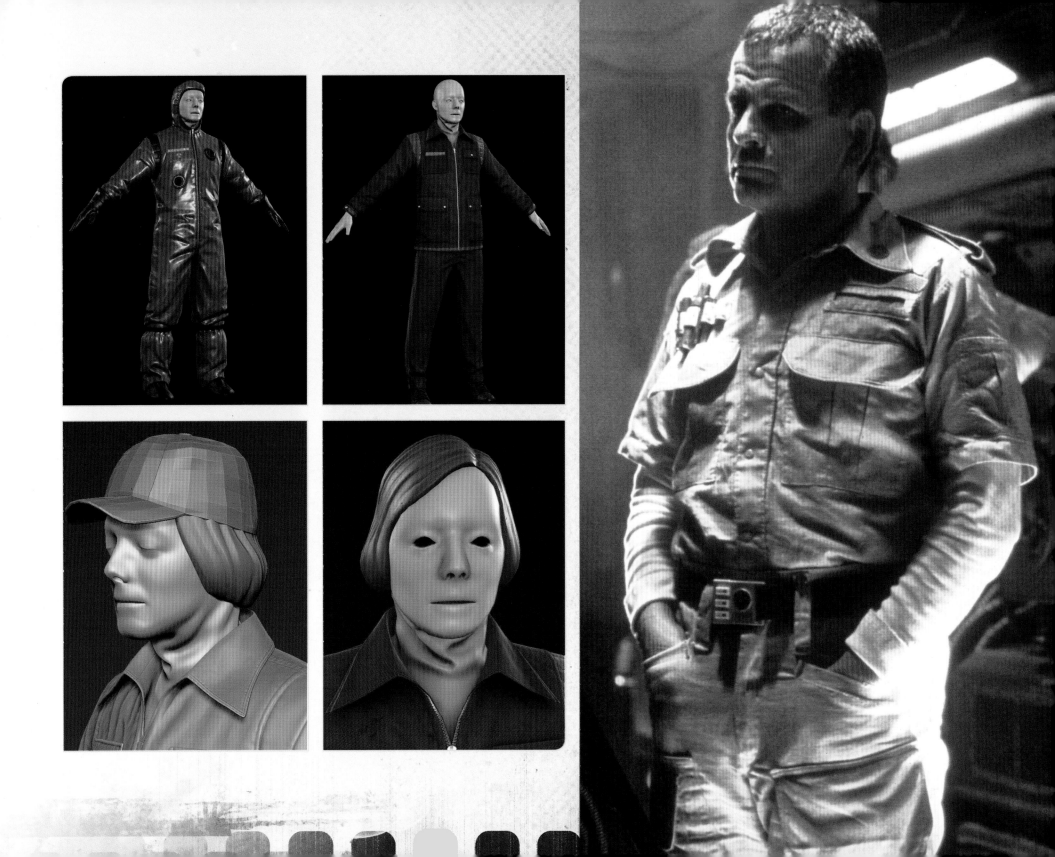

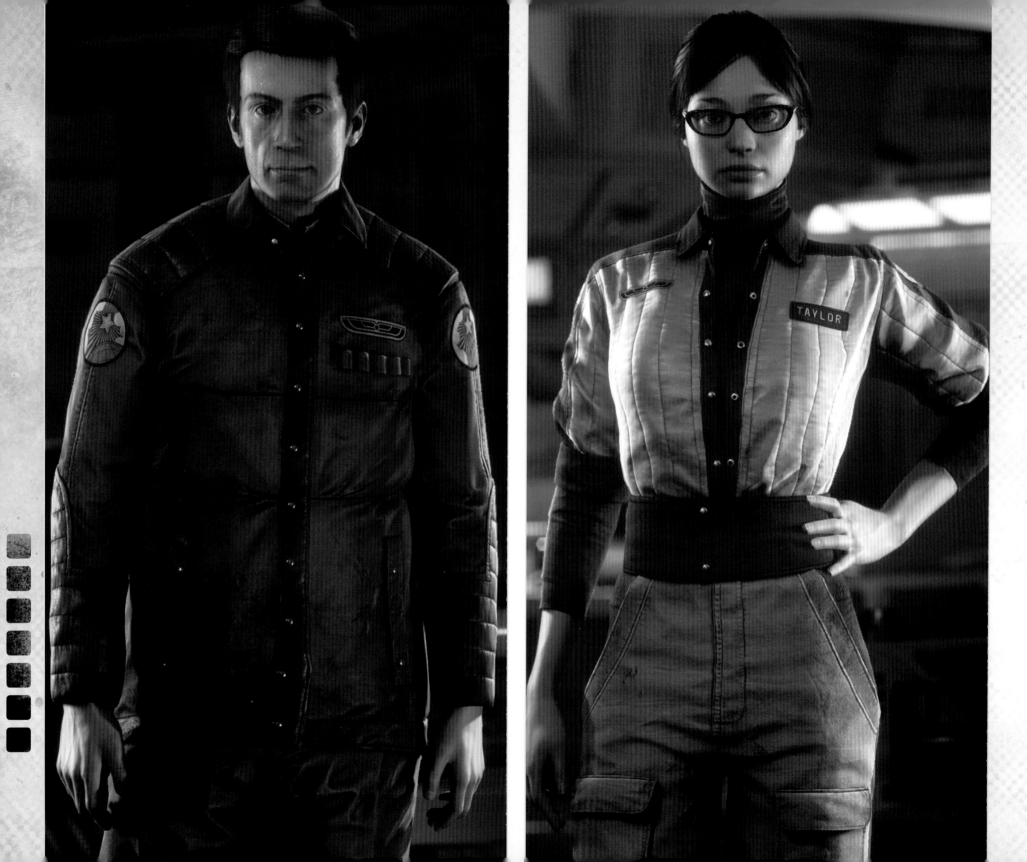

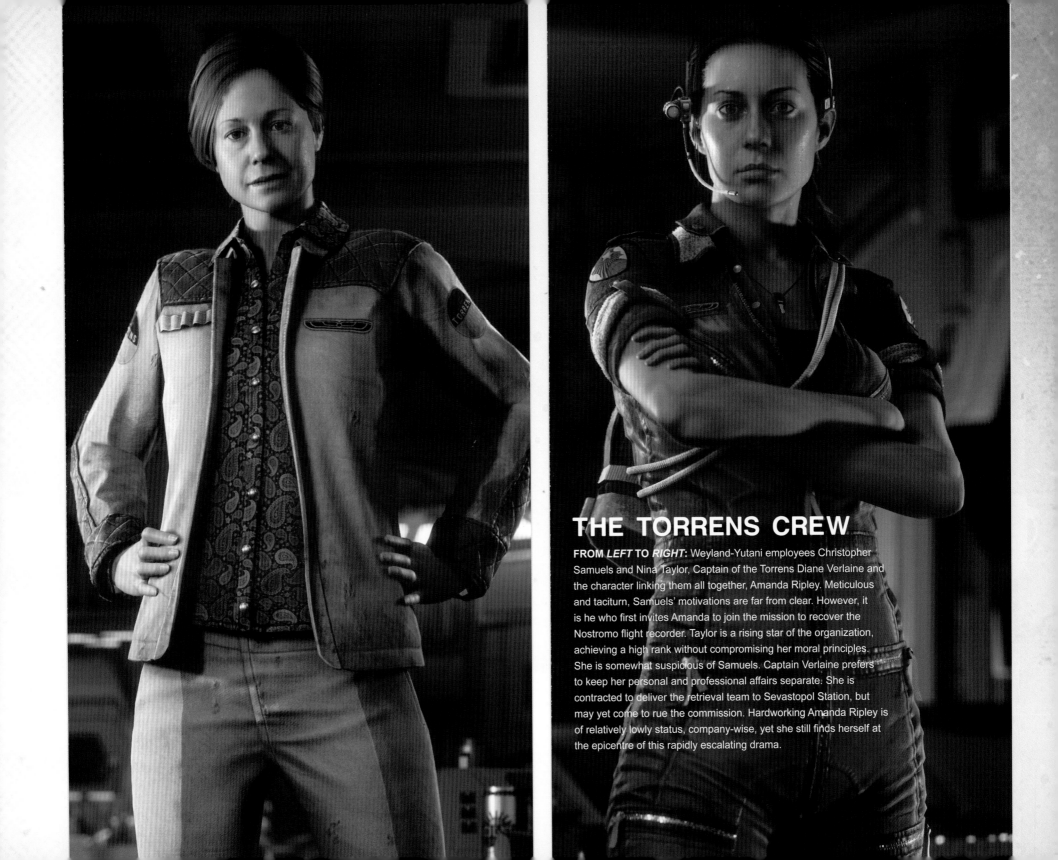

THE TORRENS CREW

FROM *LEFT* TO *RIGHT*: Weyland-Yutani employees Christopher Samuels and Nina Taylor, Captain of the Torrens Diane Verlaine and the character linking them all together, Amanda Ripley. Meticulous and taciturn, Samuels' motivations are far from clear. However, it is he who first invites Amanda to join the mission to recover the Nostromo flight recorder. Taylor is a rising star of the organization, achieving a high rank without compromising her moral principles. She is somewhat suspicious of Samuels. Captain Verlaine prefers to keep her personal and professional affairs separate: She is contracted to deliver the retrieval team to Sevastopol Station, but may yet come to rue the commission. Hardworking Amanda Ripley is of relatively lowly status, company-wise, yet she still finds herself at the epicentre of this rapidly escalating drama.

CH002 / WEAPONS AND EQUIPMENT

// "Weapons can be used to kill humans and androids, but the caveat is that the noise they make, and the sound of conflict or of people dying, will make the Alien aware. That wouldn't be good at all." //
Lead Artist, Jude Bond.

AMANDA RIPLEY DOES not arrive at Sevastopol expecting any kind of trouble. As such, she's drastically unequipped to deal with the homicidal androids, errant security guards and paranoid citizens she encounters, let alone the elemental terror that stalks the station unhindered. She must make do with whatever armaments come to hand and improvise as much as the prevailing circumstances and available resources allow.

Self-preservation is Amanda's first concern, of course, although the weapons she is able to locate are usually in short supply and often with very limited ammunition. "The key thing that we kept coming back to is that weapons are a useful tool, but they're a blunt tool too," says Jude Bond. "They're not going to fix the problems that the player has – they might buy some time but they're not going to provide the solution." With all of this in mind, it is always wise to remember that she who fights and runs away lives to fight another day.

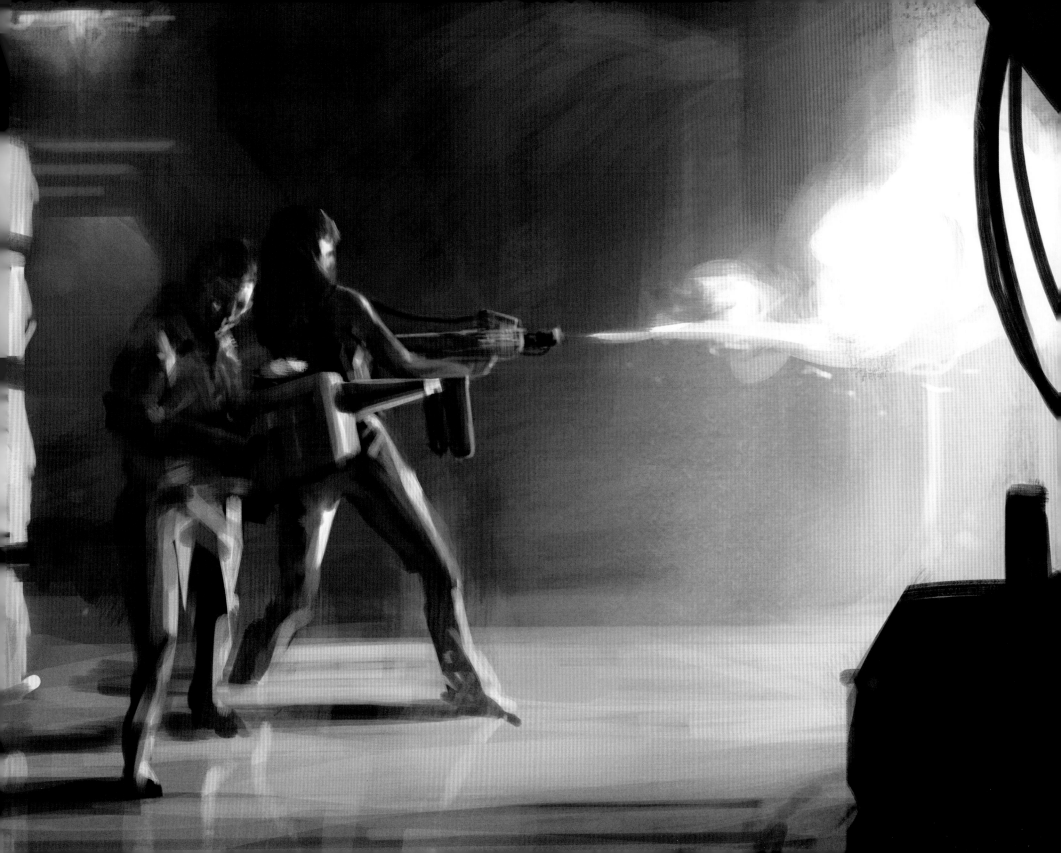

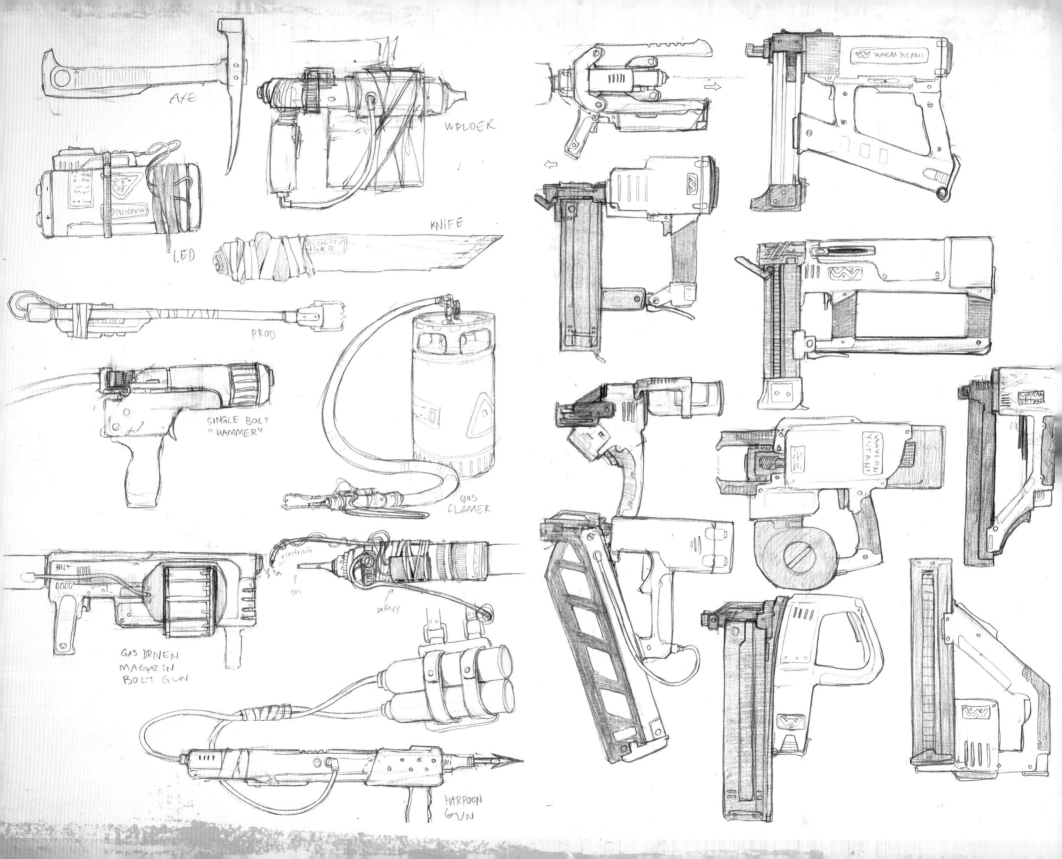

AXE

WELDER

LED

KNIFE

PROD

SINGLE BOLT
"HAMMER"

GAS
FLAMER

GAS DRIVEN
MAGAZIN
BOLT GUN

electricity

gas

battery

HARPOON
GUN

WAYLAN YUTANI

WAYLAND
YUTANI

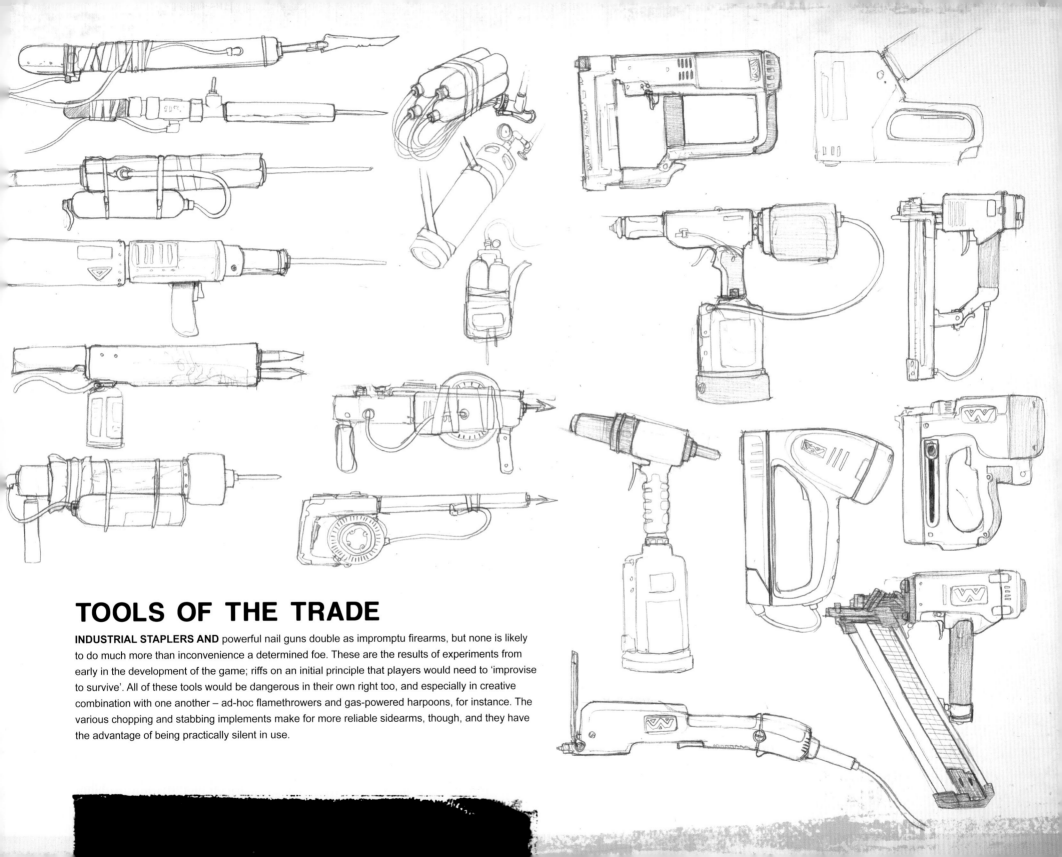

TOOLS OF THE TRADE

INDUSTRIAL STAPLERS AND powerful nail guns double as impromptu firearms, but none is likely to do much more than inconvenience a determined foe. These are the results of experiments from early in the development of the game; riffs on an initial principle that players would need to 'improvise to survive'. All of these tools would be dangerous in their own right too, and especially in creative combination with one another – ad-hoc flamethrowers and gas-powered harpoons, for instance. The various chopping and stabbing implements make for more reliable sidearms, though, and they have the advantage of being practically silent in use.

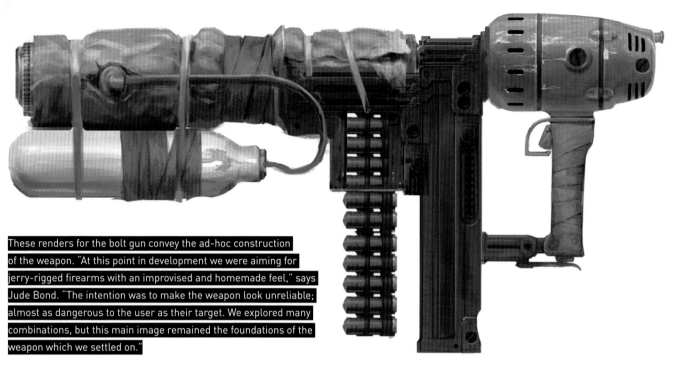

These renders for the bolt gun convey the ad-hoc construction of the weapon. "At this point in development we were aiming for jerry-rigged firearms with an improvised and homemade feel," says Jude Bond. "The intention was to make the weapon look unreliable; almost as dangerous to the user as their target. We explored many combinations, but this main image remained the foundations of the weapon which we settled on."

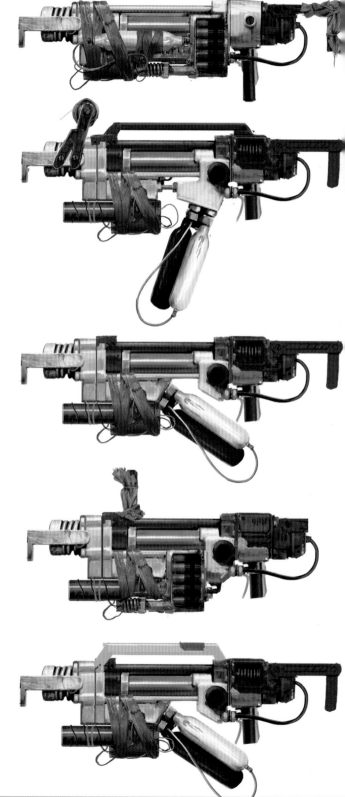

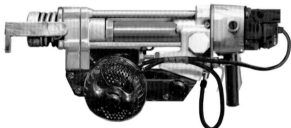

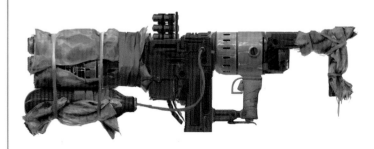

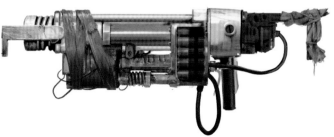

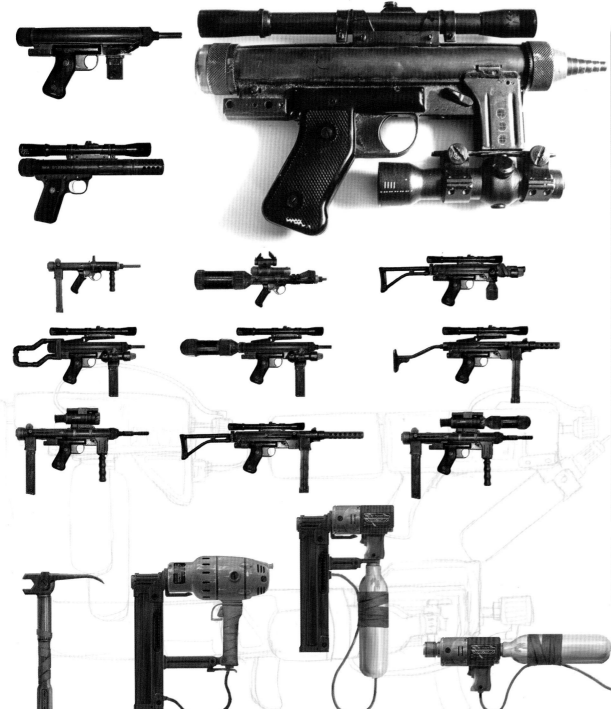

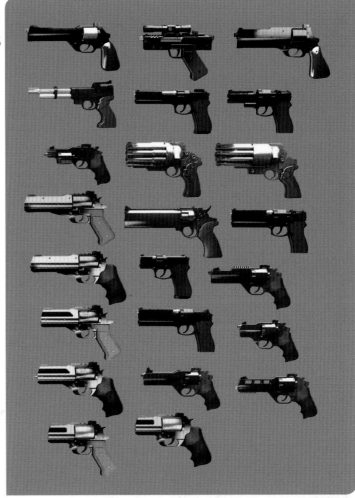

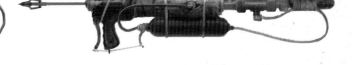

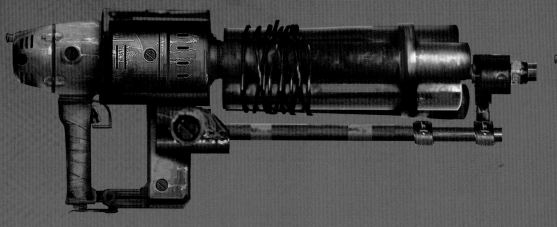

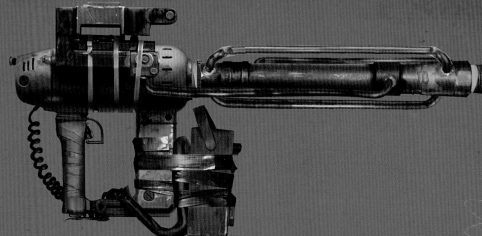

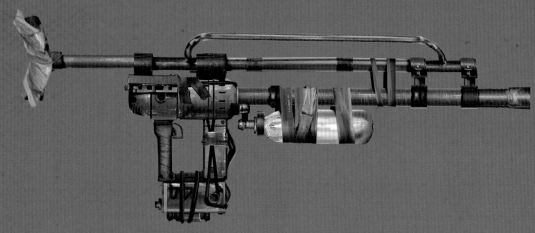

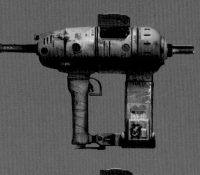

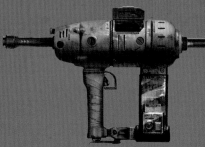

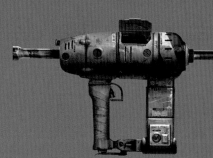

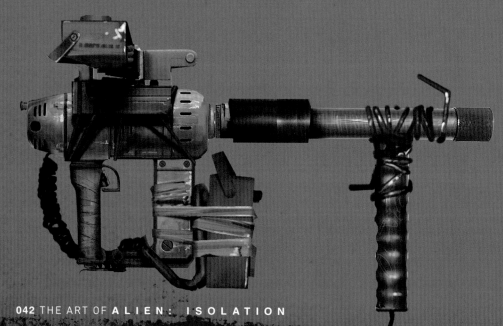

A GREAT MANY ideas have been conceived and, for various reasons, discarded during the production of *Alien: Isolation*. Such is the case with the three renders to the left, which illustrate how several weapons could be assembled from the same core parts. However, the crafting aspect of gameplay has been scaled back in order to make armaments a rarer and more precious commodity on the whole. That's probably a sensible decision too, since the time taken to build a weapon is doubtless better spent running and hiding from the many dangers more immediately afoot.

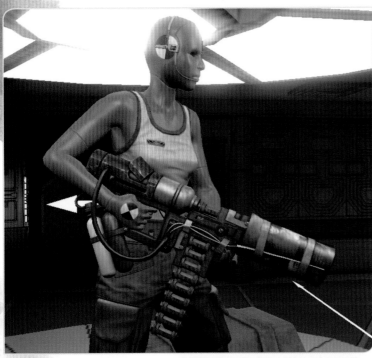

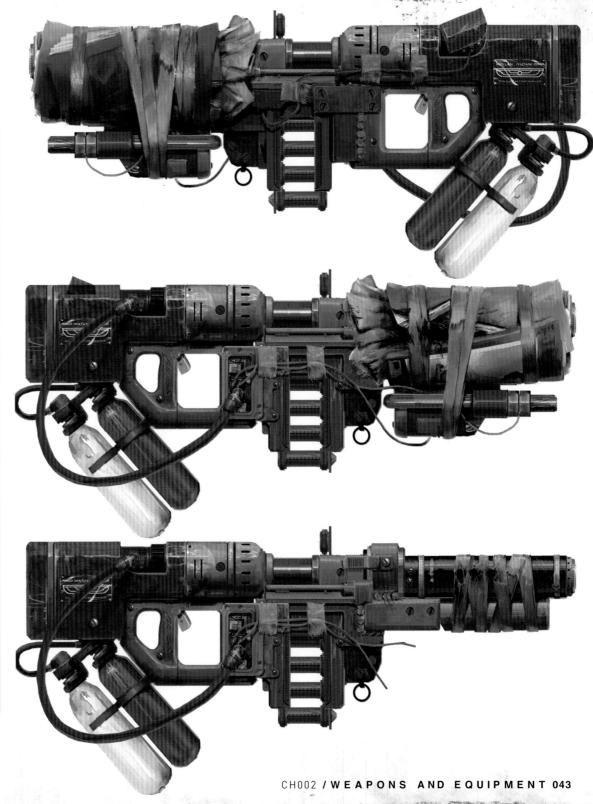

OPPOSITE: The blue weapon to the *left* is close to how the bolt gun looks in the game, with a selection of handle options beneath. The weapon has elements of its antecedents too – the khaki power pack references an item carried by Brett in the ALIEN movie and the gun barrel resembles the cattle prod.

RIGHT: A selection of early iterations of the bolt gun; still jerry-rigged but perhaps a little more conventional in design and rather unwieldy. "I'm rather sad that they didn't make it into the game," adds Jude Bond.

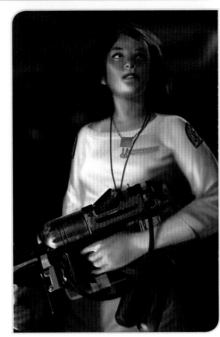

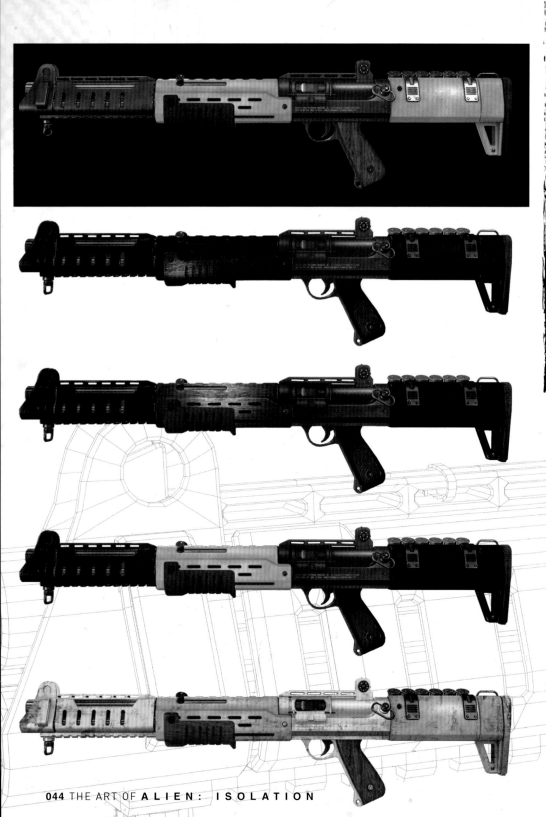
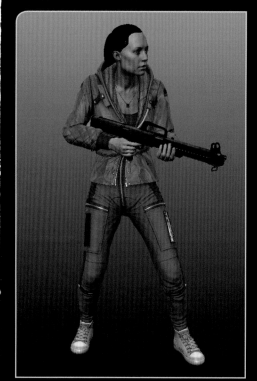
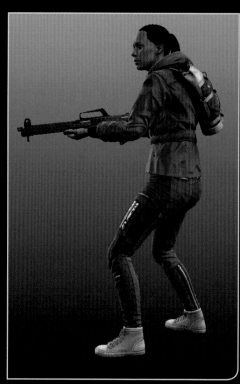

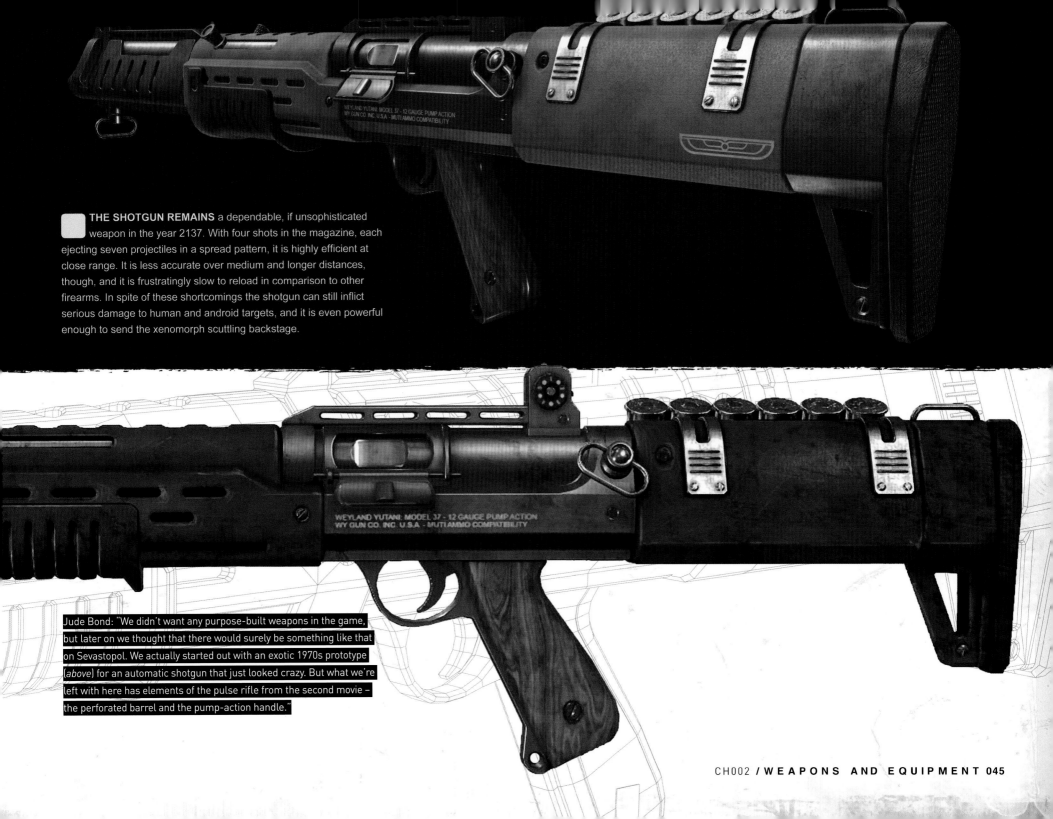

THE SHOTGUN REMAINS a dependable, if unsophisticated weapon in the year 2137. With four shots in the magazine, each ejecting seven projectiles in a spread pattern, it is highly efficient at close range. It is less accurate over medium and longer distances, though, and it is frustratingly slow to reload in comparison to other firearms. In spite of these shortcomings the shotgun can still inflict serious damage to human and android targets, and it is even powerful enough to send the xenomorph scuttling backstage.

Jude Bond: "We didn't want any purpose-built weapons in the game, but later on we thought that there would surely be something like that on Sevastopol. We actually started out with an exotic 1970s prototype (*above*) for an automatic shotgun that just looked crazy. But what we're left with here has elements of the pulse rifle from the second movie – the perforated barrel and the pump-action handle."

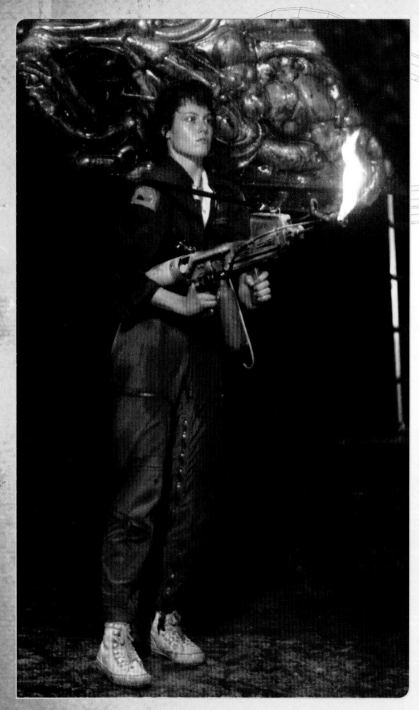

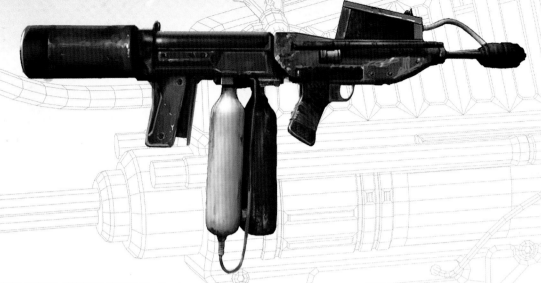

THE FLAMETHROWER IS effective against all adversaries, but careful deployment is recommended. The weapon consumes fuel constantly while it is being used and only fires in three-second bursts before entering a two-second cooling phase. This may be a significant impediment when facing synthetic foes, which tend to keep advancing until permanently stopped. However, the xenomorph soon learns to keep its distance, just as long as the weapon has fuel remaining.

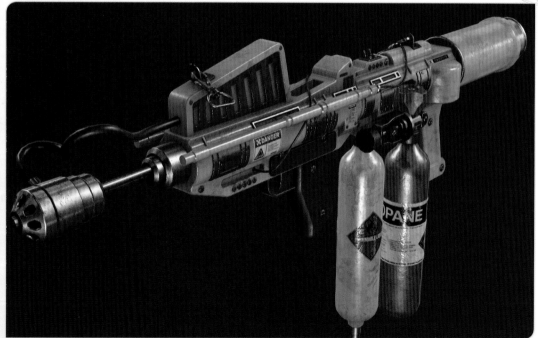

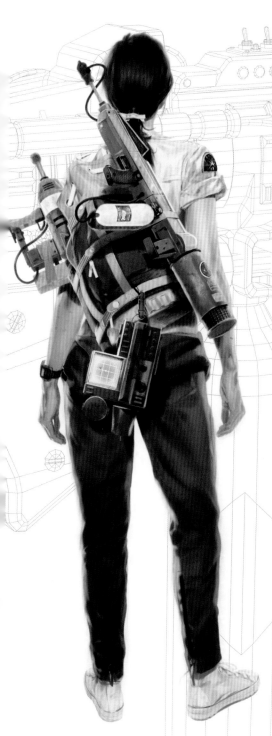

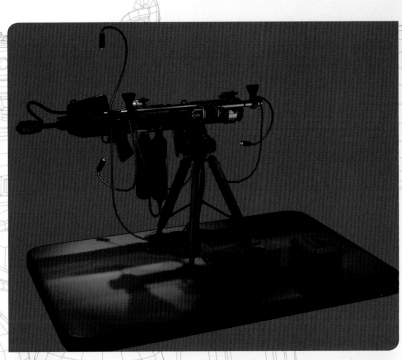

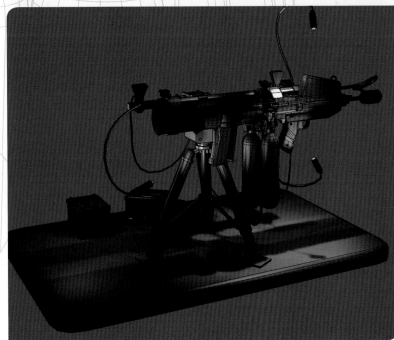

LEFT: The flamethrower is rigged on a stand to make for easier access. The iconic motion tracker to the right is authentic in every detail. However, the unit only scans in a relatively narrow arc and weapons cannot be fired while it is being held.

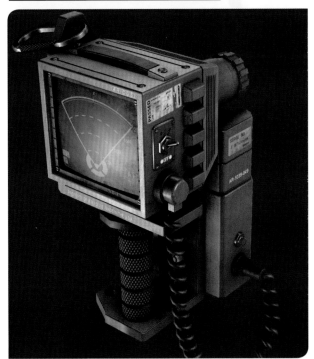

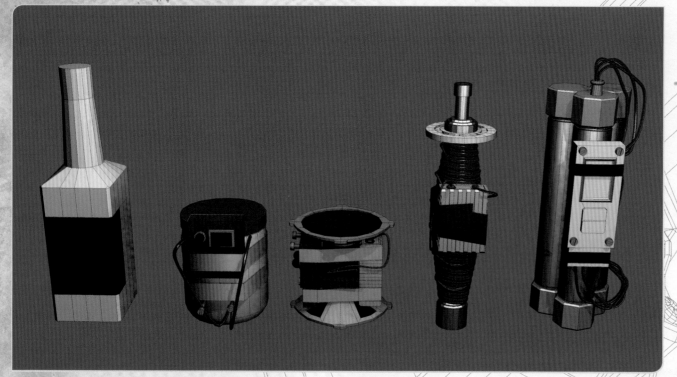

THE ASSORTED NOISEMAKERS, pipe-bombs, Molotov cocktails, electromagnetic pulse emitters and remote-detonated explosives presented here have all been assembled from other materials. The crafting component of the game has largely been restricted to such devices, as Jude Bond explains: "The idea of improvised weapons was dialed back in the design, leaving us to focus the mantra of 'improvise to survive' for handmade grenades or IEDs.

The visual development of these items occurred directly in 3D. Functionally, we were looking at distinctive and characterful forms for each bomb type. This obviously informed the aesthetic decisions, and such weapons were finished off with tape and wires to create a crude and hand-built feel."

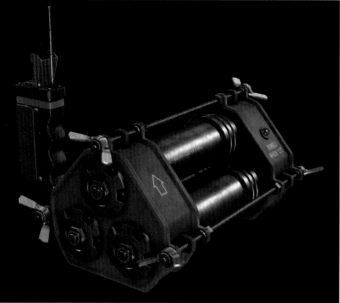

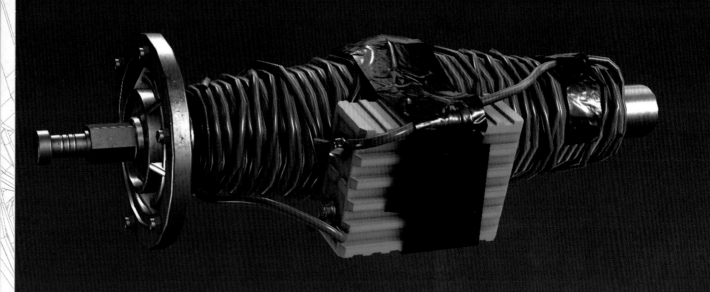

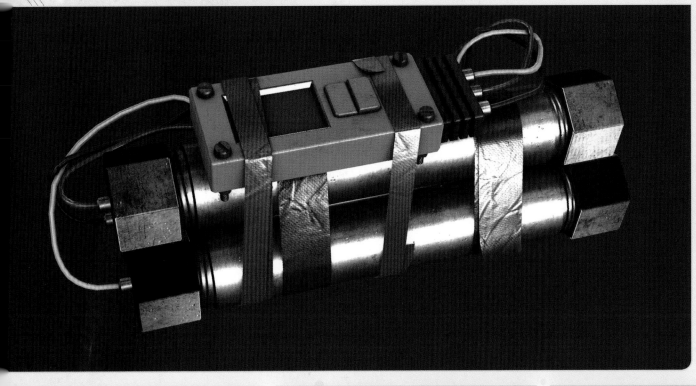

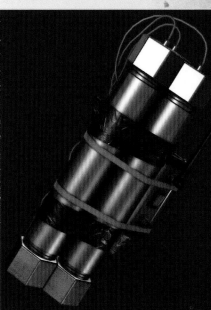

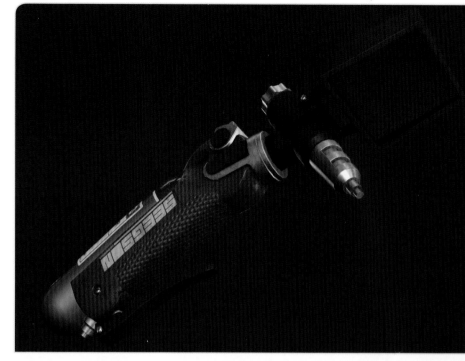

AMANDA IS BOUND to encounter a great many locked doors and secure computer systems on her journey through Sevastopol Station, thus the plasma torch and hacking tool are vital components of her armory. The bolt gun *far-right* is pneumatically-powered and markedly sluggish to operate. The industrial-grade hardware it fires is nevertheless devastating against human adversaries. Although powerful, the bolt gun has no effect on the xenomorph and is of little practical use in fast-paced combat scenarios.

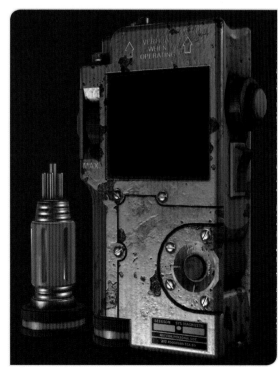

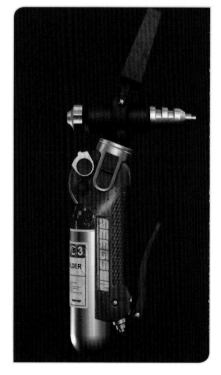

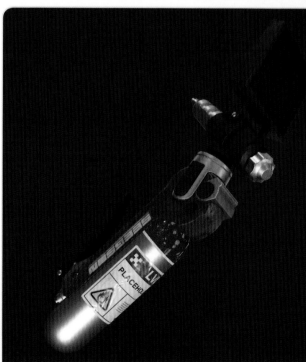

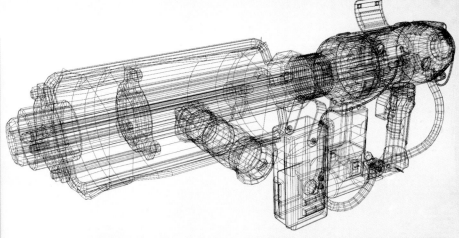

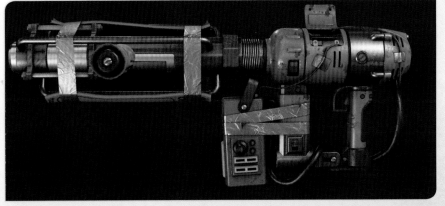

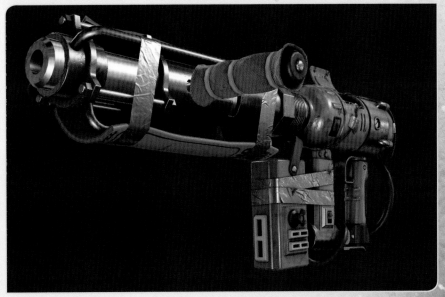

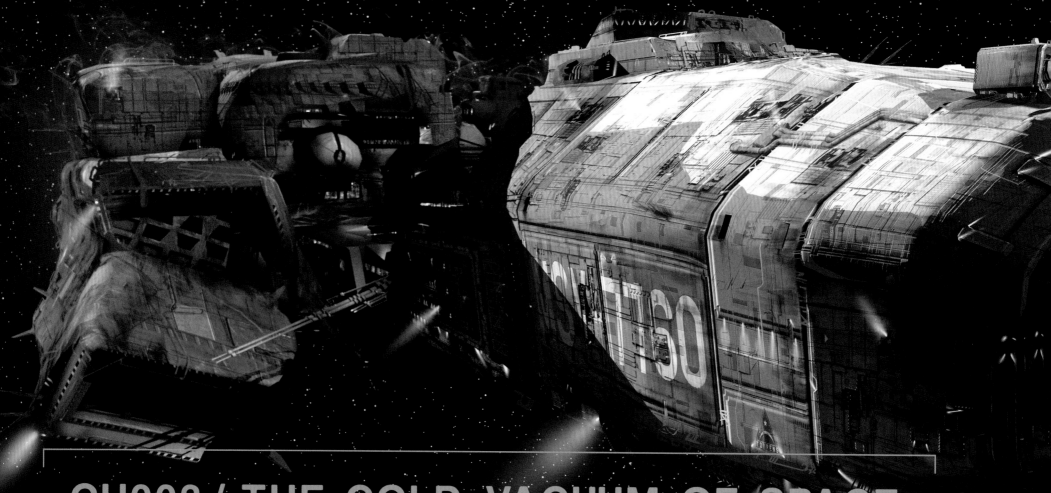

CH003 / THE COLD VACUUM OF SPACE

// "She was a wreck when I bought her. I had to take a lot of contracts to get her into shape, but now she more than pays for herself." //
Captain of the Torrens, Diane Verlaine

FORMS ARE SLAVE to vital functions in vessels that are designed to span the vast and airless expanses of space. Morphologies are brutish and lumpen, and the aesthetic is certainly industrial. The spacecraft of *Alien: Isolation* fit well within the visual lexicon of the ALIEN movie franchise, and some are even based on unused production materials. However, artists also sought other 20th century inspirations. "We developed some of the concept imagery from the original ALIEN film and looked at real world references too – The NASA Apollo missions for example," says Lead Artist Jude Bond.

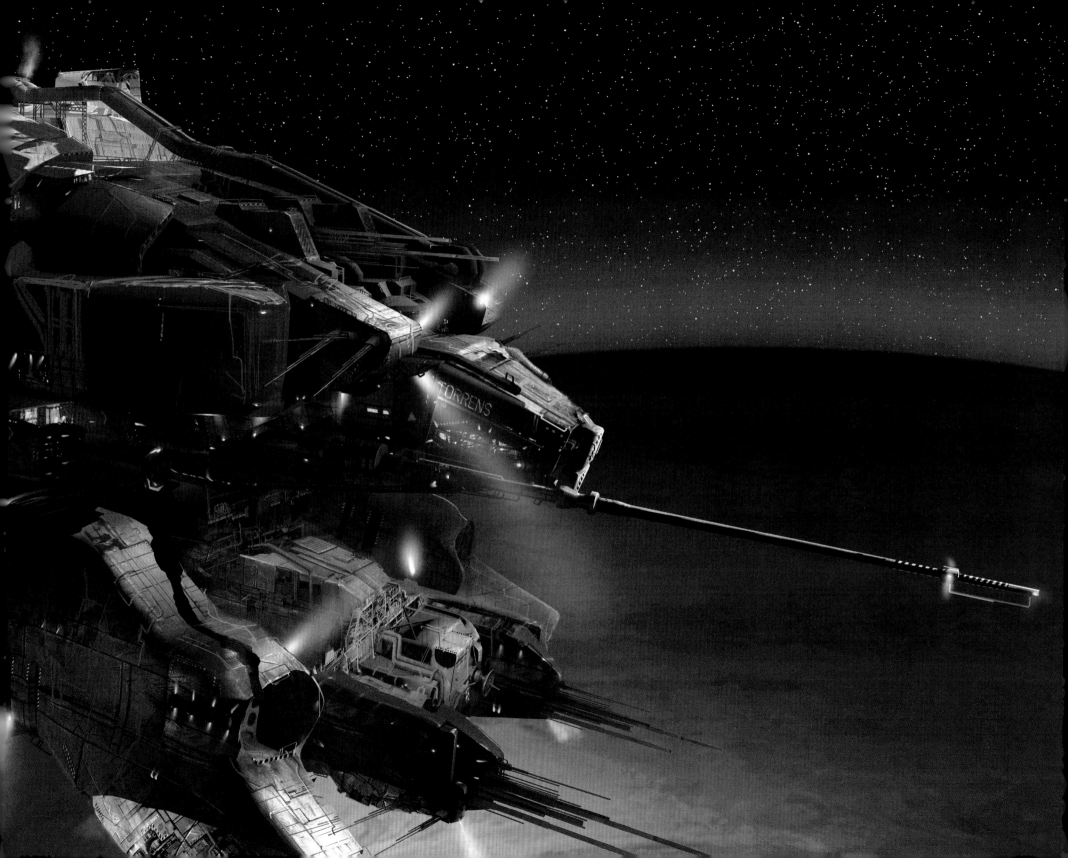

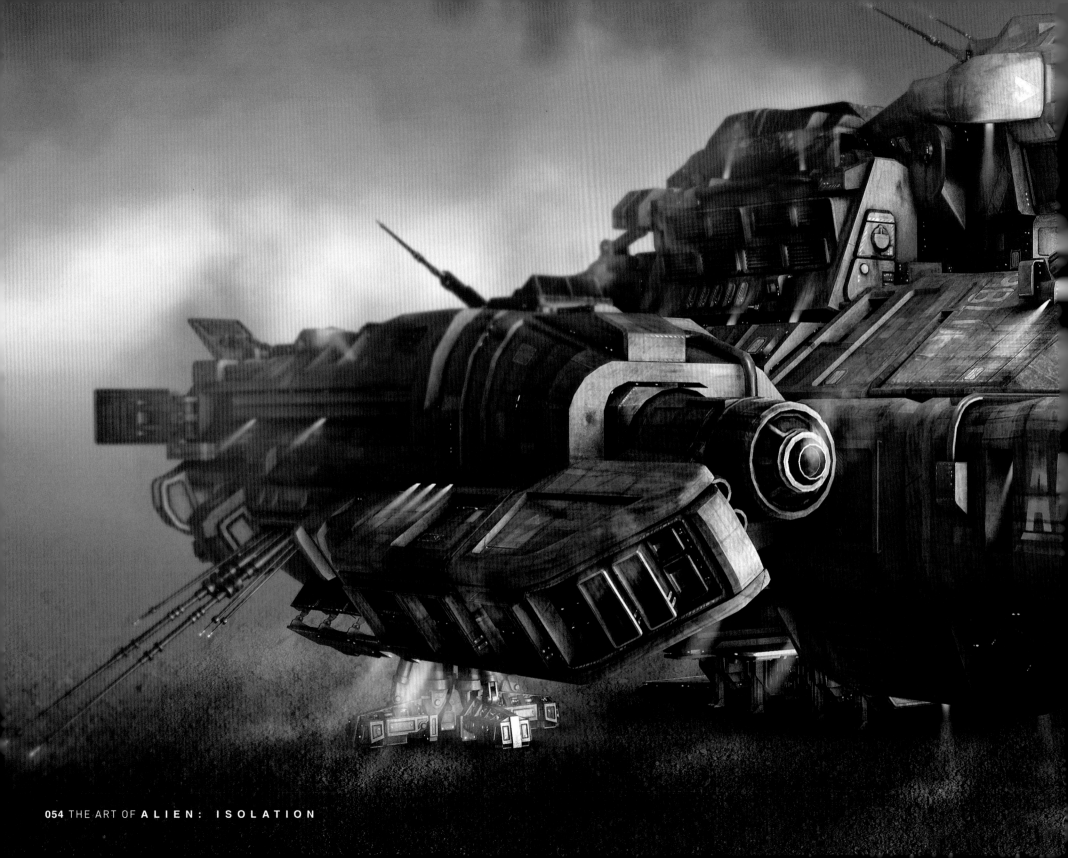

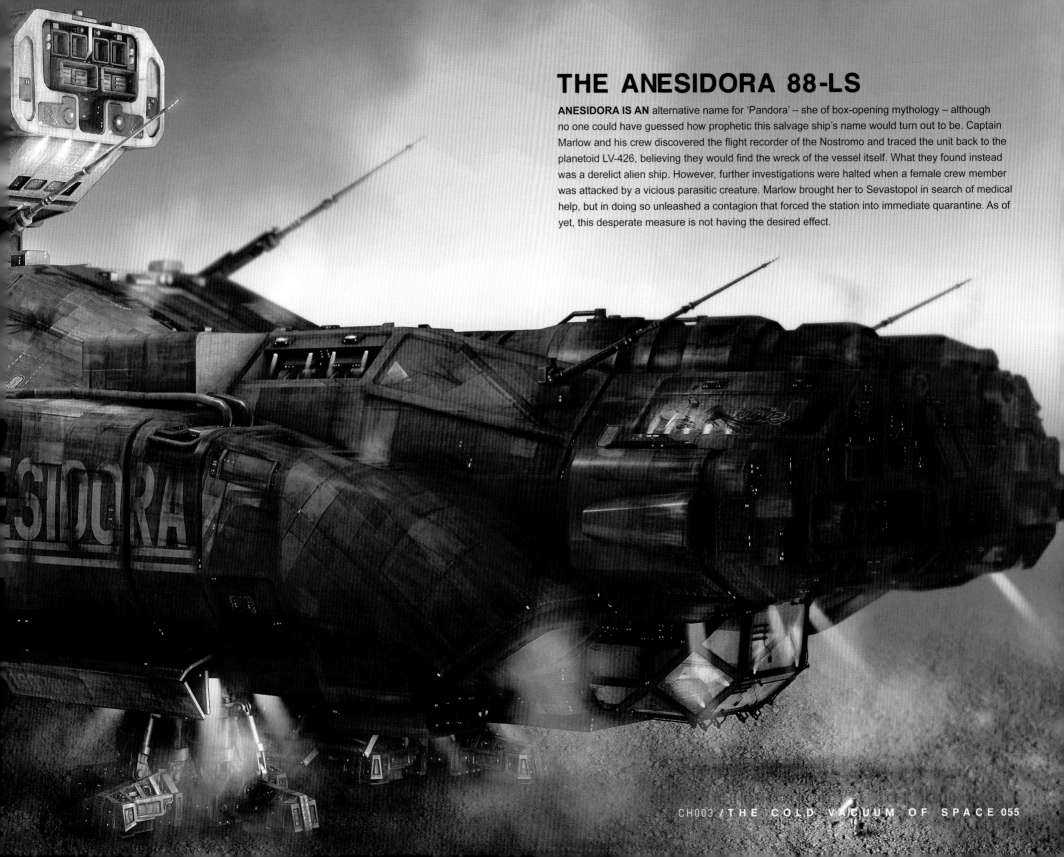

THE ANESIDORA 88-LS

ANESIDORA IS AN alternative name for 'Pandora' – she of box-opening mythology – although no one could have guessed how prophetic this salvage ship's name would turn out to be. Captain Marlow and his crew discovered the flight recorder of the Nostromo and traced the unit back to the planetoid LV-426, believing they would find the wreck of the vessel itself. What they found instead was a derelict alien ship. However, further investigations were halted when a female crew member was attacked by a vicious parasitic creature. Marlow brought her to Sevastopol in search of medical help, but in doing so unleashed a contagion that forced the station into immediate quarantine. As of yet, this desperate measure is not having the desired effect.

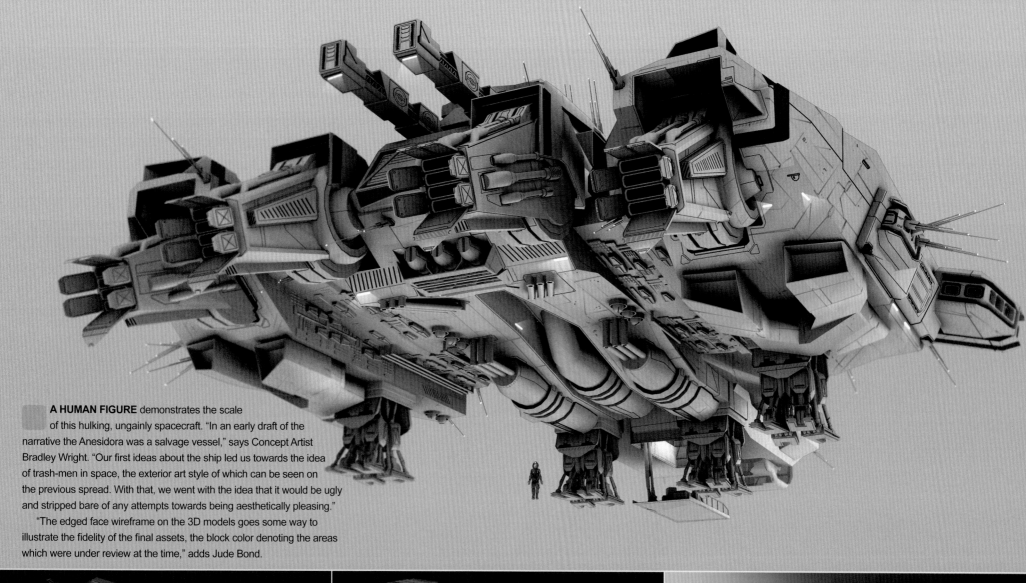

A HUMAN FIGURE demonstrates the scale of this hulking, ungainly spacecraft. "In an early draft of the narrative the Anesidora was a salvage vessel," says Concept Artist Bradley Wright. "Our first ideas about the ship led us towards the idea of trash-men in space, the exterior art style of which can be seen on the previous spread. With that, we went with the idea that it would be ugly and stripped bare of any attempts towards being aesthetically pleasing."

"The edged face wireframe on the 3D models goes some way to illustrate the fidelity of the final assets, the block color denoting the areas which were under review at the time," adds Jude Bond.

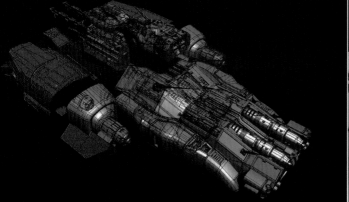
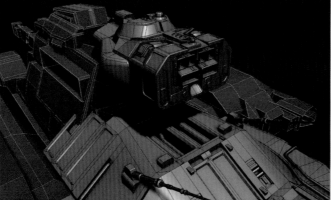
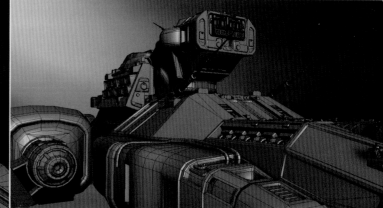

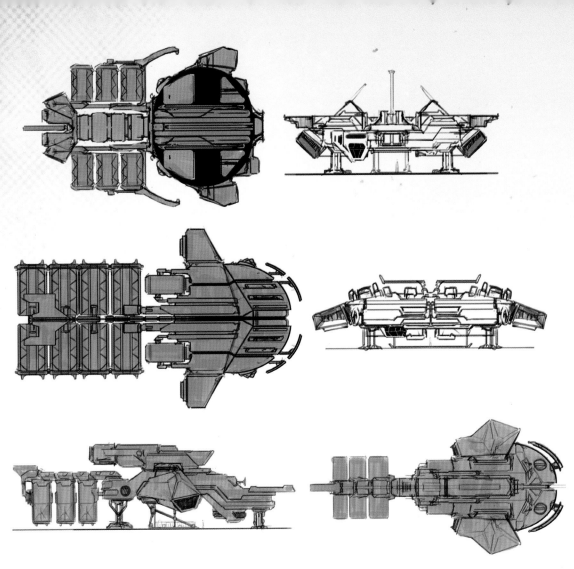

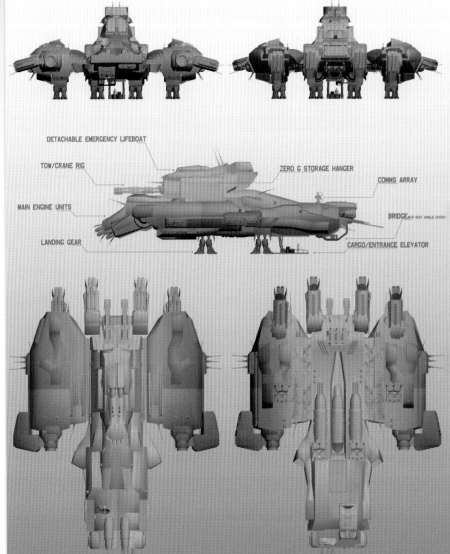

DETACHABLE EMERGENCY LIFEBOAT

TOW/CRANE RIG

ZERO G STORAGE HANGER

COMMS ARRAY

MAIN ENGINE UNITS

BRIDGE (WITH HEAT SHIELD COVERS)

LANDING GEAR

CARGO/ENTRANCE ELEVATOR

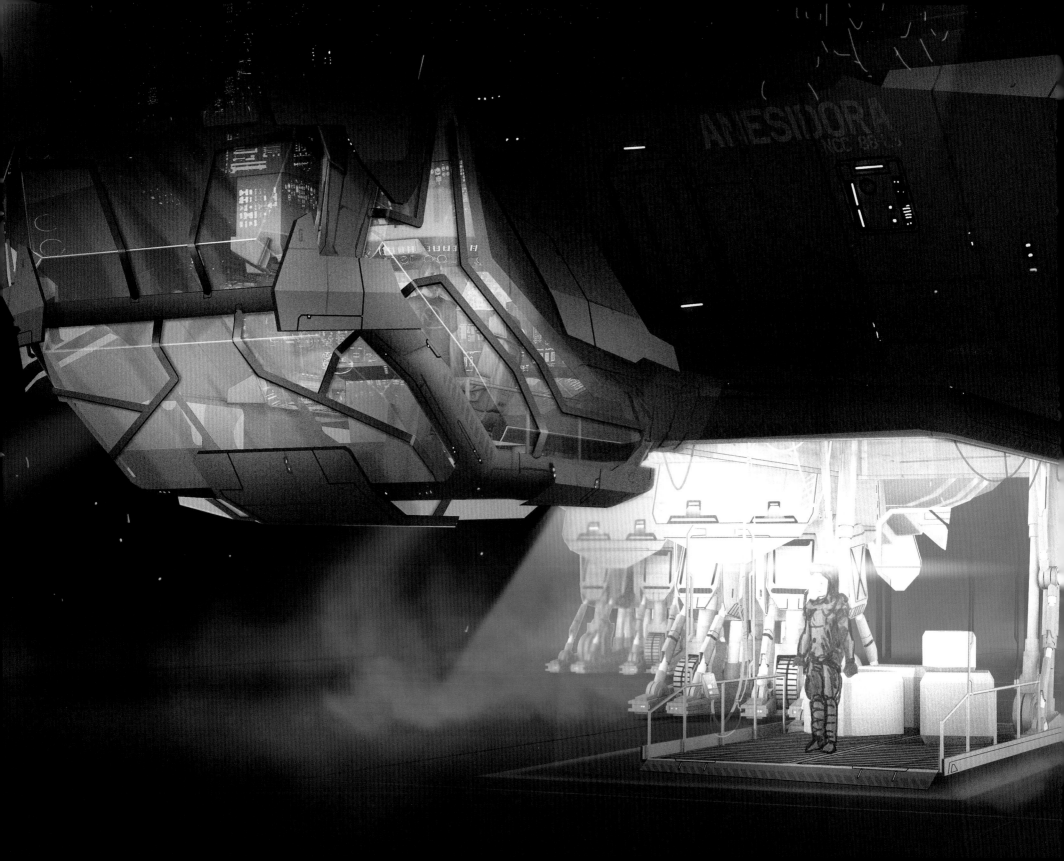

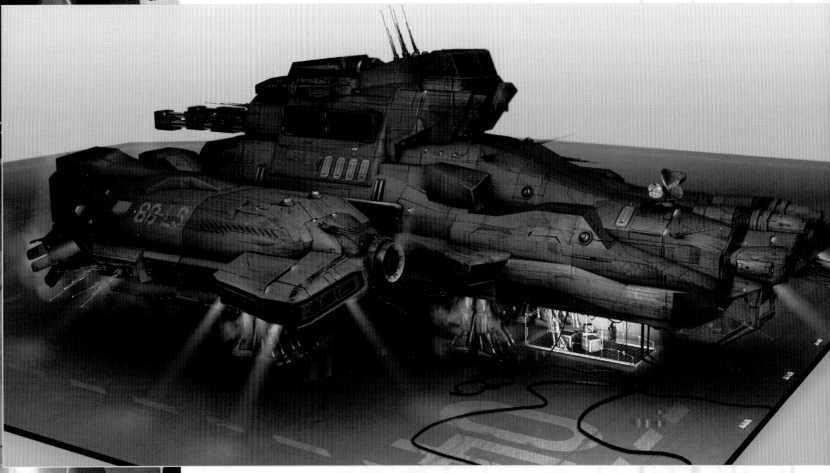

LEFT: "I developed the practical nature of this vessel using the Nostromo's landing gear and disembarking platform as a reference," reveals Bradley Wright. "I also explored ideas for an even larger belly elevator, filled with cranes, workstations, and pressurized suits."

RIGHT: "These guys are deep space salvage hunters and I wanted to add some design elements to suggest this. The bridge hangs under the nose of the ship so the captain can monitor the progress of his crew as they work, loading and unloading cargo."

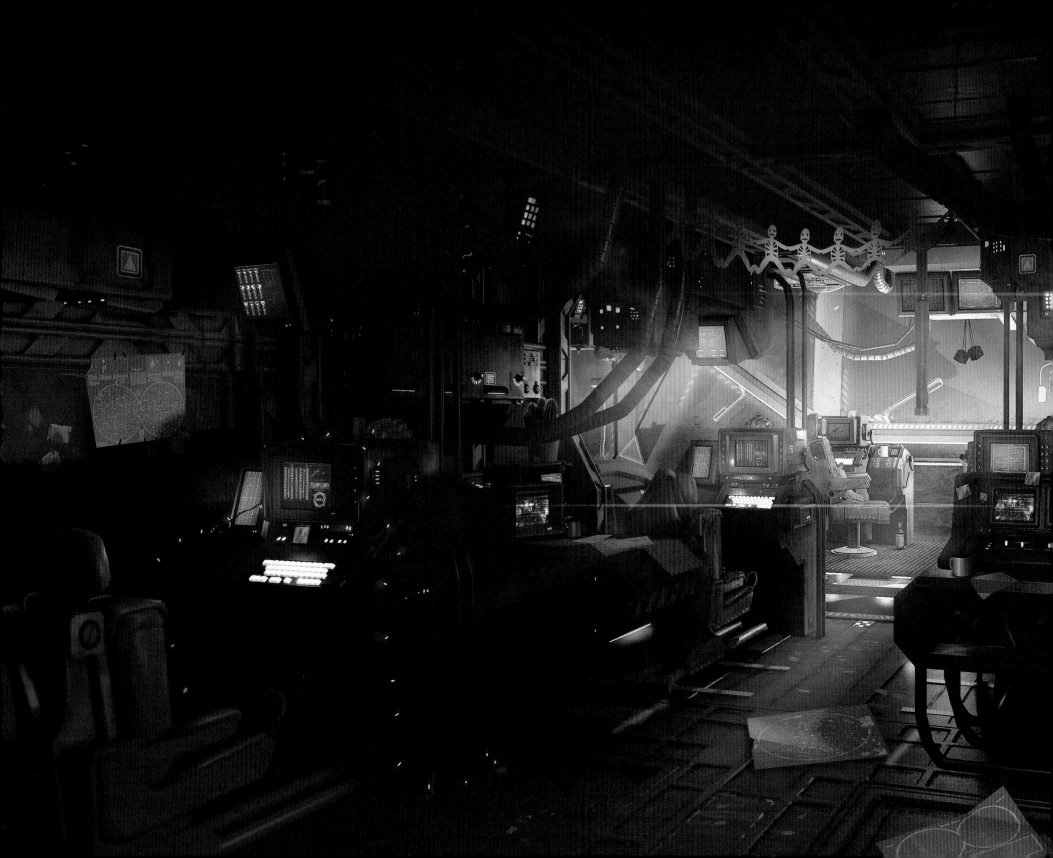

VIDEO SCREENS FLICKER in the half-light of the Anesidora's bridge. "Our use of old technology is primarily to help us capture the essence of the late 70s in an authentic fashion," says Jude Bond. "We mistreated old VCR players to create noisy and distorted signals, and then used the analogue signals to overlay or soften up our own imagery. The aim isn't to make this stuff particularly noticeable, it's about the quality of the subtle textures and it provides an authentic retro vibe."

"I wanted to go even further with the idea of a more lived-in space," adds Bradley Wright. "This crew isn't formal or military; they would have plenty of personal effects. They are somewhat untidy too, with star charts pulled out and not filed away again, and day-old coffee cups strewn about. I also wanted to hint at the purpose of this ship with my color choice here – something to keep the player on edge and in a constant state of alertness."

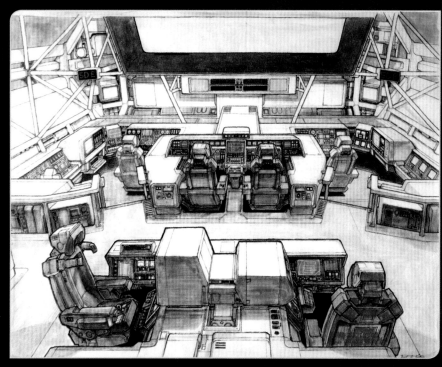

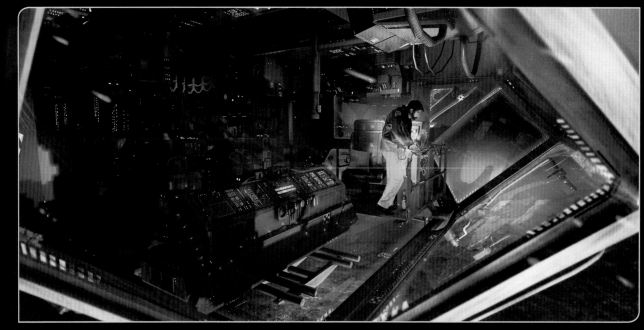

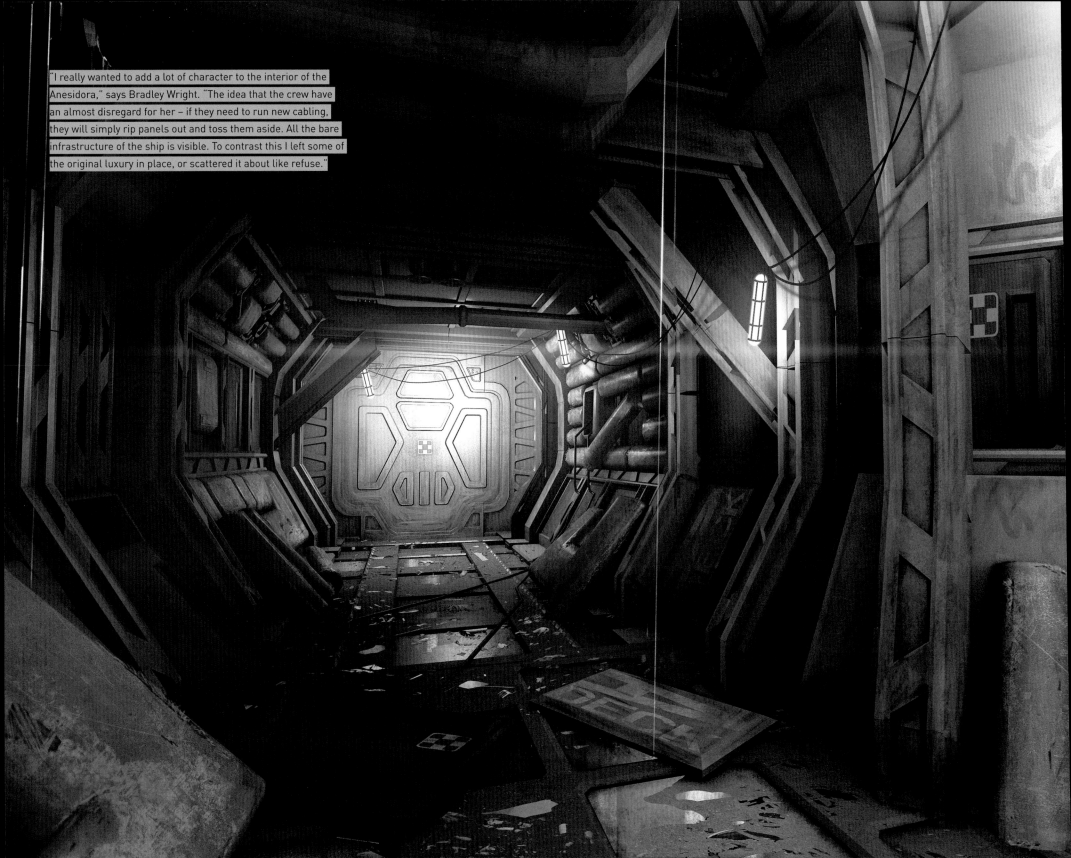

"I really wanted to add a lot of character to the interior of the Anesidora," says Bradley Wright. "The idea that the crew have an almost disregard for her – if they need to run new cabling, they will simply rip panels out and toss them aside. All the bare infrastructure of the ship is visible. To contrast this I left some of the original luxury in place, or scattered it about like refuse."

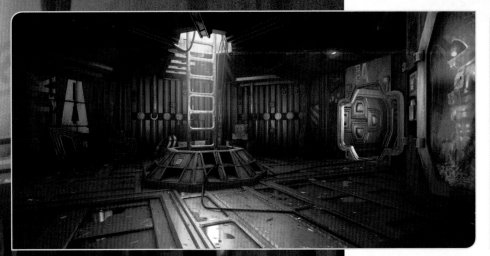

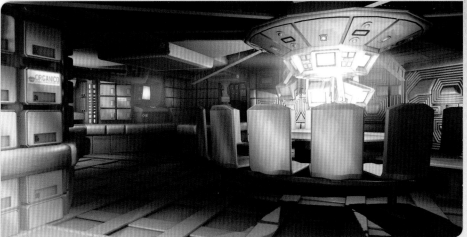

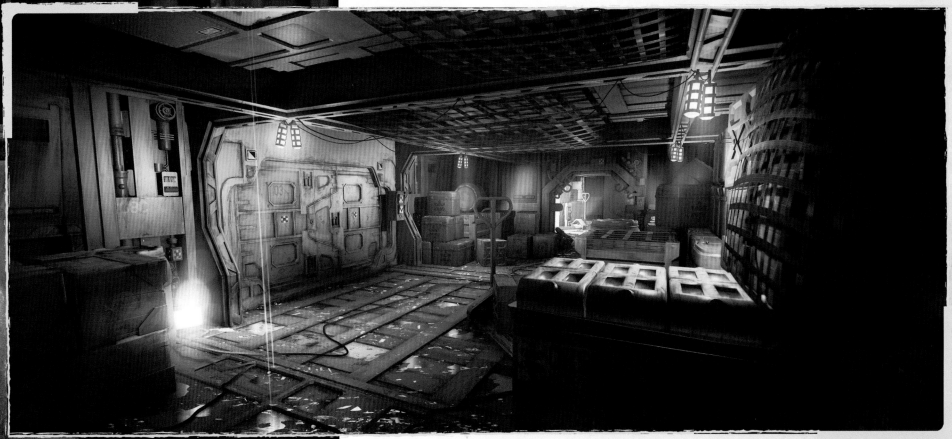

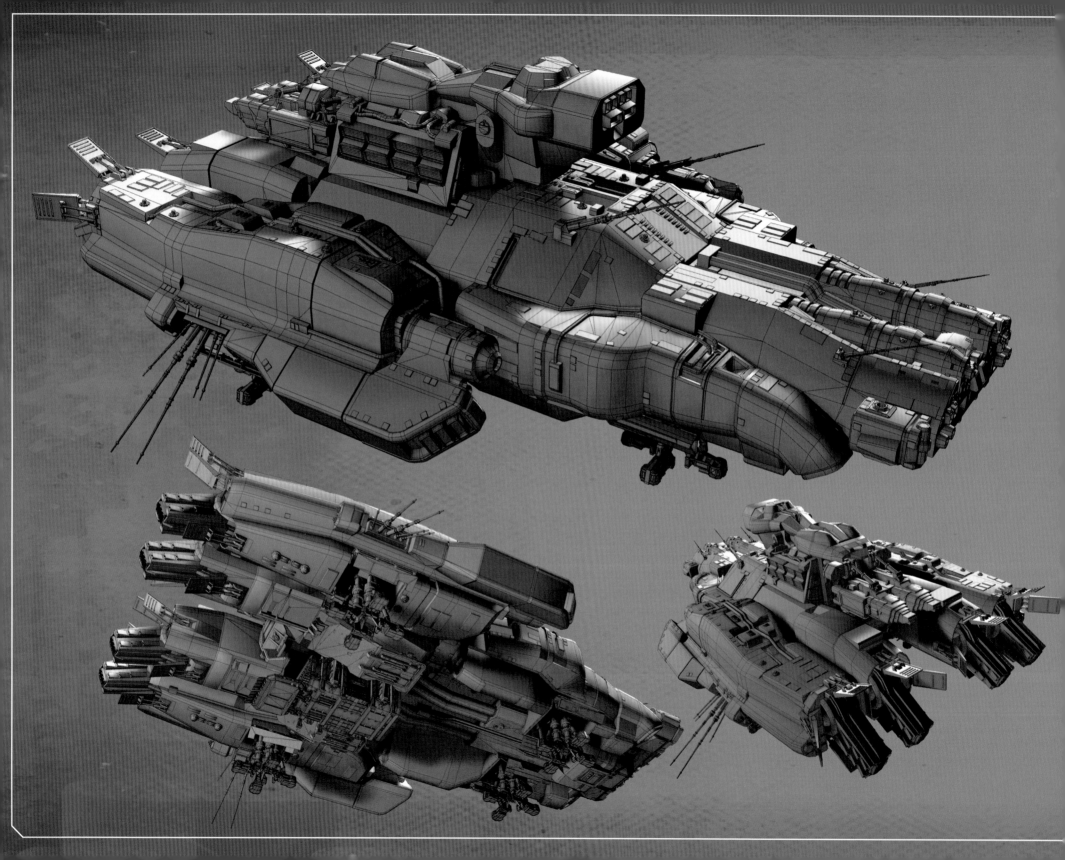

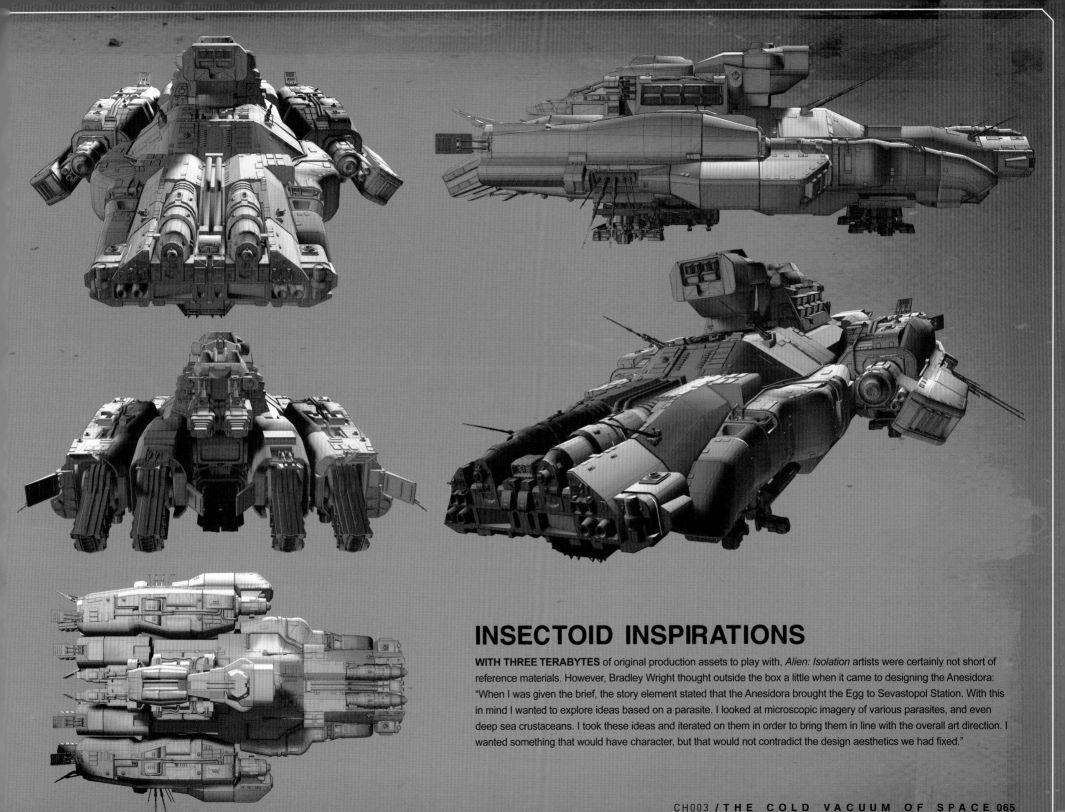

INSECTOID INSPIRATIONS

WITH THREE TERABYTES of original production assets to play with, *Alien: Isolation* artists were certainly not short of reference materials. However, Bradley Wright thought outside the box a little when it came to designing the Anesidora: "When I was given the brief, the story element stated that the Anesidora brought the Egg to Sevastopol Station. With this in mind I wanted to explore ideas based on a parasite. I looked at microscopic imagery of various parasites, and even deep sea crustaceans. I took these ideas and iterated on them in order to bring them in line with the overall art direction. I wanted something that would have character, but that would not contradict the design aesthetics we had fixed."

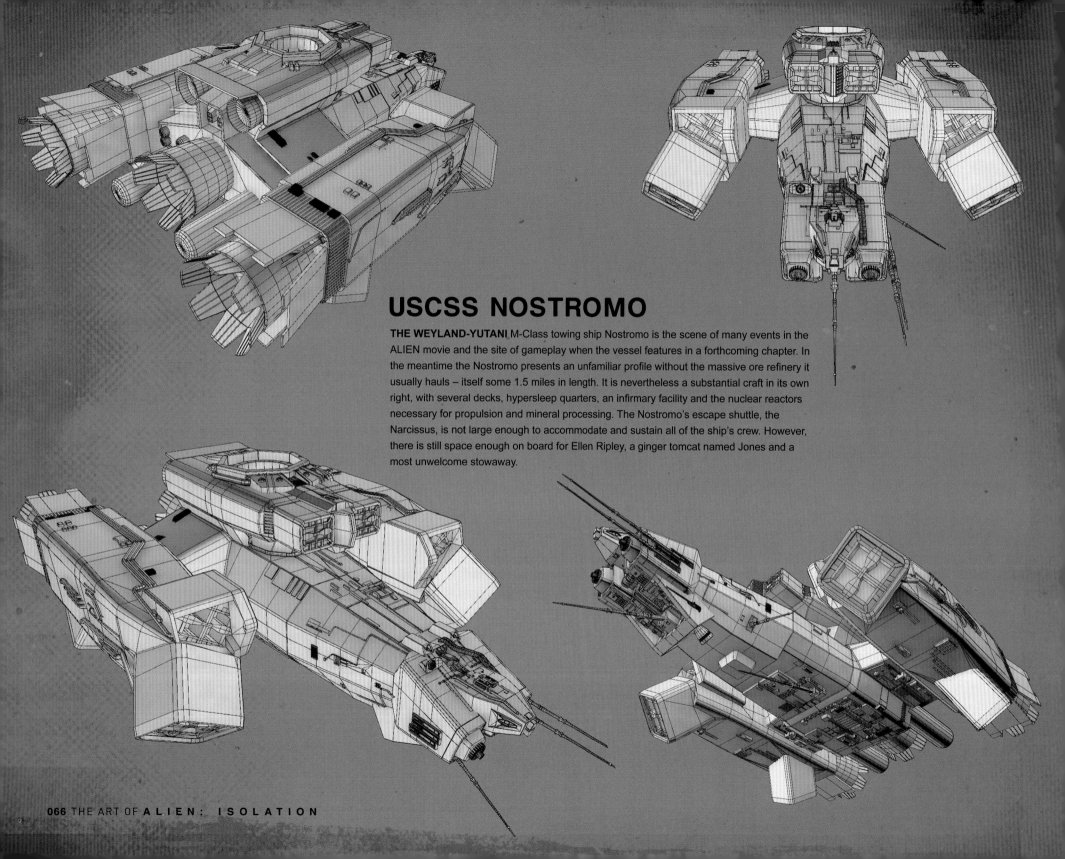

USCSS NOSTROMO

THE WEYLAND-YUTANI M-Class towing ship Nostromo is the scene of many events in the ALIEN movie and the site of gameplay when the vessel features in a forthcoming chapter. In the meantime the Nostromo presents an unfamiliar profile without the massive ore refinery it usually hauls – itself some 1.5 miles in length. It is nevertheless a substantial craft in its own right, with several decks, hypersleep quarters, an infirmary facility and the nuclear reactors necessary for propulsion and mineral processing. The Nostromo's escape shuttle, the Narcissus, is not large enough to accommodate and sustain all of the ship's crew. However, there is still space enough on board for Ellen Ripley, a ginger tomcat named Jones and a most unwelcome stowaway.

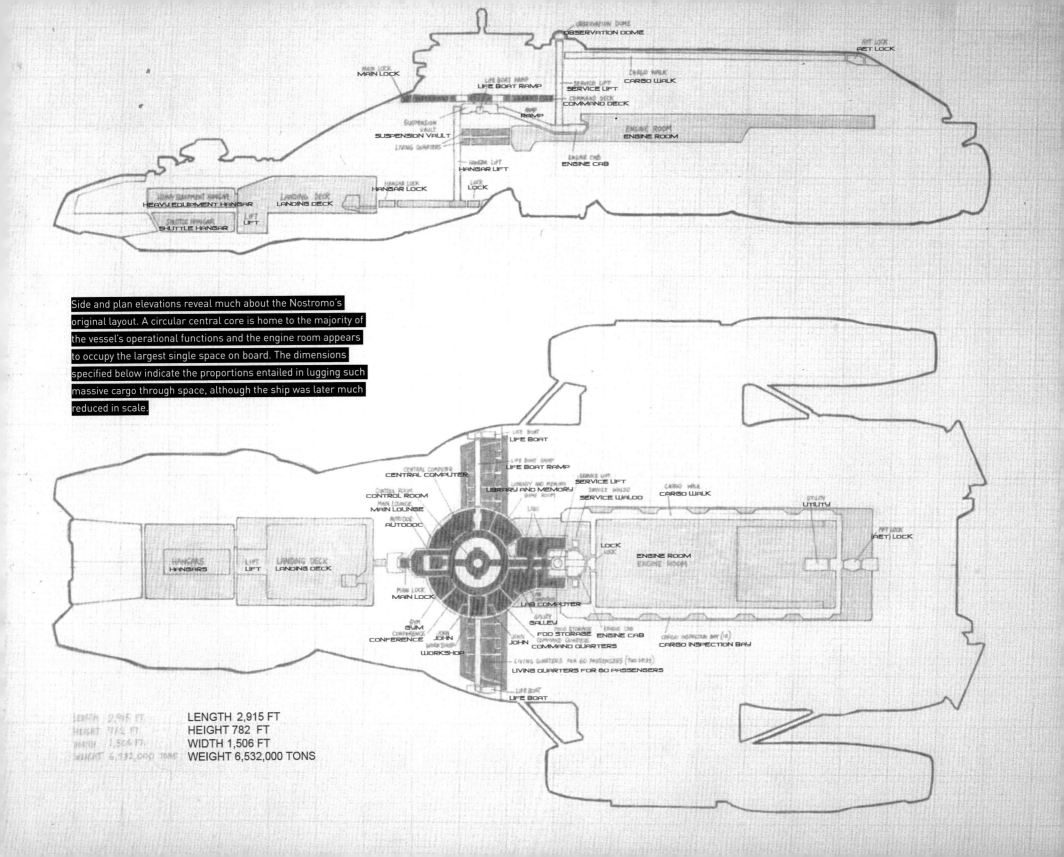

Side and plan elevations reveal much about the Nostromo's original layout. A circular central core is home to the majority of the vessel's operational functions and the engine room appears to occupy the largest single space on board. The dimensions specified below indicate the proportions entailed in lugging such massive cargo through space, although the ship was later much reduced in scale.

Side elevation labels:

OBSERVATION DOME
AFT LOCK
MAIN LOCK
LIFE BOAT RAMP
SERVICE LIFT
CARGO WALK
COMMAND DECK
SUSPENSION VAULT
RAMP
LIVING QUARTERS
ENGINE ROOM
HANGAR LIFT
ENGINE CAB
HEAVY EQUIPMENT HANGAR
LANDING DECK
HANGAR LOCK
LOCK
SHUTTLE HANGAR
LIFT

Plan elevation labels:

LIFE BOAT
CENTRAL COMPUTER
LIFE BOAT RAMP
SERVICE LIFT
CONTROL ROOM
LIBRARY AND MEMORY
SERVICE WALDO
CARGO WALK
MAIN LOUNGE
AUTODOC
LAB
UTILITY
HANGARS
LIFT
LANDING DECK
LOCK
ENGINE ROOM
(AFT) LOCK
LAB COMPUTER
MAIN LOCK
GALLEY
GYM
FOOD STORAGE
ENGINE CAB
CARGO INSPECTION BAY
CONFERENCE
JOHN
COMMAND QUARTERS
WORKSHOP
JOHN
LIVING QUARTERS FOR 60 PASSENGERS
LIFE BOAT

LENGTH 2,915 FT
HEIGHT 782 FT
WIDTH 1,506 FT
WEIGHT 6,532,000 TONS

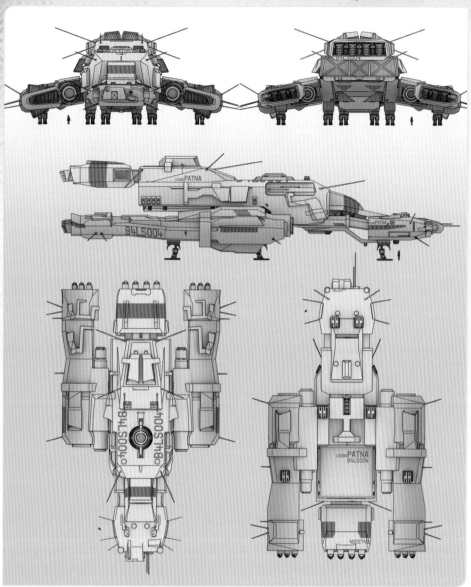

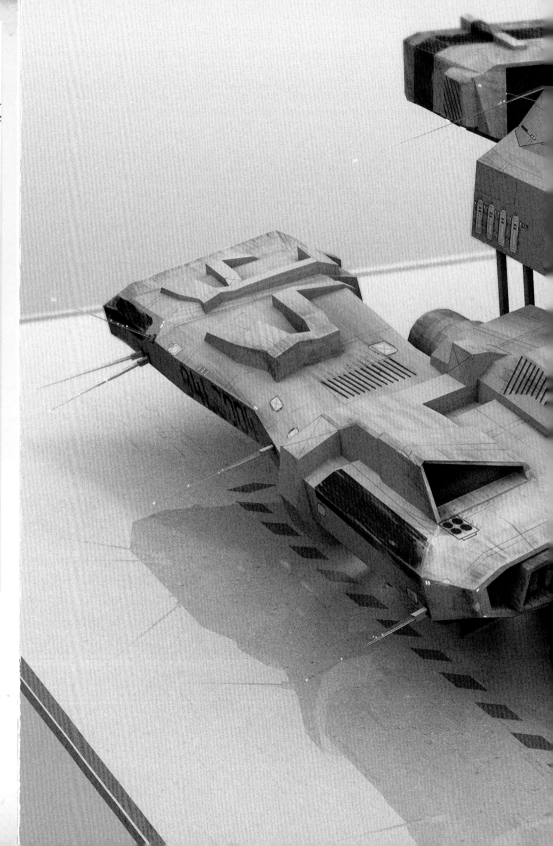

PATNA B4LS004

This unassuming medical transport vessel's principal function is the fast transport of sick and wounded patients from Sevastopol Station. Basic infirmary, hypersleep and even morgue facilities are available as required. "We gave her proportionally larger engines, keeping the overall silhouette in tune with (original ALIEN concept artist) Ron Cobb's design aesthetic," begins Bradley Wright. "I added some more familiar 'emergency response' touches too. Such as the color, emergency lights and the exposed coolant chamber at its center. This suggests that the contents can be frozen for transit."

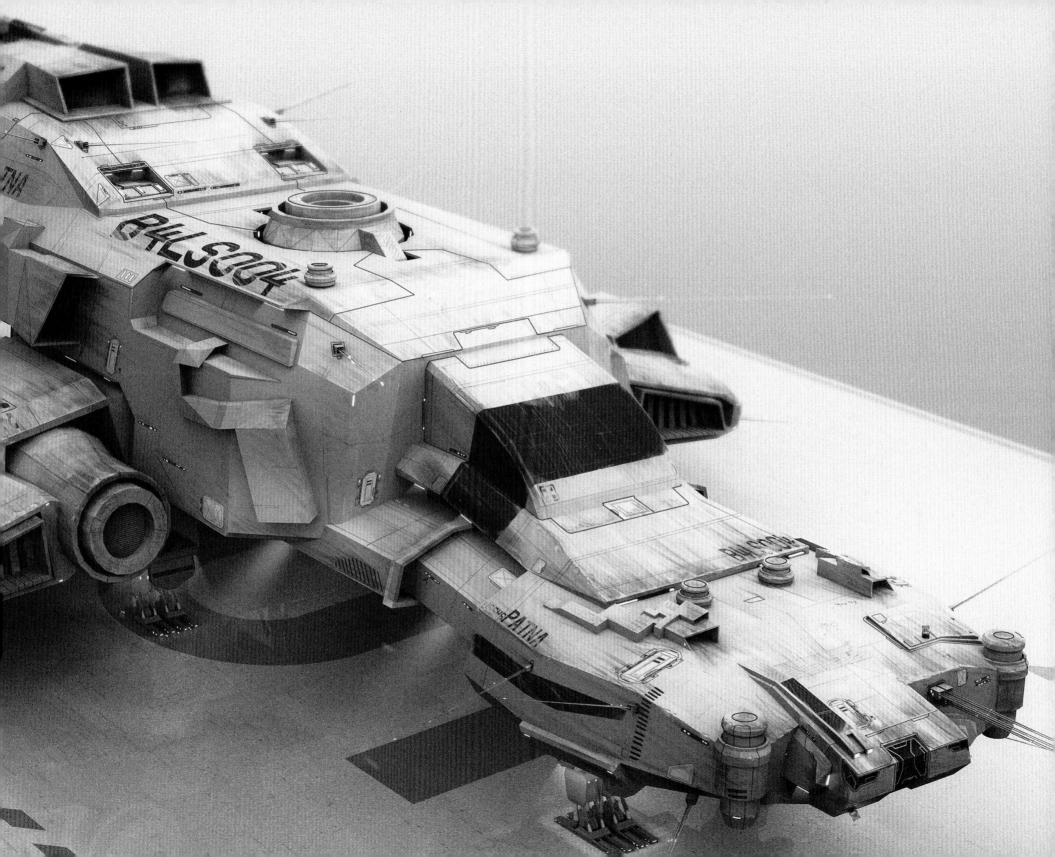

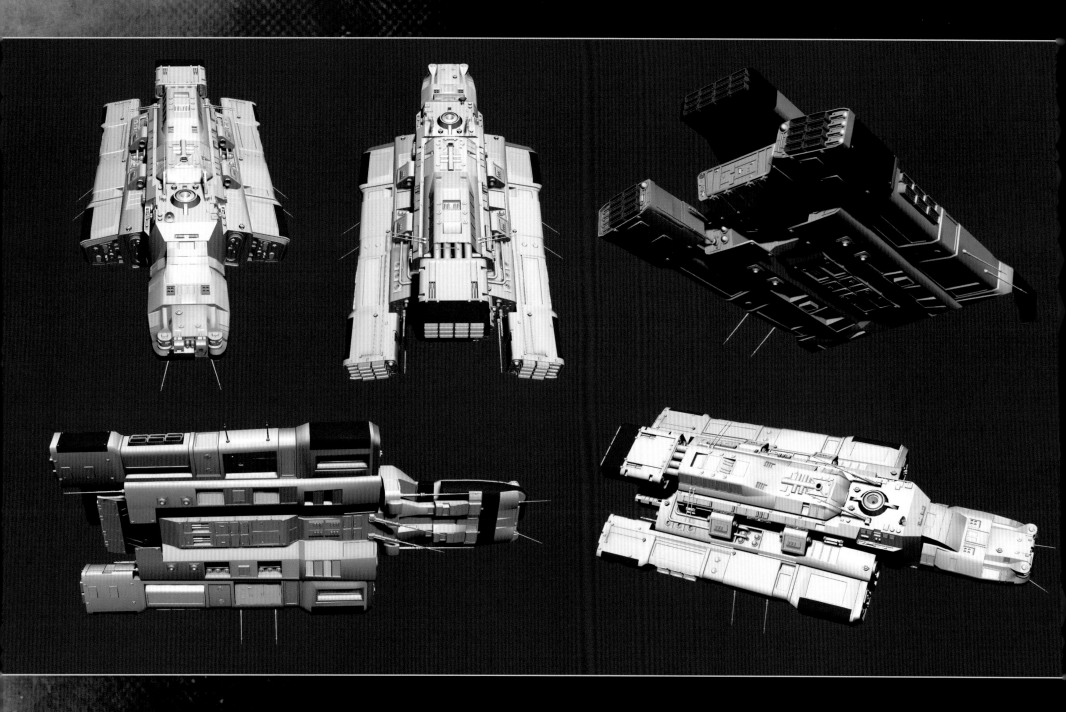

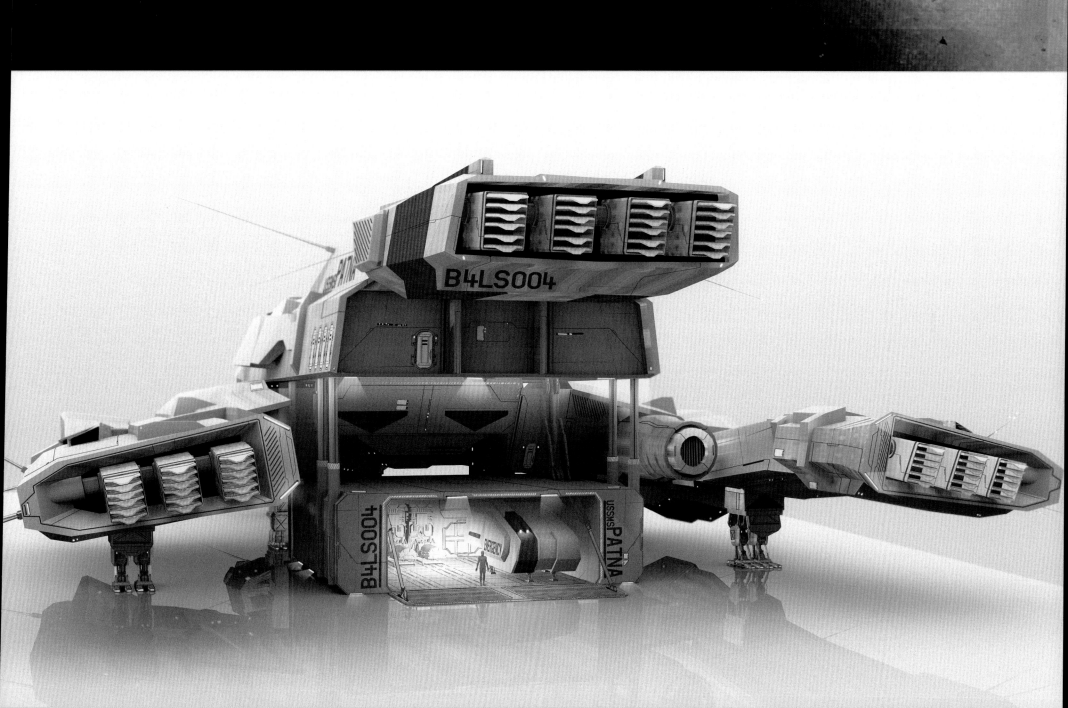

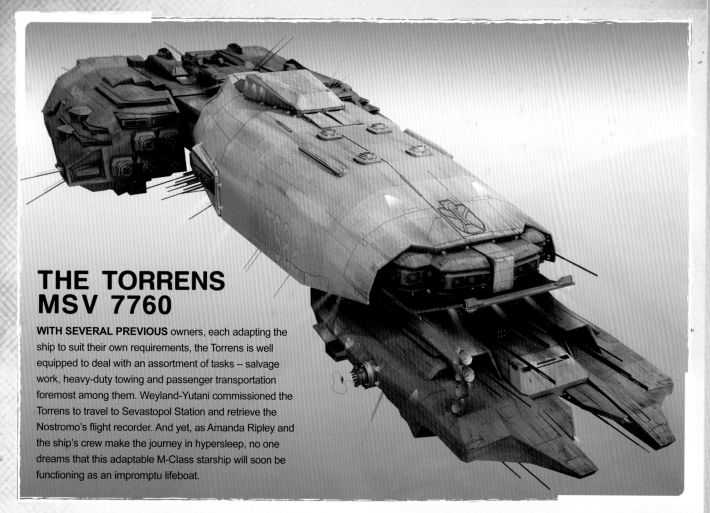

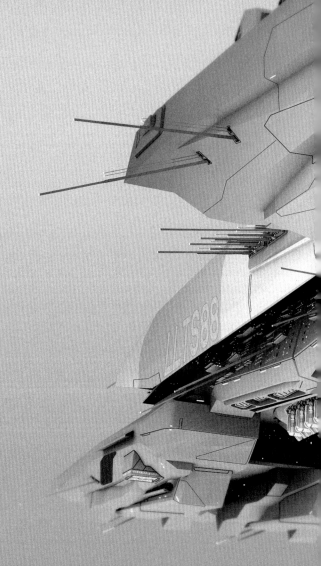

Bradley Wright: "These were some early plan drawings for the Torrens, later iterated on and refined; simple projections for review and modelling reference. These practical design elements, that won't ever be seen or developed in game, help to sell the functionality of the ship.

The color choice was a nod to the simplified graphic nature of Ron Cobb's designs for the original movie. It was always going to be difficult to get such a strong visual like this to work in the game. In this case we went for a more neutral color scheme."

THE TORRENS MSV 7760

WITH SEVERAL PREVIOUS owners, each adapting the ship to suit their own requirements, the Torrens is well equipped to deal with an assortment of tasks – salvage work, heavy-duty towing and passenger transportation foremost among them. Weyland-Yutani commissioned the Torrens to travel to Sevastopol Station and retrieve the Nostromo's flight recorder. And yet, as Amanda Ripley and the ship's crew make the journey in hypersleep, no one dreams that this adaptable M-Class starship will soon be functioning as an impromptu lifeboat.

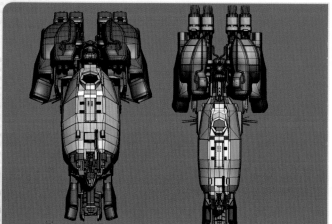

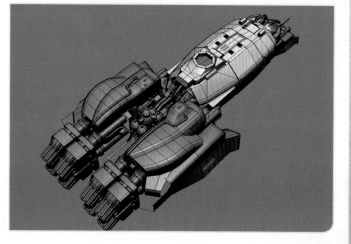

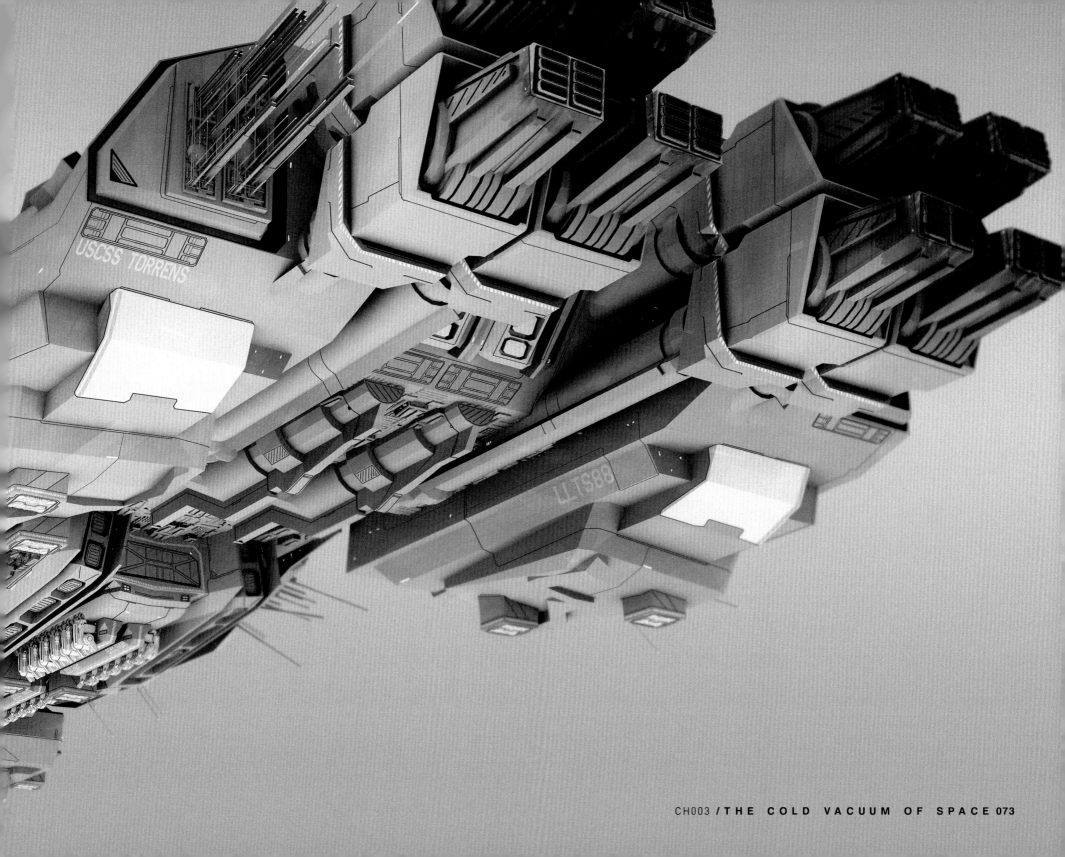

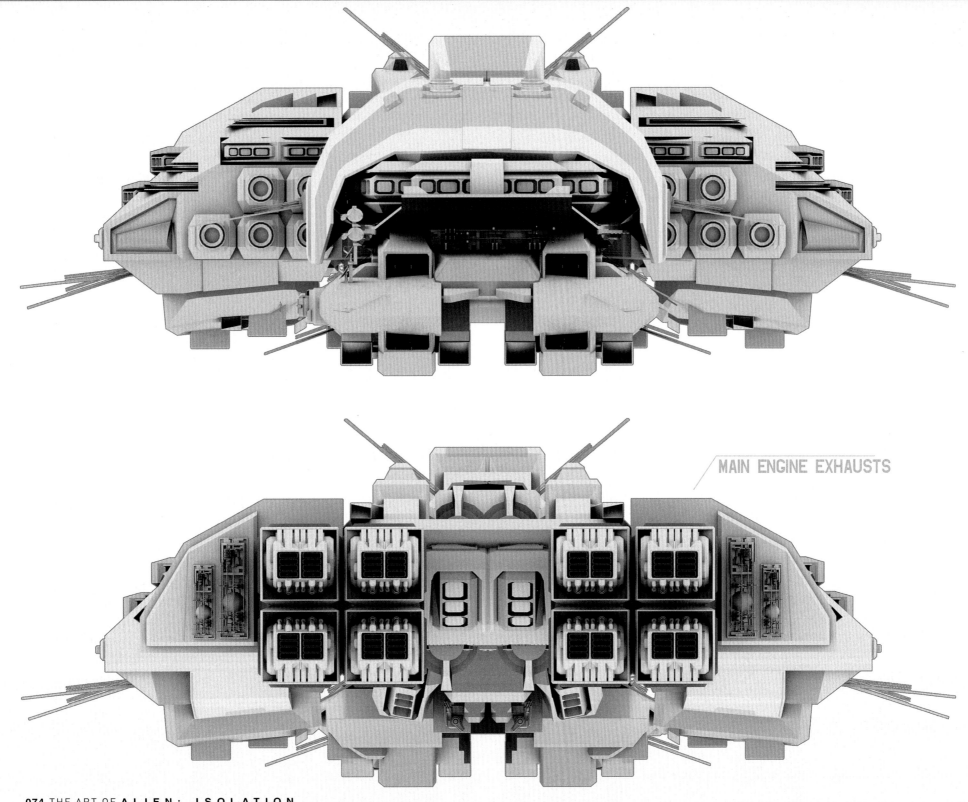

MAIN ENGINE EXHAUSTS

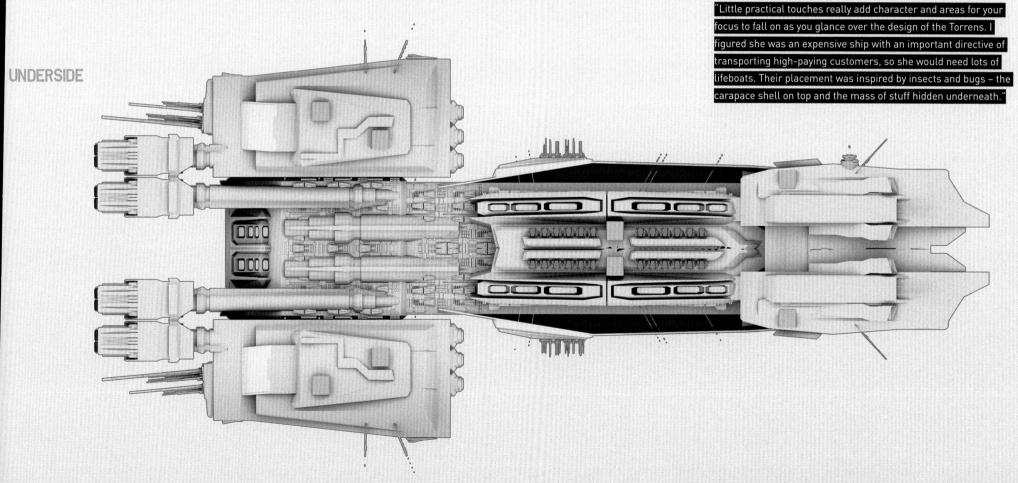

SIDE

BRIDGE

COMMS ARRAY

LANDING GEAR BAYS

LIFEBOATS

MAIN HANGER BAY

UNDERSIDE

"Little practical touches really add character and areas for your focus to fall on as you glance over the design of the Torrens. I figured she was an expensive ship with an important directive of transporting high-paying customers, so she would need lots of lifeboats. Their placement was inspired by insects and bugs – the carapace shell on top and the mass of stuff hidden underneath."

CH004 / SEVASTOPOL STATION

// "Something we've said since day one is that if something couldn't have been built on the original set in 1979 we wouldn't build it. This isn't a catch-all design mantra, merely a tool to sanity check our designs. We've created an enormous amount of content, all of which references the movie on one way or another." //

Lead Artist, Jude Bond.

SEVASTOPOL STATION TEETERS within the orbit of the gas giant KG348 in the region of Zeta II Reticula. This freeport was originally designed to exploit the rich mineral resources of the nearby planet and to service the trade routes between Earth and the Outer Rim. Commercial priorities are prone to change, however, and such business soon dried up. Sevastopol's population has since dwindled to just 500 permanent residents, although it is large enough to house as many as 3000.

With its infrastructure failing fast, law and order on the verge of permanent collapse, and a siege mentality developing among its residents, Sevastopol's sole remaining purpose is to refuel and refit passing traffic. Precious little of that ever finds its way to such a remote outpost, of course. And bearing in mind the dramatic events that have been ocurring recently, it might have been better for all parties if certain ships had never docked at all.

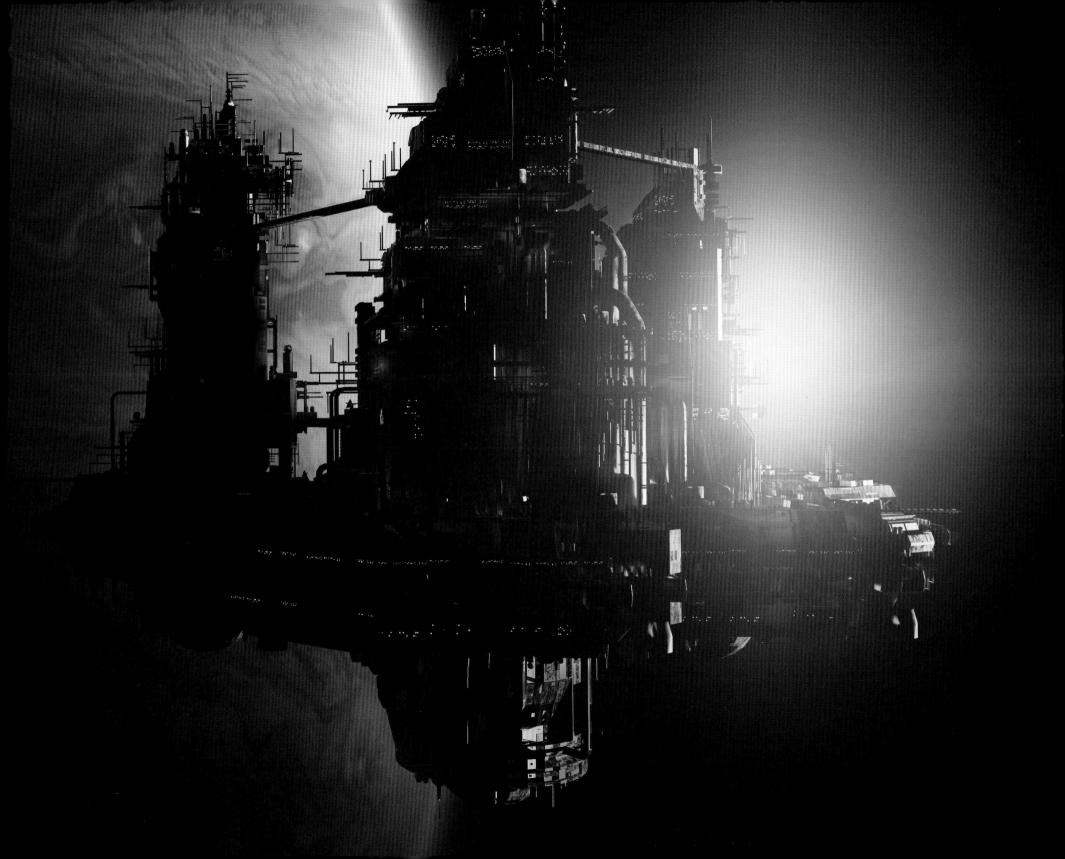

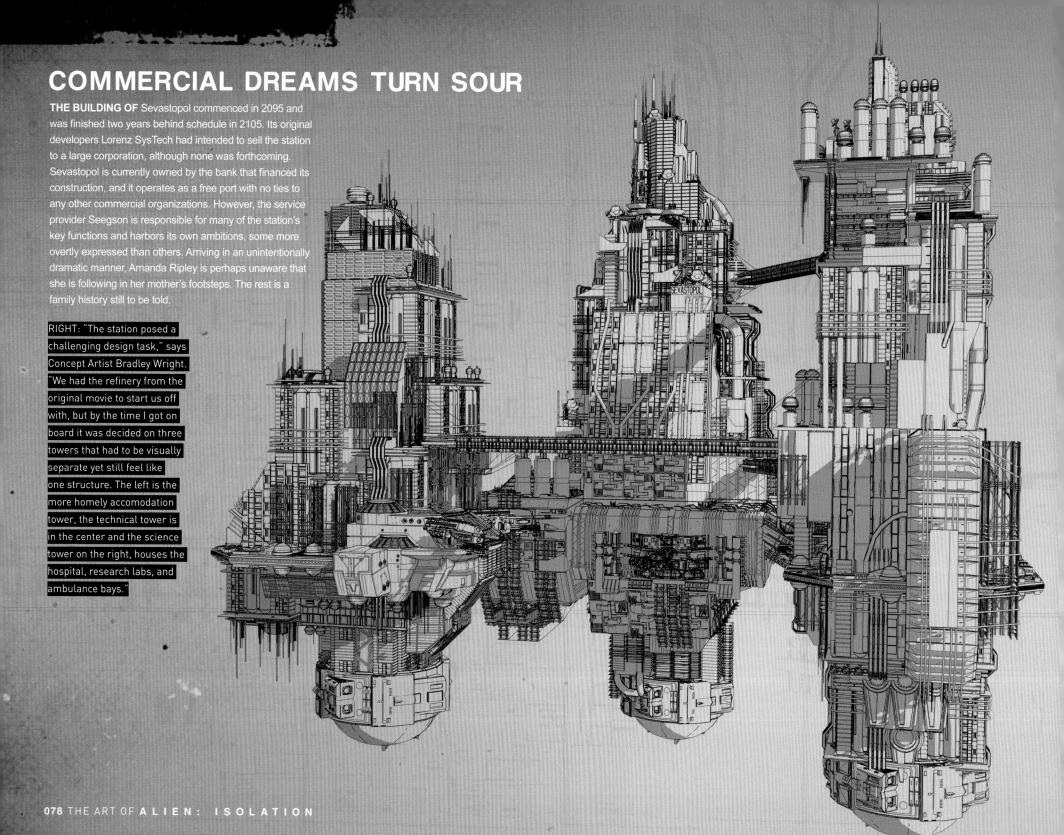

COMMERCIAL DREAMS TURN SOUR

THE BUILDING OF Sevastopol commenced in 2095 and was finished two years behind schedule in 2105. Its original developers Lorenz SysTech had intended to sell the station to a large corporation, although none was forthcoming. Sevastopol is currently owned by the bank that financed its construction, and it operates as a free port with no ties to any other commercial organizations. However, the service provider Seegson is responsible for many of the station's key functions and harbors its own ambitions, some more overtly expressed than others. Arriving in an unintentionally dramatic manner, Amanda Ripley is perhaps unaware that she is following in her mother's footsteps. The rest is a family history still to be told.

RIGHT: "The station posed a challenging design task," says Concept Artist Bradley Wright. "We had the refinery from the original movie to start us off with, but by the time I got on board it was decided on three towers that had to be visually separate yet still feel like one structure. The left is the more homely accomodation tower, the technical tower is in the center and the science tower on the right, houses the hospital, research labs, and ambulance bays."

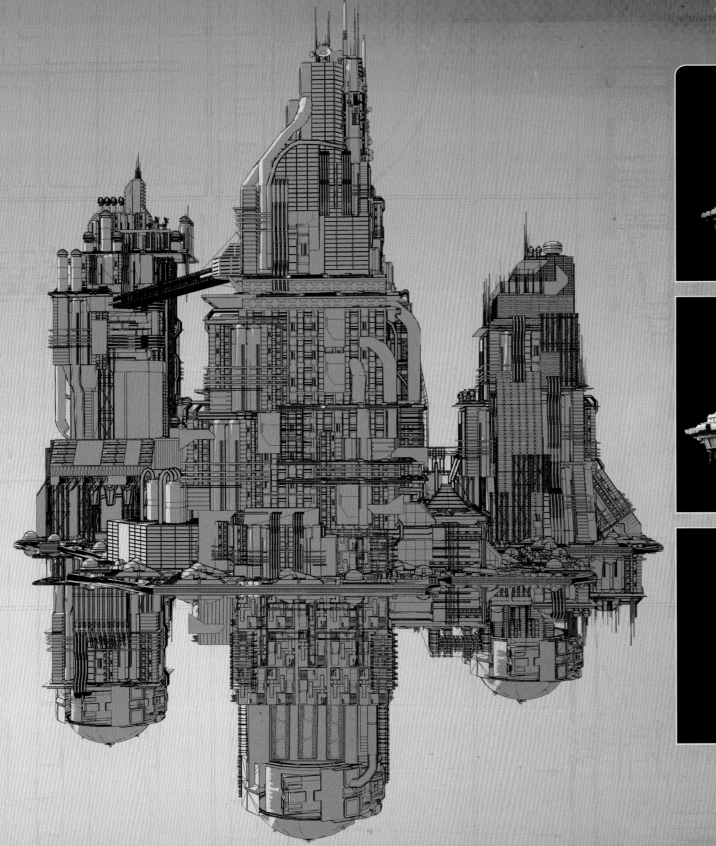

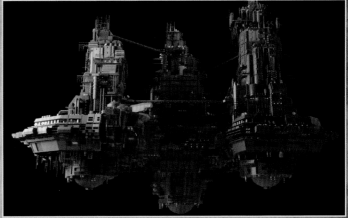
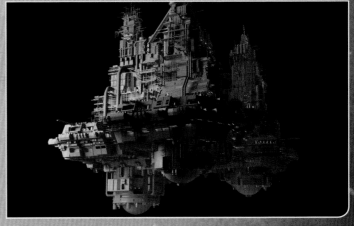

CH004 / SEVASTOPOL STATION 079

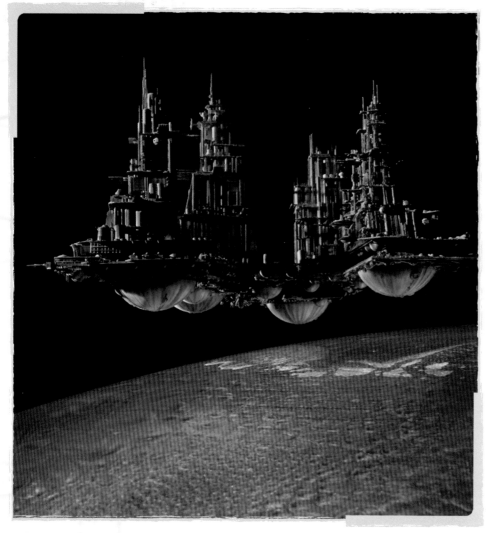

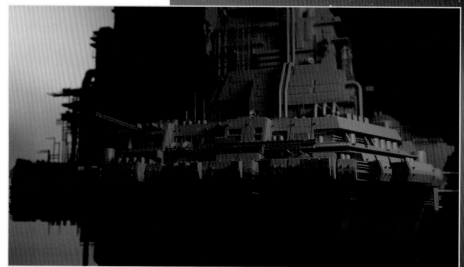

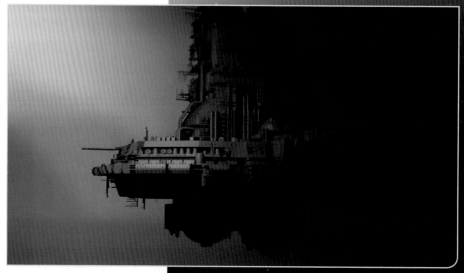

WITH ITS LOOMING towers and hemispherical protrusions beneath, Sevastopol Station casts an ominous yet very familiar profile. That was a long considered but ultimately deliberate decision too, as Lead Artist Jude Bond explains: "We looked at a lot of options very early on, but kept coming back to that huge piece of architecture that was the ore refinery from the first movie. Sevastopol has three towers instead of four, though, and the overall form, with the projections that go up as well as downwards, was something that we just fell upon. The central platform creates an artificial ground level and provides a definite sense of above and below decks. When we started putting the game together we broke the environments down into the archetypal spaces we'd seen in the movie – habitation, technical, and science in the three towers and engineering on the lower decks."

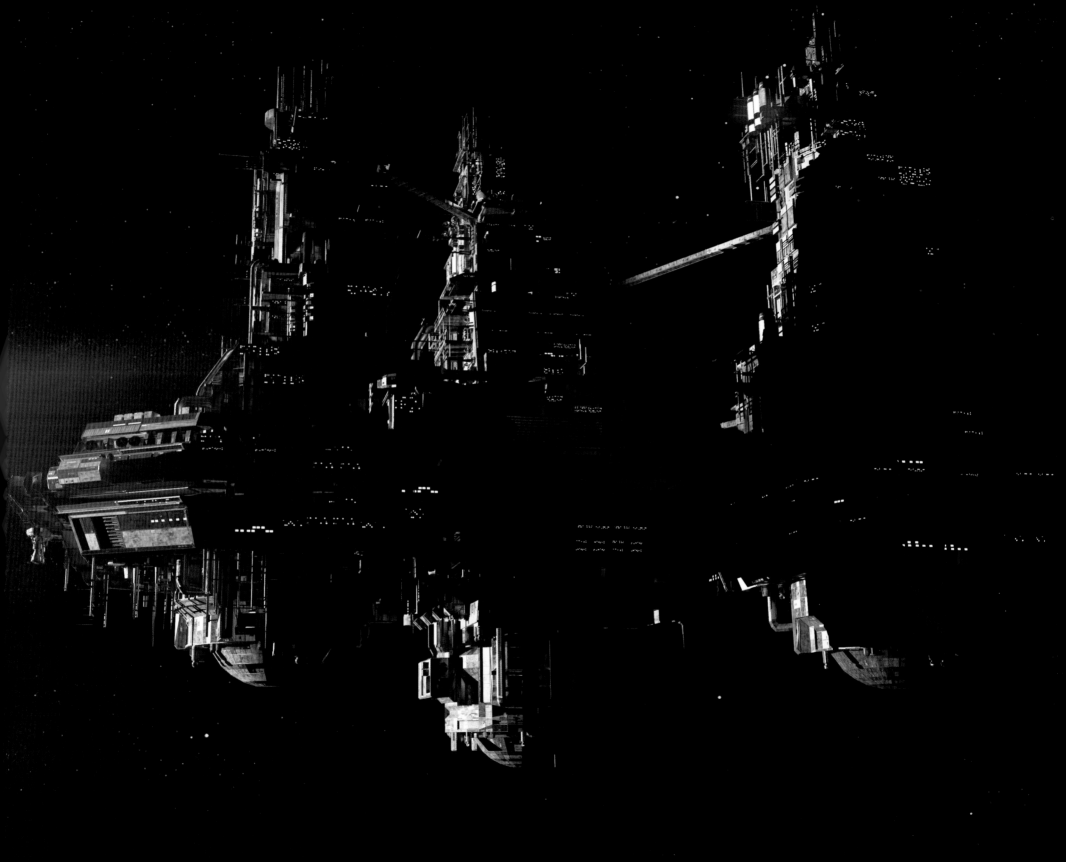

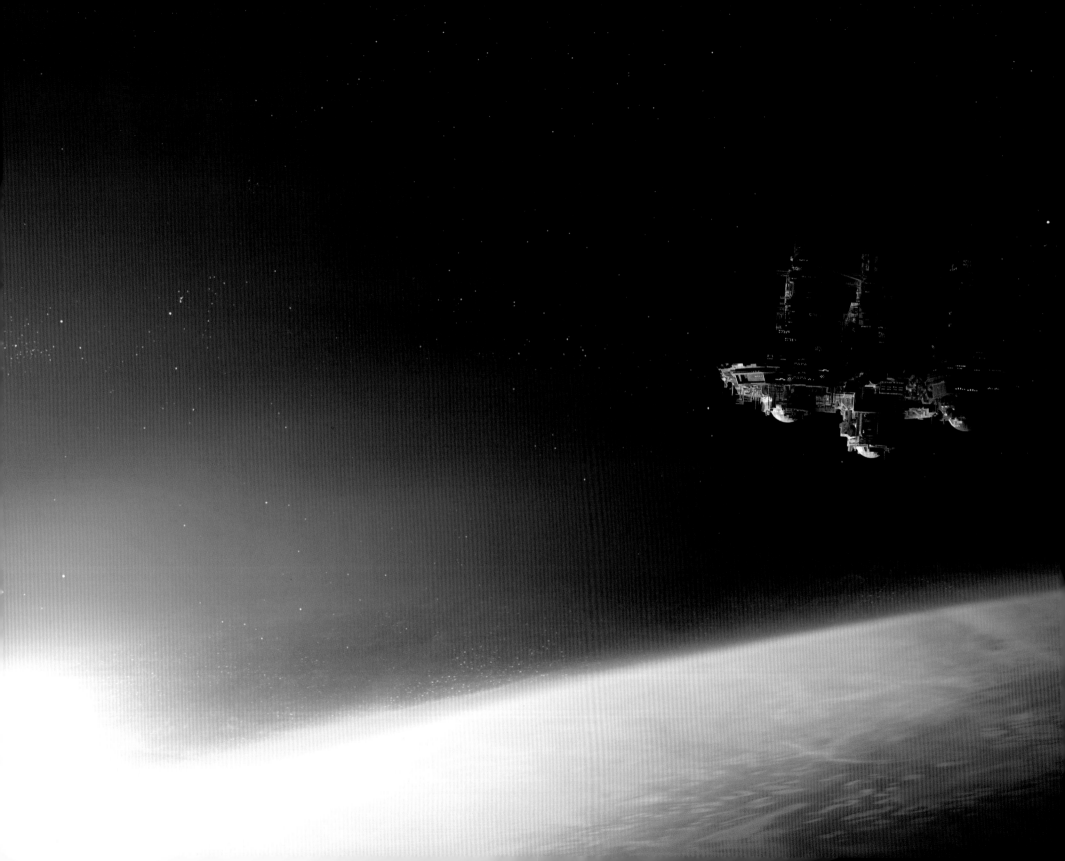

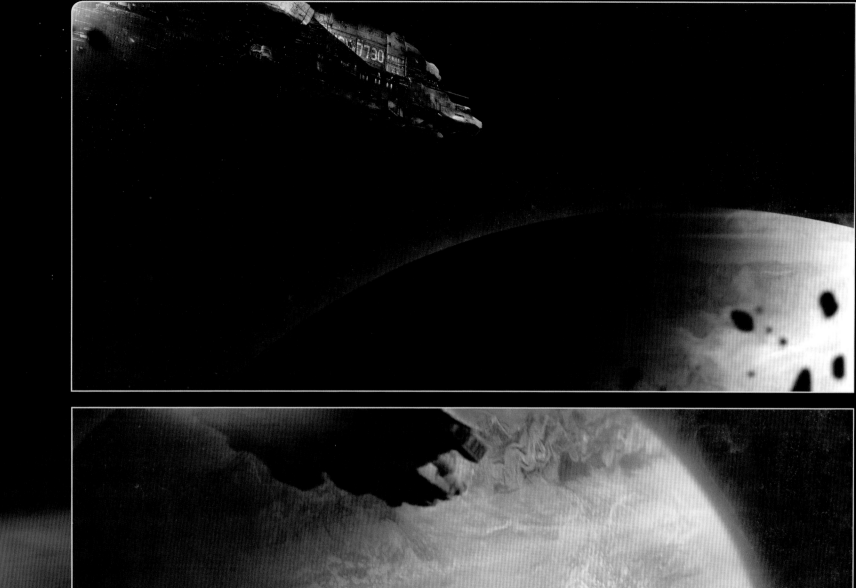
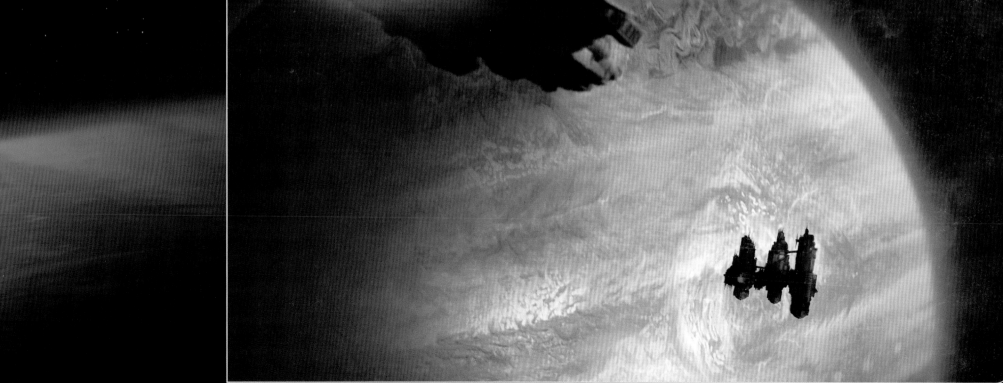

PREVIOUS: "Early visualizations for the look of our space shots. These were created quickly, to get a general feel for the exteriors before going in and doing the planned-out work," says Concept Artist Bradley Wright.

RIGHT: The devastating results of an accident seen from several different angles. However, these images also reveal the layered structure of Sevastopol beneath its outer skin.

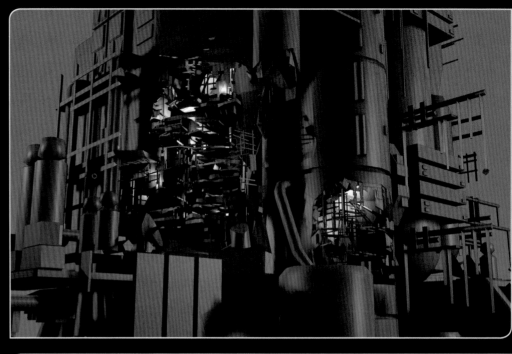

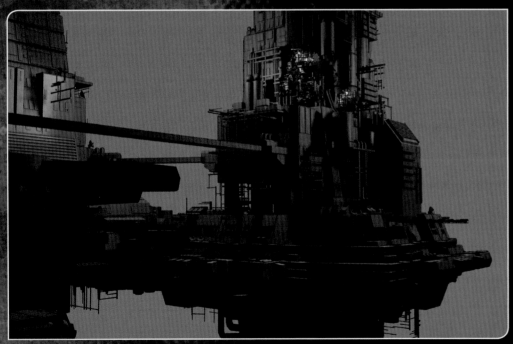

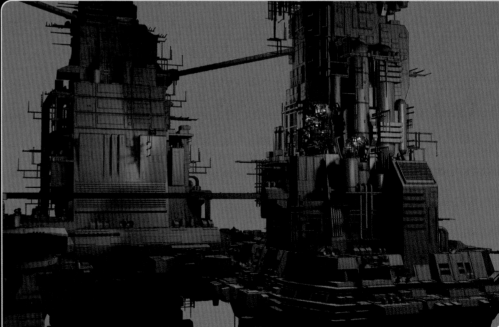

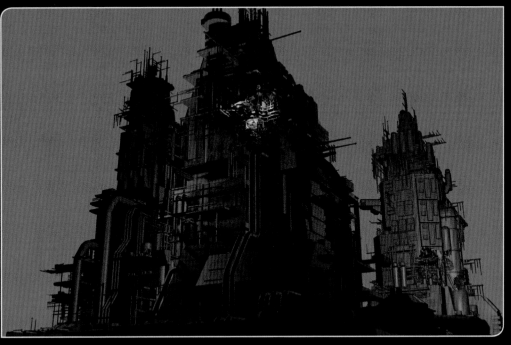
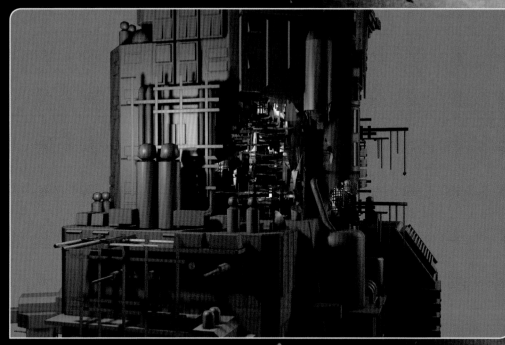
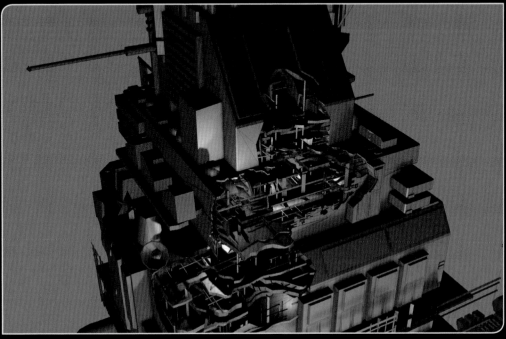
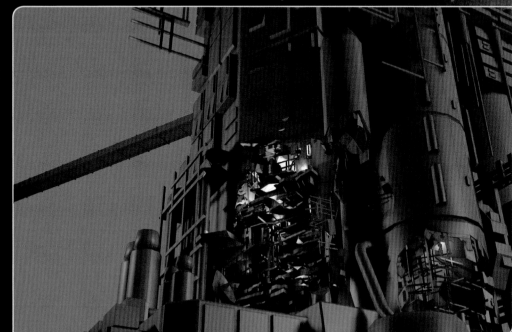

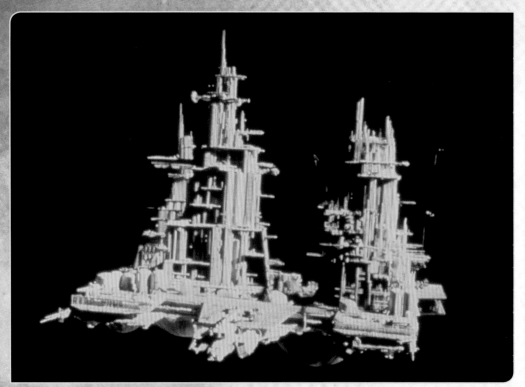

The original ore refinery from ALIEN to the *left* and several design iterations for Sevastopol Station. Perhaps most interesting is the cruciform construction depicted *below*. This never made the final build of the game and was, as Jude Bond describes "...just one of about a billion options considered very, very early on."

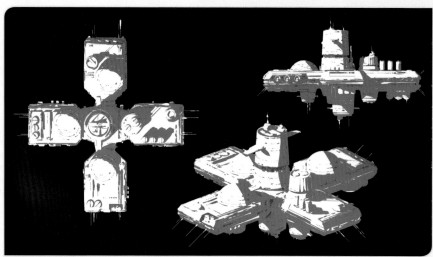

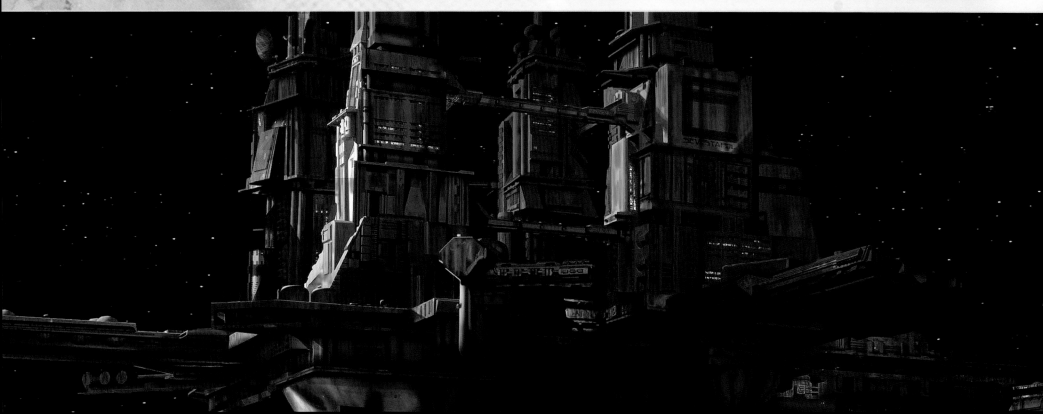

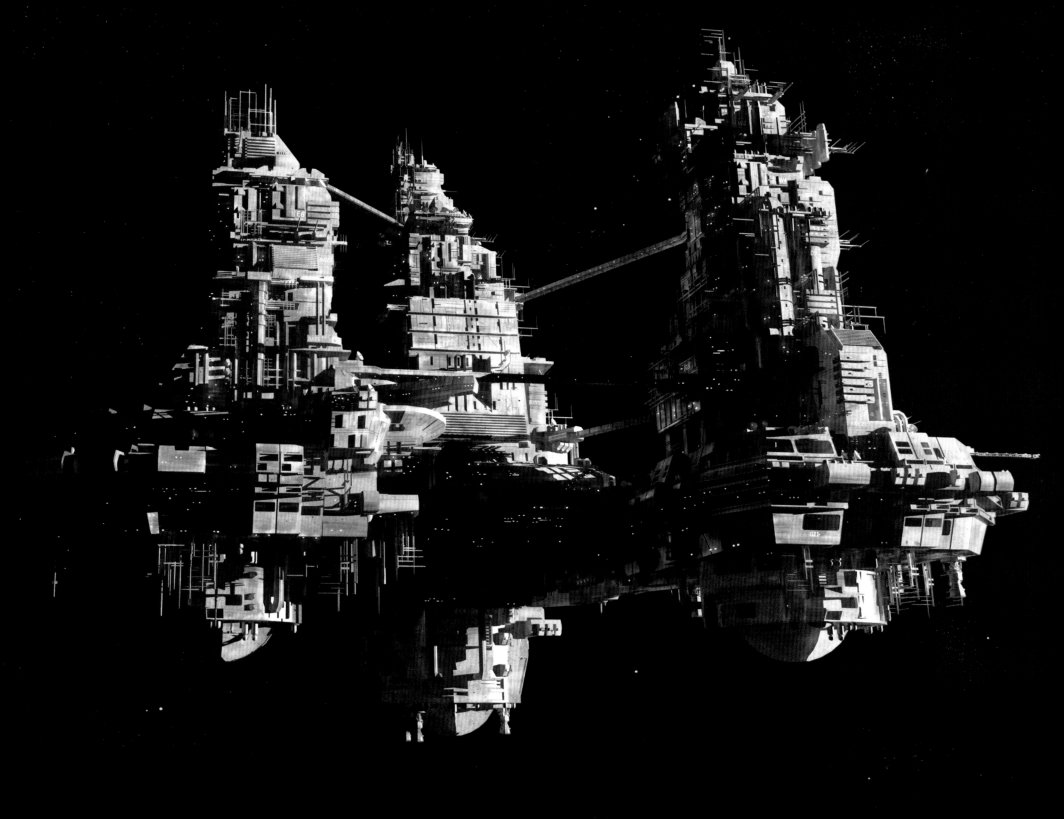

ROOM WITH A VIEW

HARSH FRAMING, HARD lines and a cool color palette convey the cold comforts of space, but closer examination reveals a few signs of activity. "This particular shot shows the Anesidora in dock, with the crew performing routine checks and maintenance," says Bradley Wright. "We knew we wanted strong contrast lighting to all the exteriors. The graphical values really push that chilly feeling of being in the vacuum of space. This image also explores the actual exterior of our station in closer detail – the raw, ugly, and industrial nature of its surfaces, with woven layers of piping, structure and protective panelling."

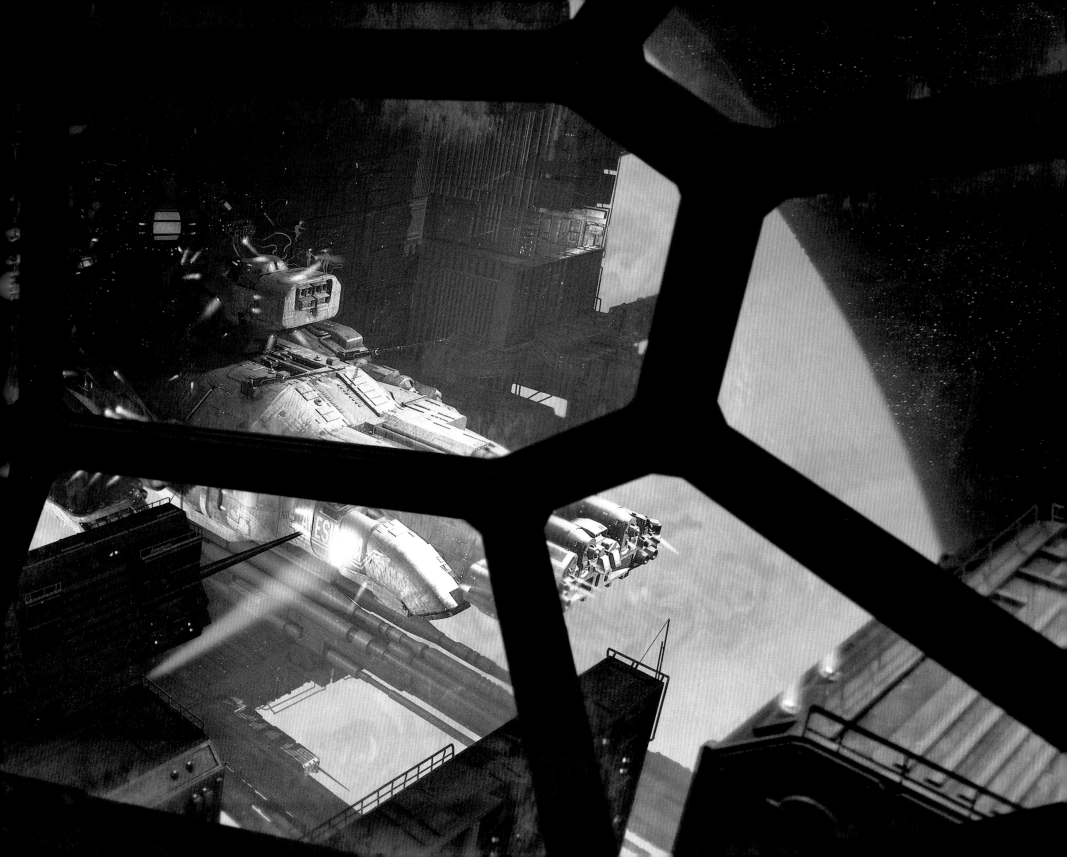

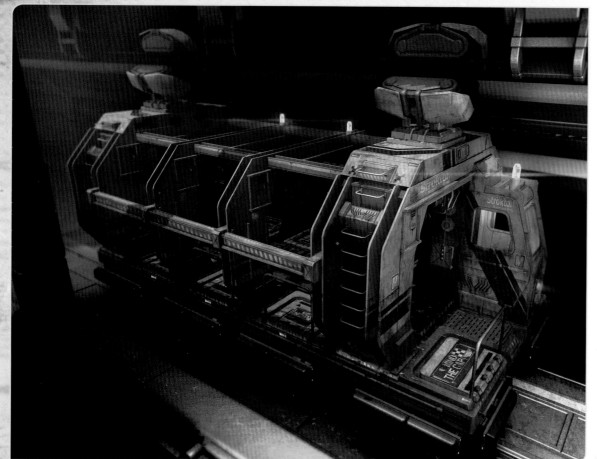

A ROUGH RIDE awaits all passengers aboard Sevastopol's transit system, and not simply because of the industrial construction of its rolling stock. "The areas and trains are not designed for comfort, or even human interaction," says Bradley Wright. "Dark spaces, where there is no real practical need for lighting, provide plenty of murky pitfalls and hiding places."

"We undertook some modelling in order to test these concepts and get a better sense of the space," adds 3D Artist Stefano Tsai. "These locations didn't make it into the game final, but the pre-visualization helped to give the team a tangible sense of the space and setting."

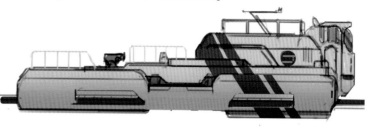

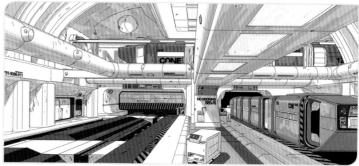

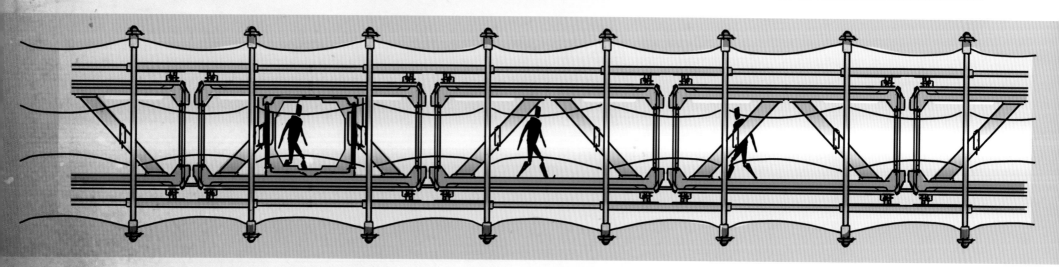

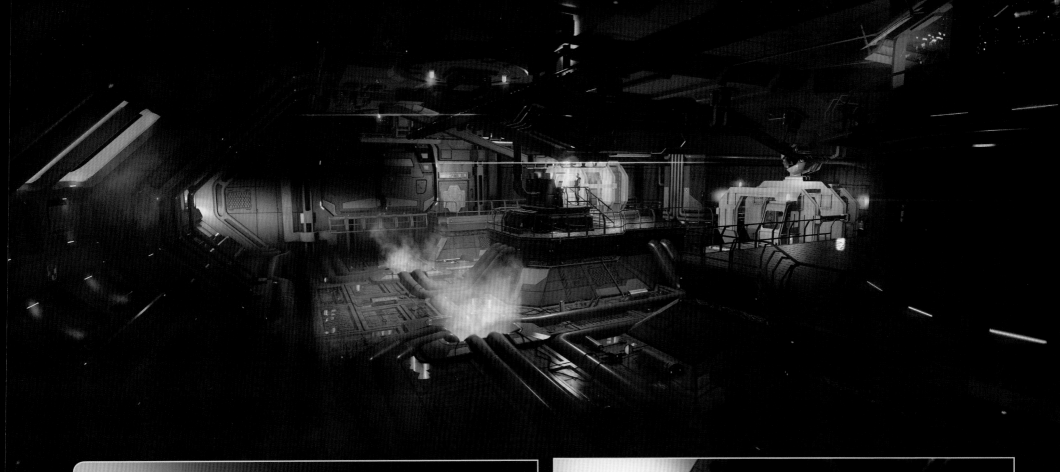

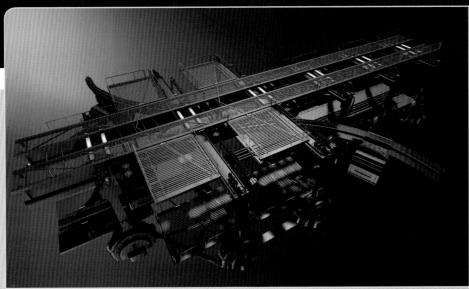

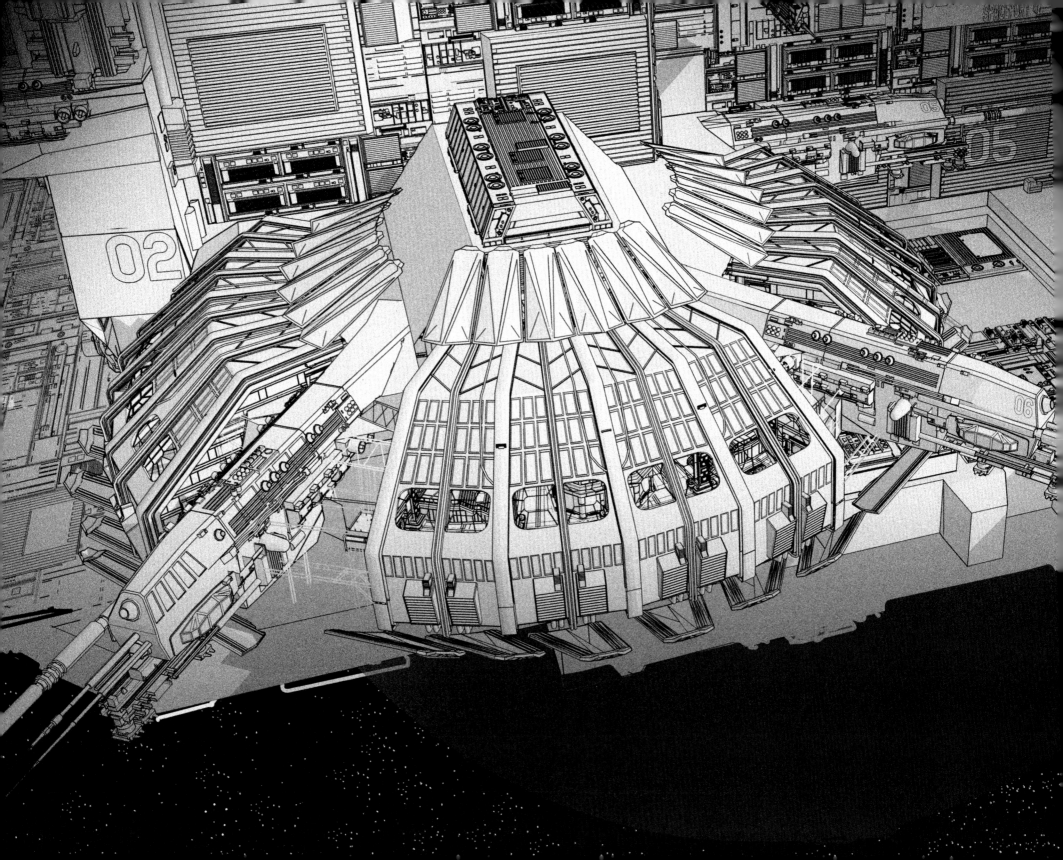

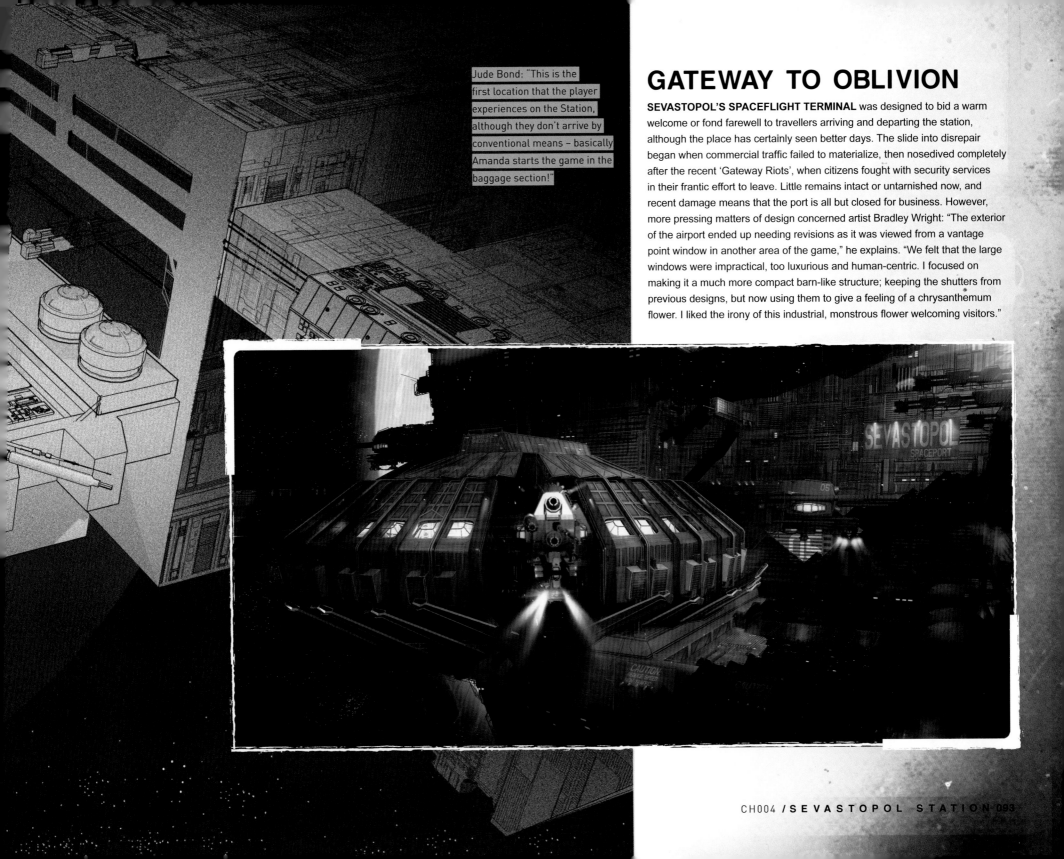

Jude Bond: "This is the first location that the player experiences on the Station, although they don't arrive by conventional means – basically Amanda starts the game in the baggage section!"

GATEWAY TO OBLIVION

SEVASTOPOL'S SPACEFLIGHT TERMINAL was designed to bid a warm welcome or fond farewell to travellers arriving and departing the station, although the place has certainly seen better days. The slide into disrepair began when commercial traffic failed to materialize, then nosedived completely after the recent 'Gateway Riots', when citizens fought with security services in their frantic effort to leave. Little remains intact or untarnished now, and recent damage means that the port is all but closed for business. However, more pressing matters of design concerned artist Bradley Wright: "The exterior of the airport ended up needing revisions as it was viewed from a vantage point window in another area of the game," he explains. "We felt that the large windows were impractical, too luxurious and human-centric. I focused on making it a much more compact barn-like structure; keeping the shutters from previous designs, but now using them to give a feeling of a chrysanthemum flower. I liked the irony of this industrial, monstrous flower welcoming visitors."

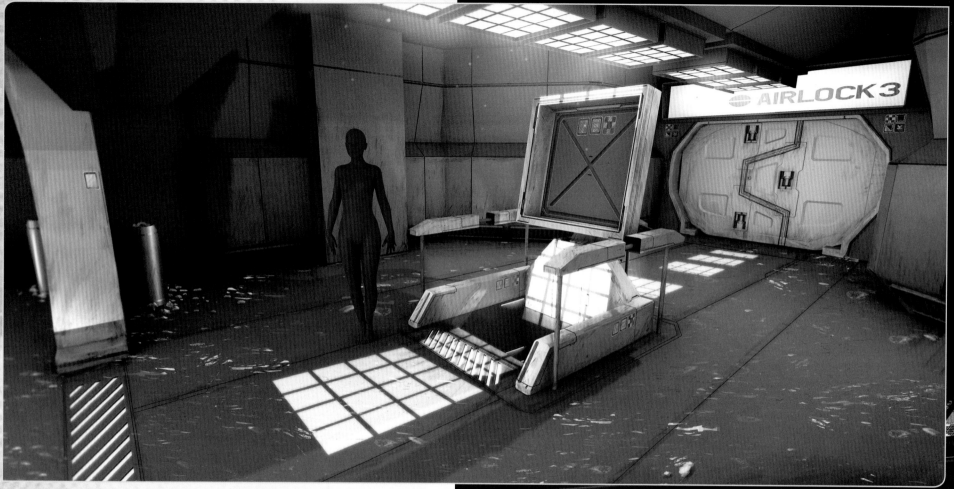

Less is often more when it comes to communicating a sense of threat. "The spaceport was to be the first look at the interior of the station," says Bradley Wright. "I really needed to sell the believability of an abandoned space, left in disrepair. We didn't want complete chaos yet – just a space to set the tone for what's about to come, to put the player on edge."

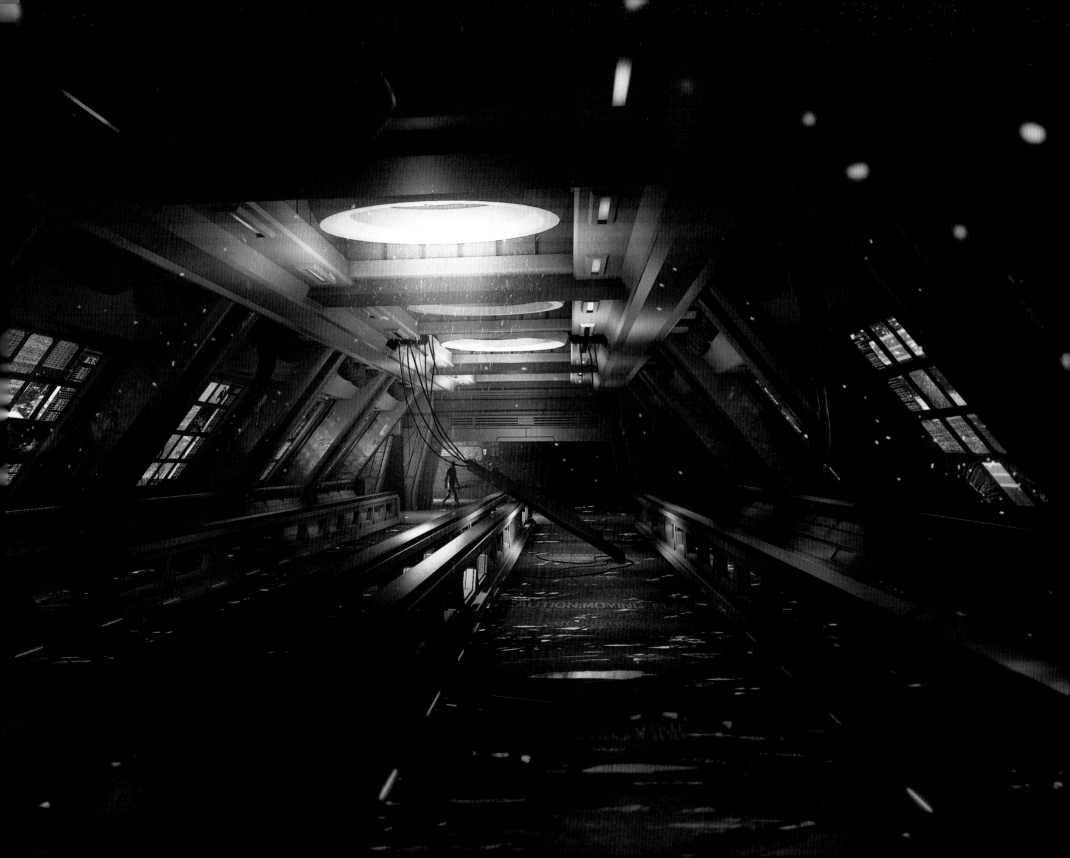

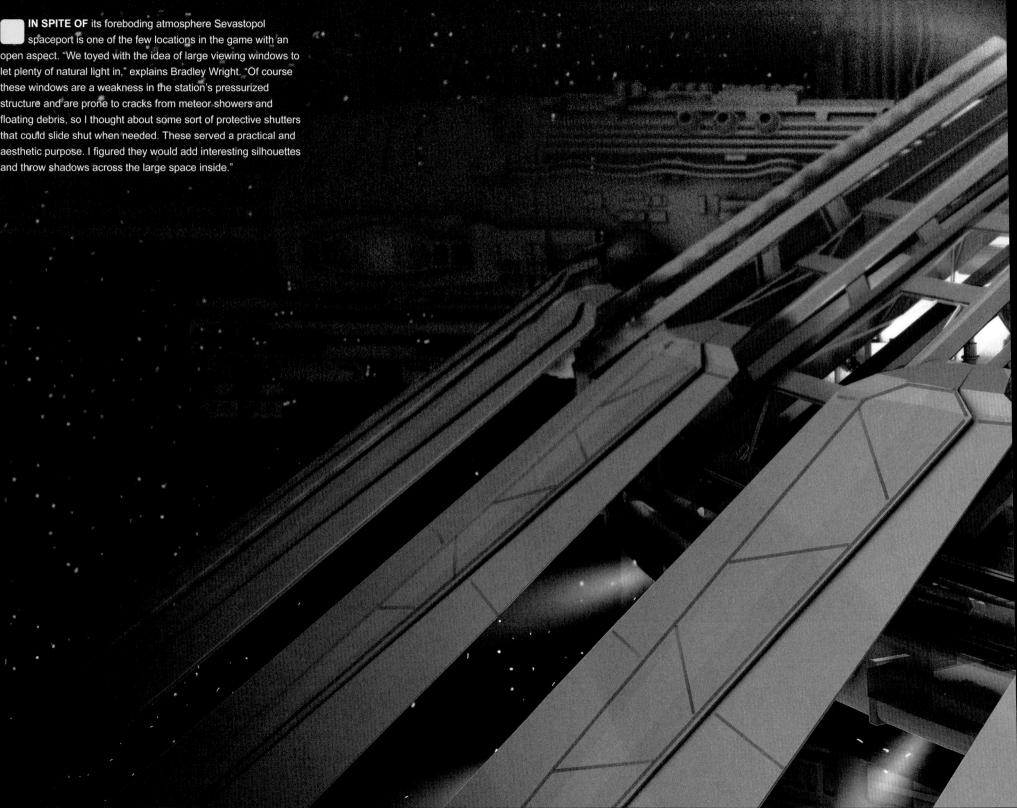

IN SPITE OF its foreboding atmosphere Sevastopol spaceport is one of the few locations in the game with an open aspect. "We toyed with the idea of large viewing windows to let plenty of natural light in," explains Bradley Wright. "Of course these windows are a weakness in the station's pressurized structure and are prone to cracks from meteor showers and floating debris, so I thought about some sort of protective shutters that could slide shut when needed. These served a practical and aesthetic purpose. I figured they would add interesting silhouettes and throw shadows across the large space inside."

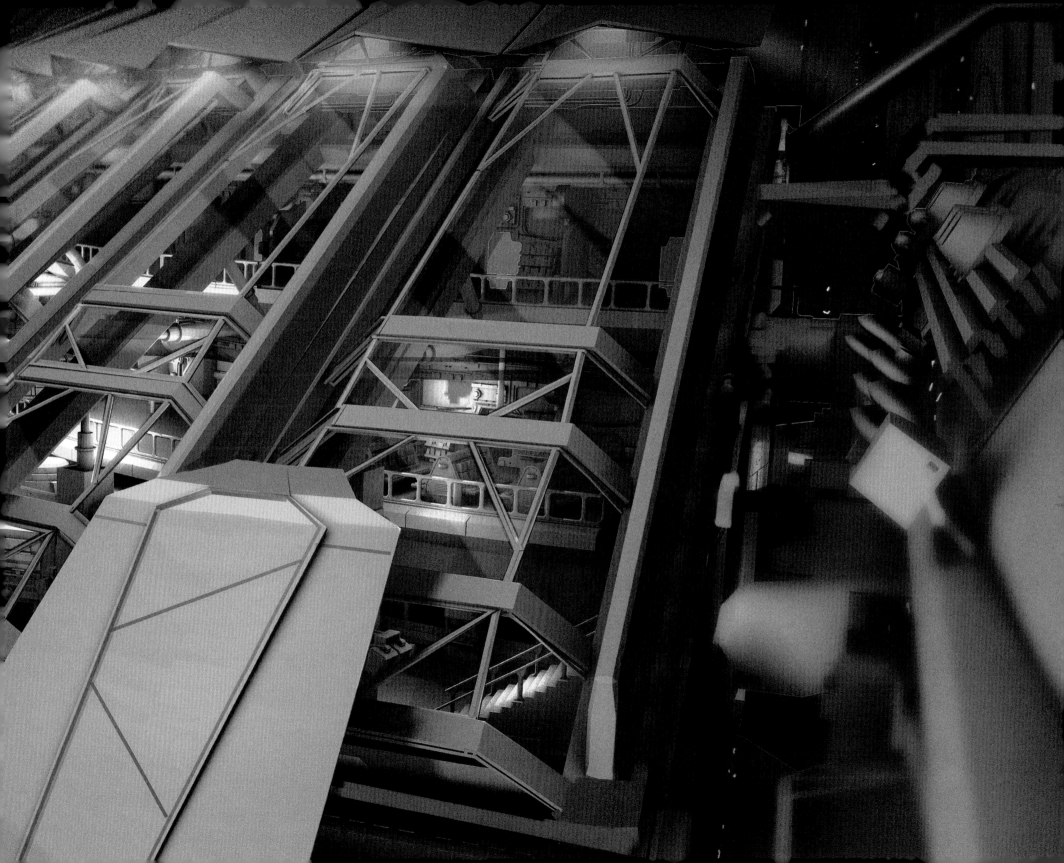

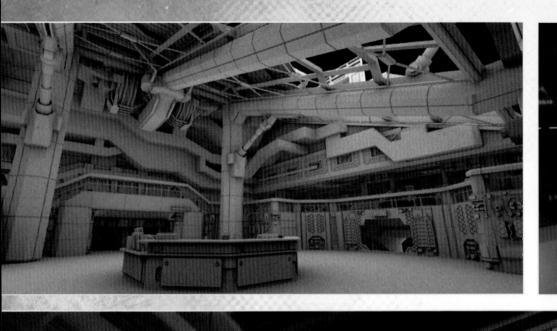
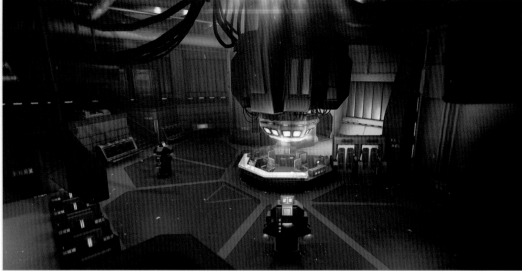
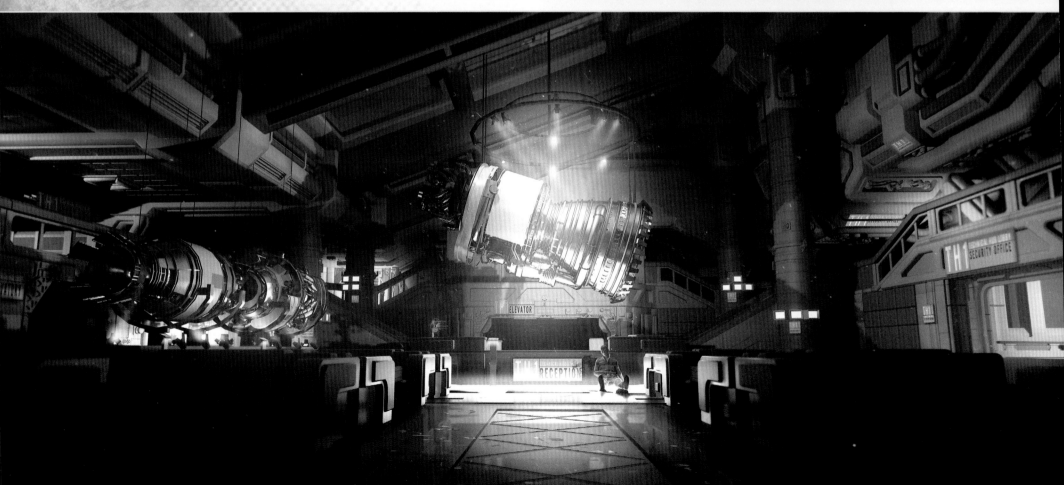

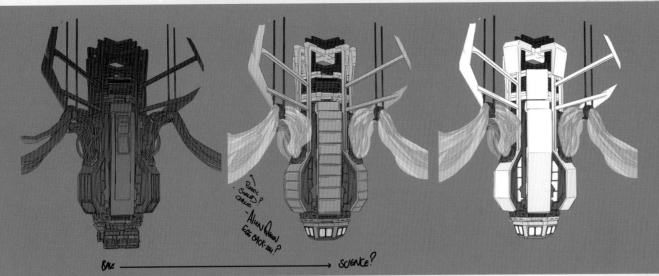

Aeronautical components on display in the heart of SysTech Spire, but any hopes of further illumination are dimmed in the stark lighting and deep shadows. "This area went through much iteration," explains Bradley Wright. "I explored ideas of this large machine structure that formed the center of each tower's hub – a mini-brain of sorts. The hub also showcases the technical achievements of the corporations working within the tower, such as the enormous rocket thruster in the main images."

"*Bottom right* is an early in-engine render of the same space," adds Jude Bond.

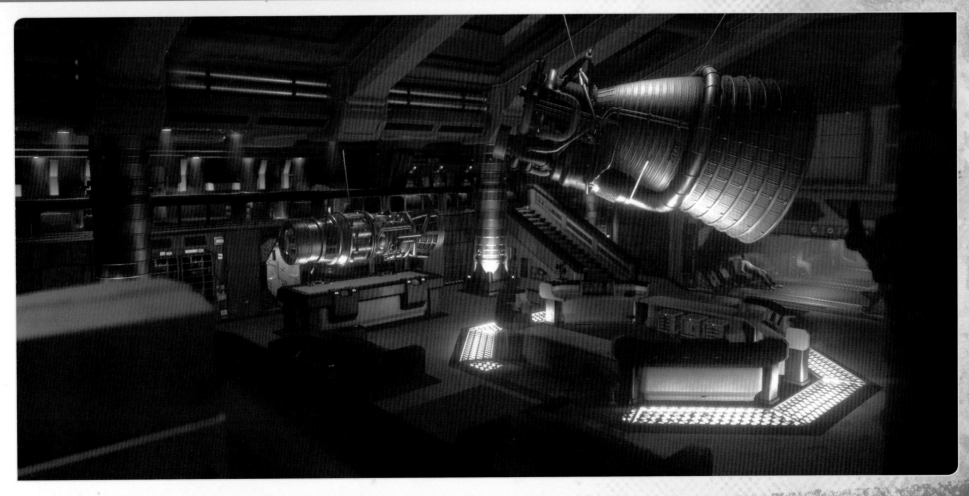

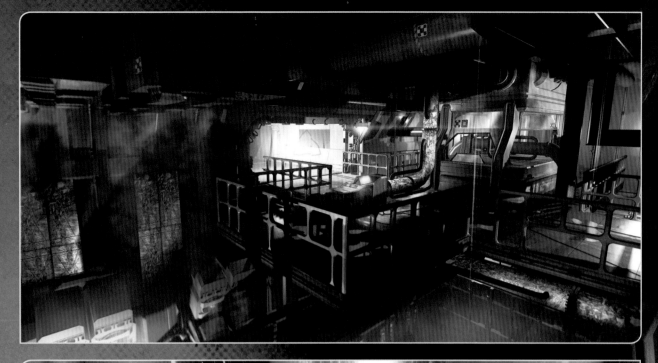

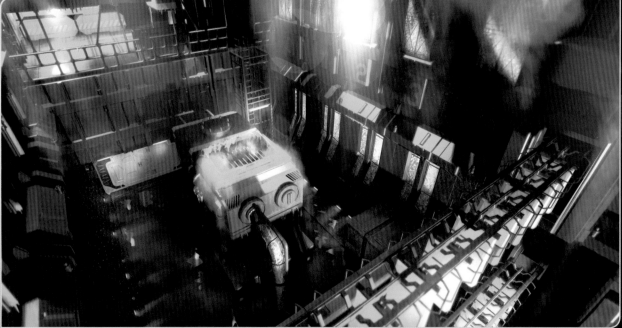

RESTORATION DRAMA

THE SEEGSON SYNTHETIC Technologies lab is fraught with dangers of many varieties; not least the peril that might be hiding in the shadows or the half-repaired androids that threaten to reawaken at any moment. "I needed to really make an effort here to create environments that would aid and obstruct the player in traversing the space," says Bradley Wright. "The idea for the android autopsy room came from watching an episode of a popular psychopath TV series – his 'kill rooms' always felt hauntingly disturbing. In my mind it seemed a perfect match, with our emotionless androids discarded and covered in plastic sheeting like ghosts. This would be an area you would stealthily creep your way through. I figured it would be terrifying to look up and see one of these inanimate faces staring back."

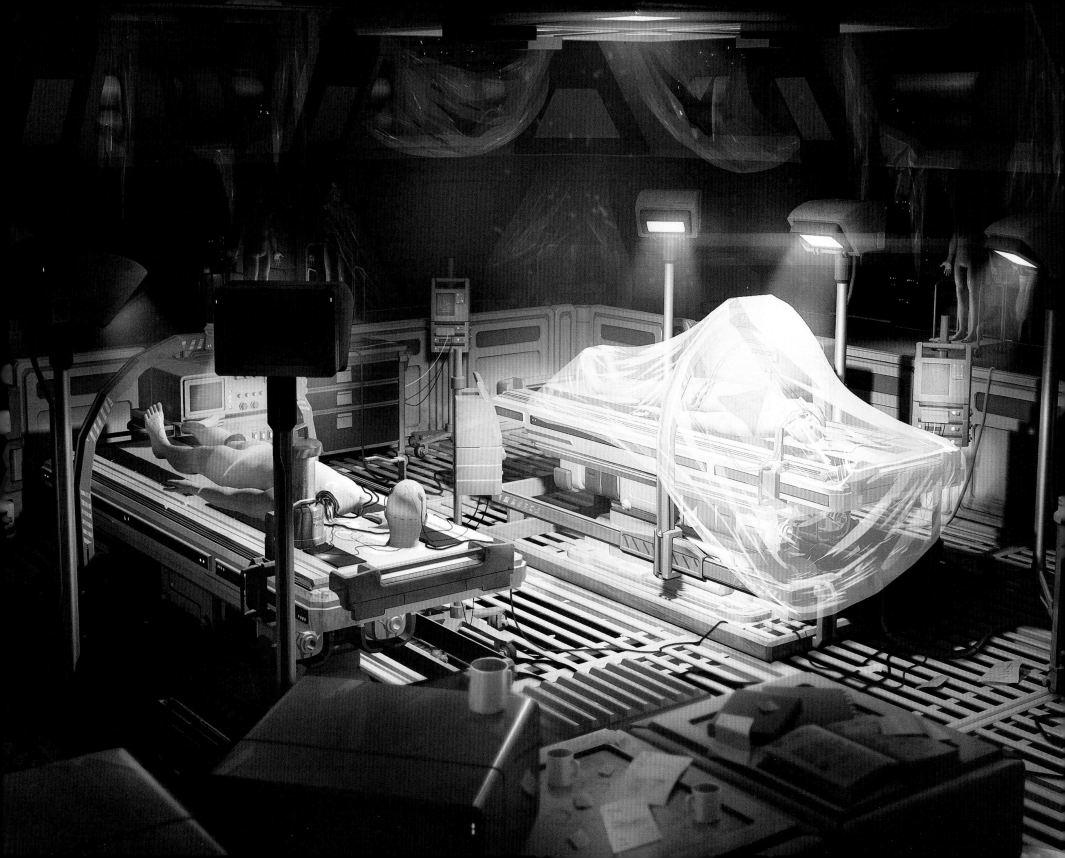

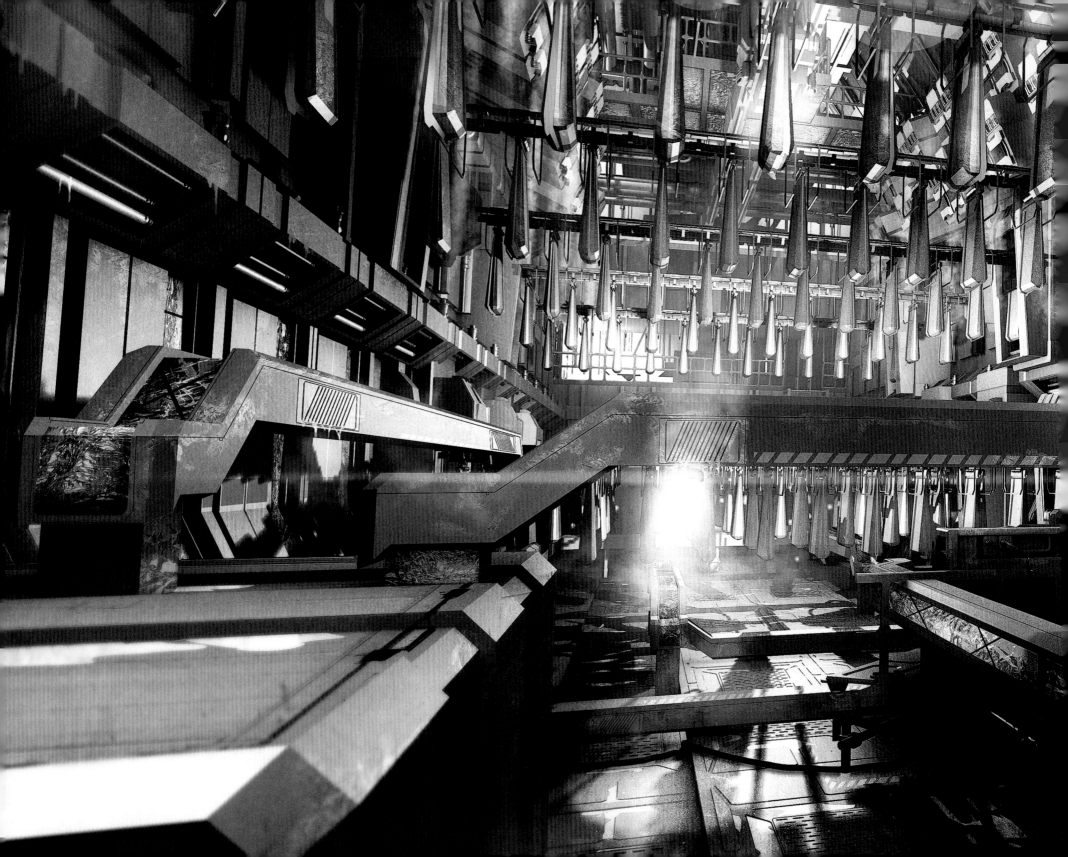

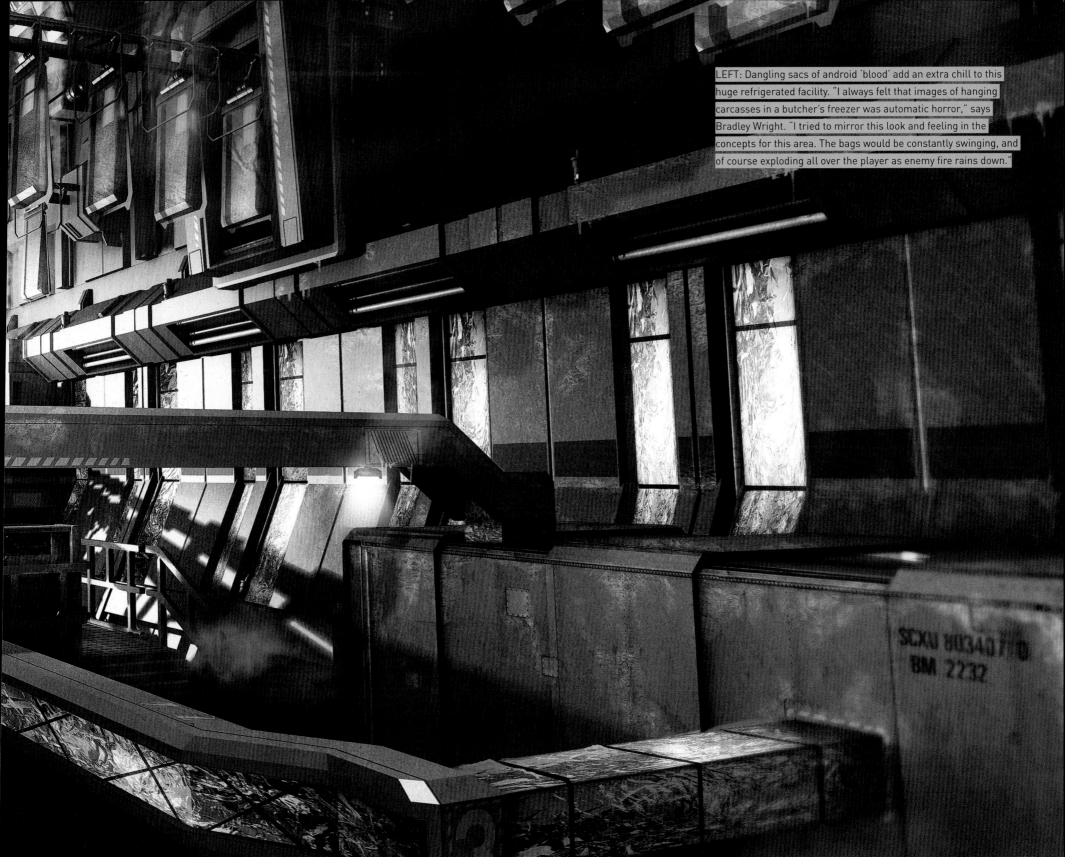

LEFT: Dangling sacs of android 'blood' add an extra chill to this huge refrigerated facility. "I always felt that images of hanging carcasses in a butcher's freezer was automatic horror," says Bradley Wright. "I tried to mirror this look and feeling in the concepts for this area. The bags would be constantly swinging, and of course exploding all over the player as enemy fire rains down."

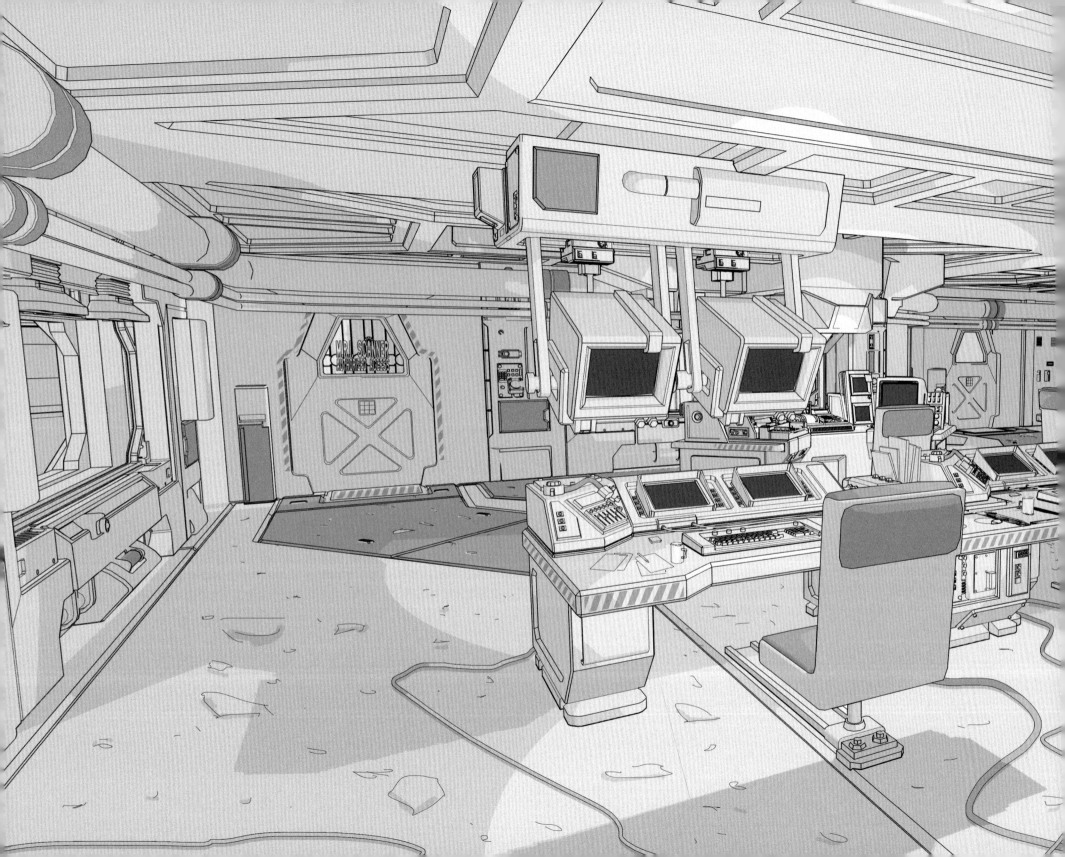

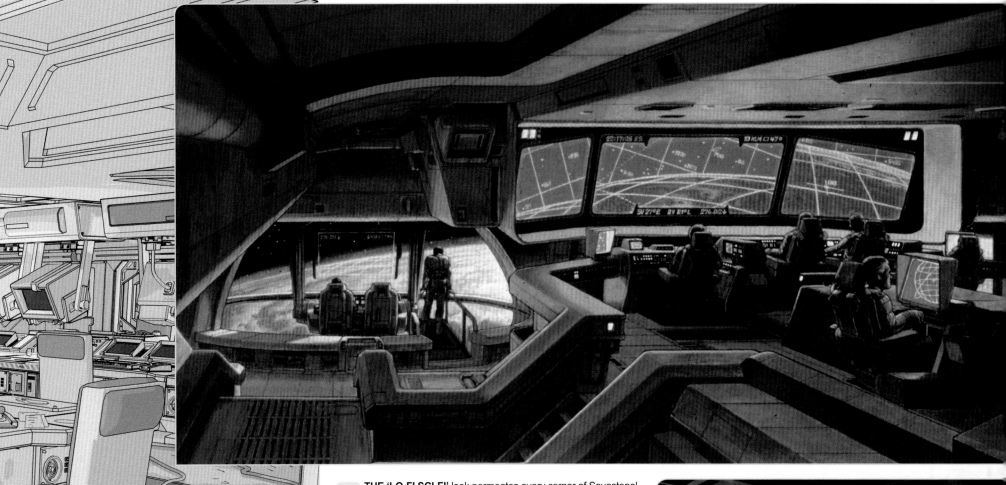

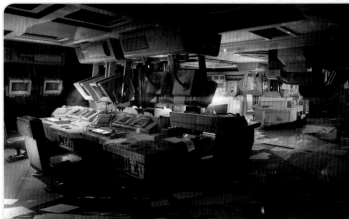

THE 'LO-FI SCI-FI' look permeates every corner of Sevastopol Station and makes this generic office space seem like a forgotten scene from the ALIEN movie. Indeed, it's difficult to distinguish the aesthetic between production art from the movie (*above*) and the game (*left*). "We tried to ensure that there is something in every room that ties us back to the original film," says Jude Bond. "We've limited ourselves to things which could've been or were available in 1979. Right down to the pieces of equipment we've built from components which pre-date '79 and could've been built on the set at Shepperton Studios."

Elsewhere Bradley Wright goes deeper into some of the aesthetic decisions he made: "I took cues from Ron Cobb's simplified utilitarian color choices above to make a clean and readable design. I imagined a team frantically collecting as much important research files as possible before they left. The aftermath of their evacuation is what we have left to explore."

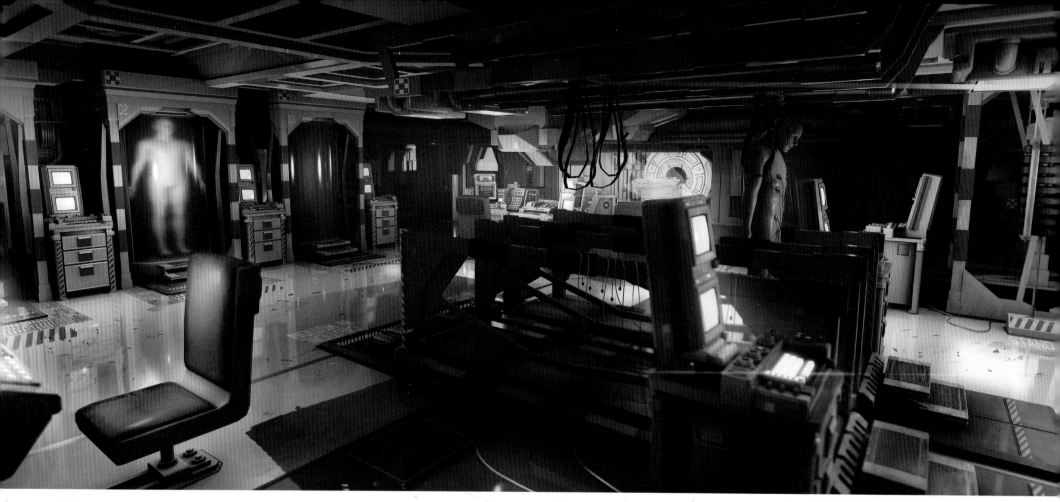

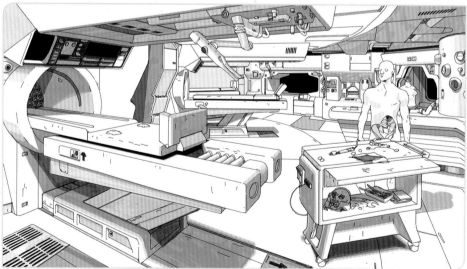

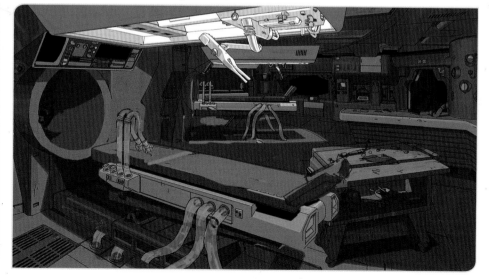

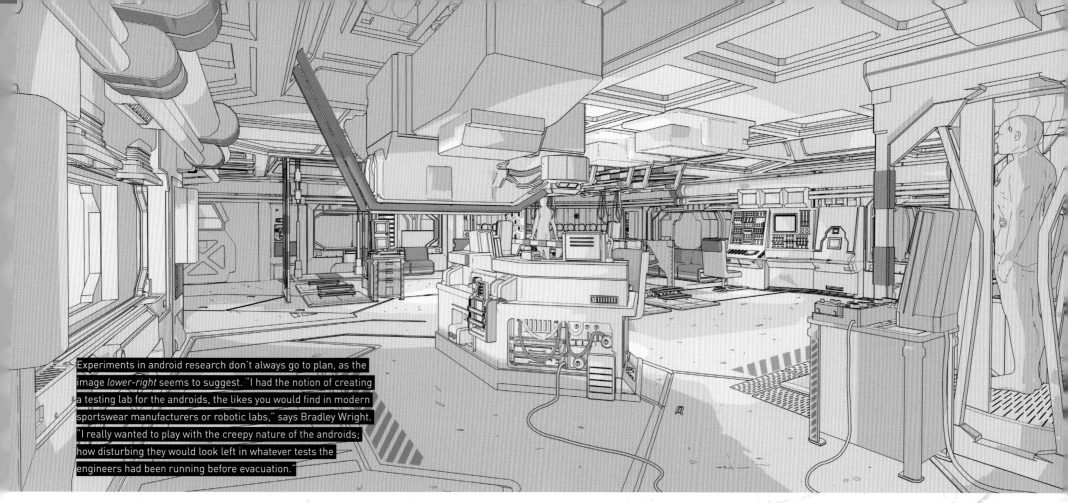

Experiments in android research don't always go to plan, as the image *lower-right* seems to suggest. "I had the notion of creating a testing lab for the androids, the likes you would find in modern sportswear manufacturers or robotic labs," says Bradley Wright. "I really wanted to play with the creepy nature of the androids; how disturbing they would look left in whatever tests the engineers had been running before evacuation."

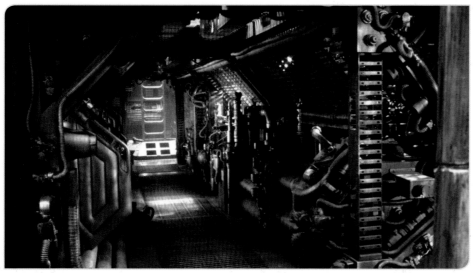

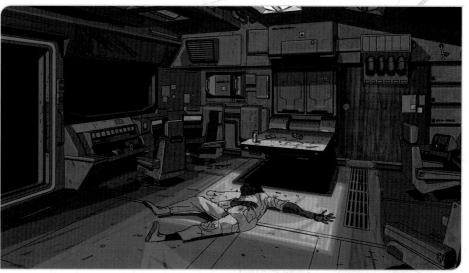

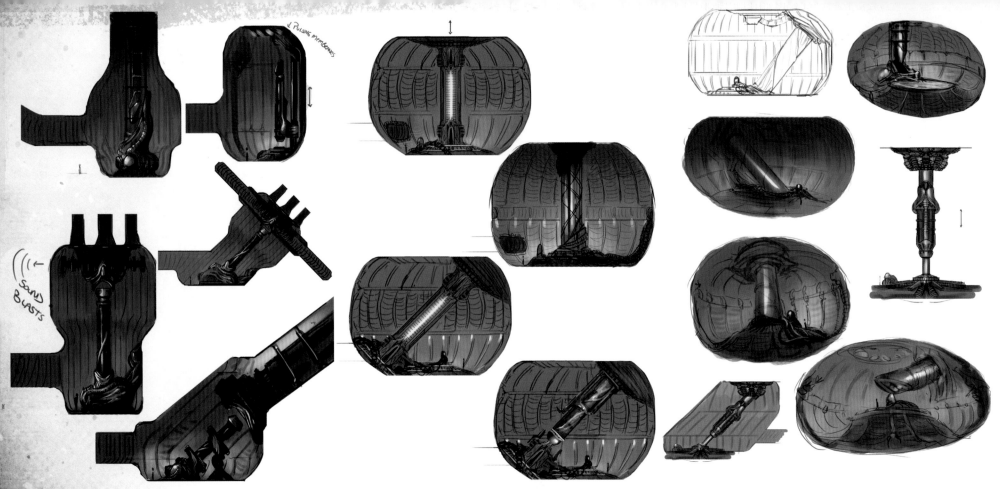

ORIGINAL PILOT MATERIAL

STEPPING OUTSIDE OF Sevastopol Station for a moment, the various images on these pages show a section of the game where the player has to locate and turn off the beacon that drew the crew of the Nostromo to the planet LV-426 in the first place. Their discovery of a wrecked alien ship and the cataclysmic events that followed have reverberated down the years leading to Amanda's current predicament. Concept Artist Bradley Wright takes up the story: "When sketching out ideas for the beacon found on the derelict alien ship, it was important to maintain a feeling of authenticity, building on the forms which are present in the original movie set. We explored a number of options, investigating various phallic compositions inspired by H.R. Giger's artwork (*above*) but in the end we settled on a re-composition of authentic components, building a new form from existing elements of the Space Jockey design."

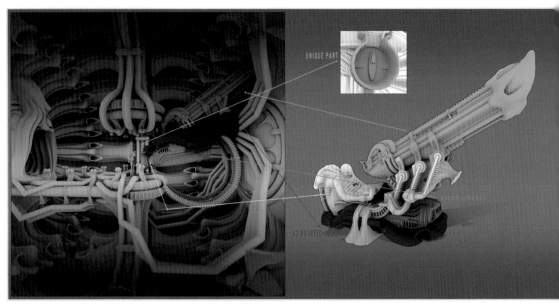

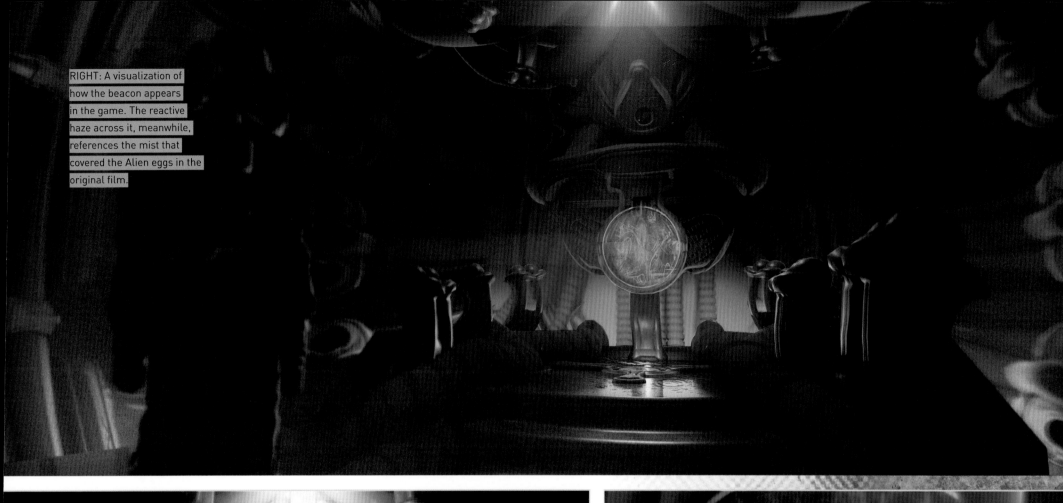

RIGHT: A visualization of how the beacon appears in the game. The reactive haze across it, meanwhile, references the mist that covered the Alien eggs in the original film.

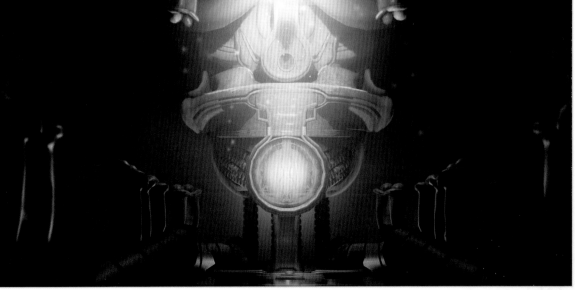

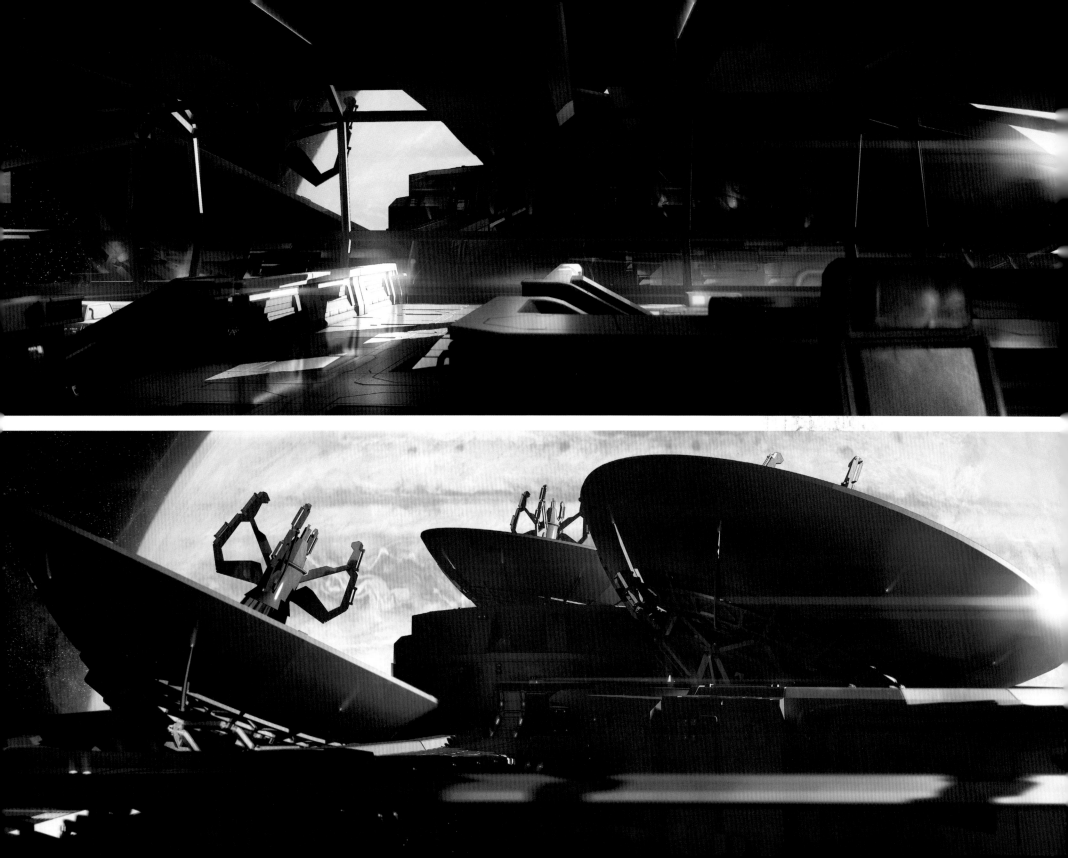

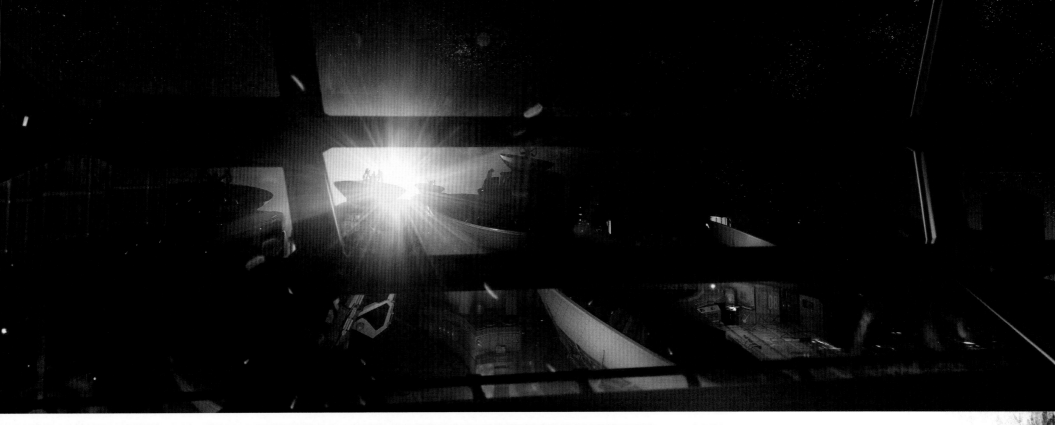

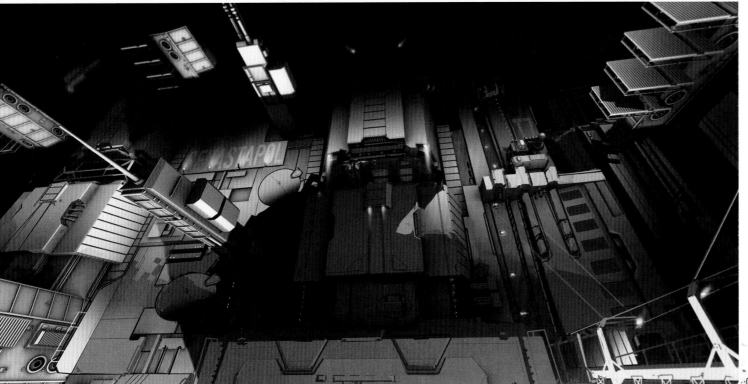

OPPOSITE: Scale is an important consideration for objects viewed against the blackness of space. "Too small and it gets lost, too big and we lose what we are actually looking at," explains Bradley Wright.

LEFT: "This sketch is actually the first chance I had to explore the outside surface of Sevastopol Station. This façade would be seen from the vantage of one of the communication dishes, and disappear up into darkness. We developed the idea of blast shields that would theoretically slide over the large window to protect it."

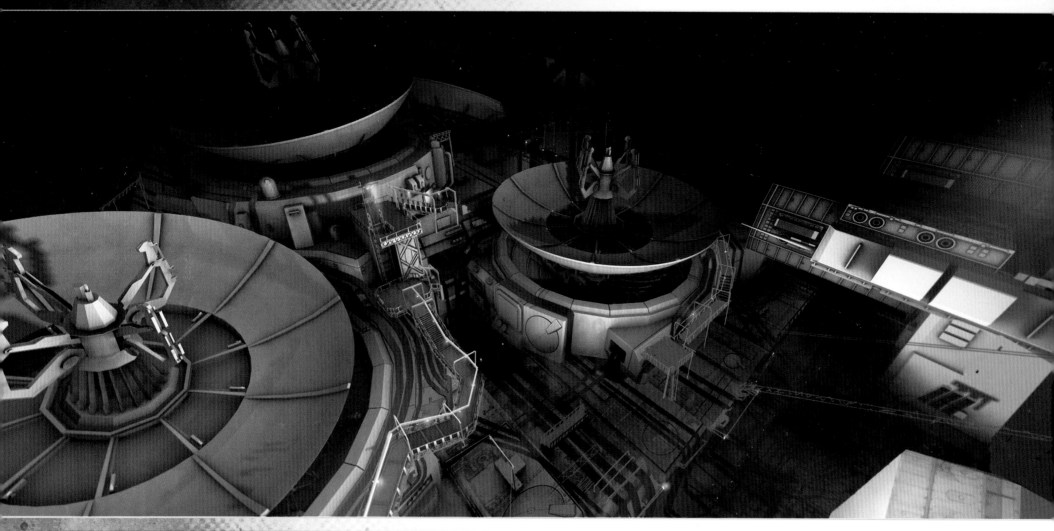

LEFT: Part of *Alien: Isolation* gameplay takes place among an array of communication dishes, which entailed threading narrow walkways in between these sizeable installations. Such slender paths are likely to make combat or a hurried escape tricky, though.

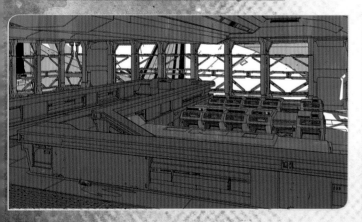

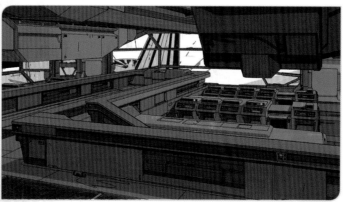

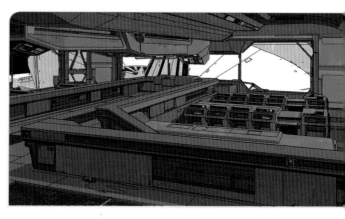

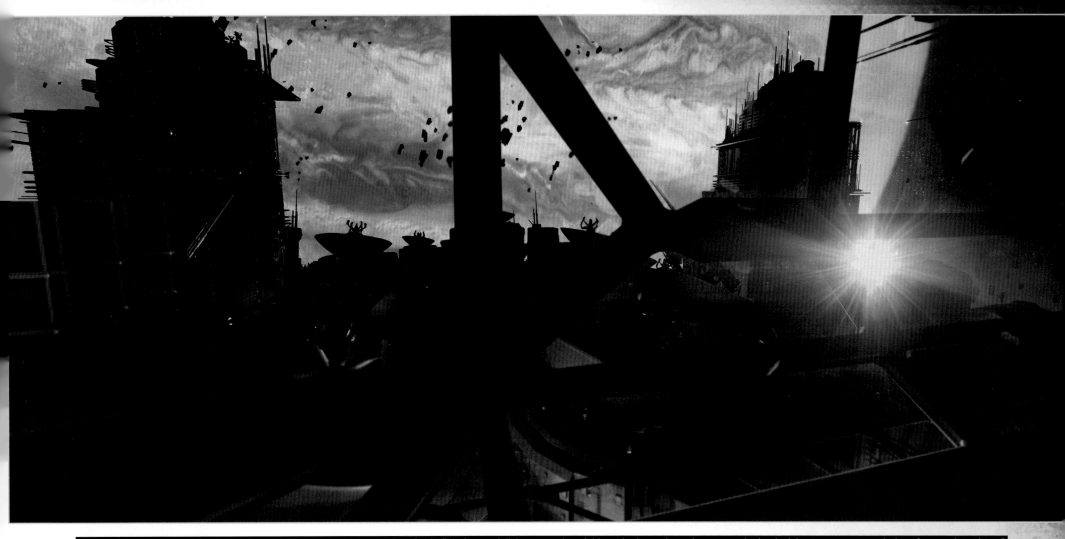

RIGHT: "These are some of Eduoard Caplain's images, as inspired by Ron Cobb. This forest of dishes proved useful later in the project when we made the decision to use matte paintings for our vista shots," says Bradley Wright. "This quickly visualized what could be seen in the game and what would be needed for a matte painting."

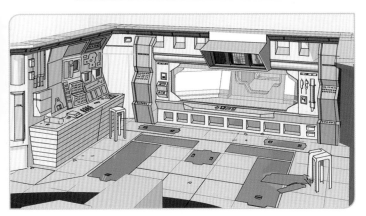

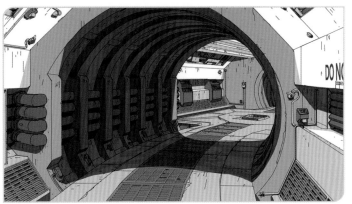

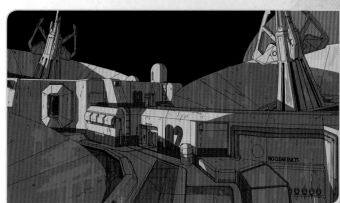

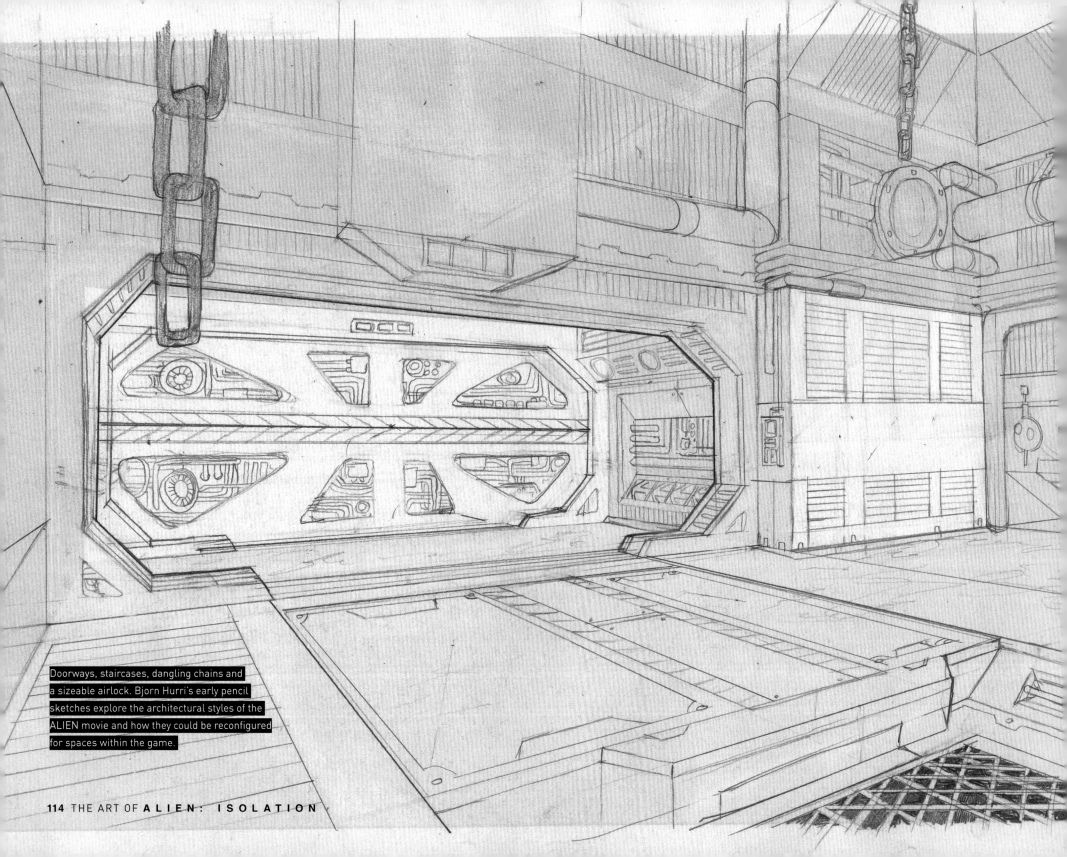

Doorways, staircases, dangling chains and a sizeable airlock. Bjorn Hurri's early pencil sketches explore the architectural styles of the ALIEN movie and how they could be reconfigured for spaces within the game.

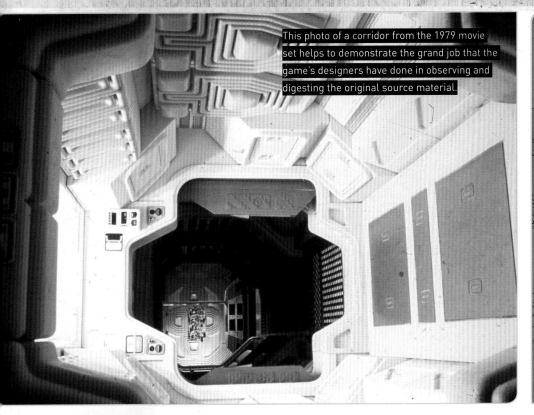

This photo of a corridor from the 1979 movie set helps to demonstrate the grand job that the game's designers have done in observing and digesting the original source material.

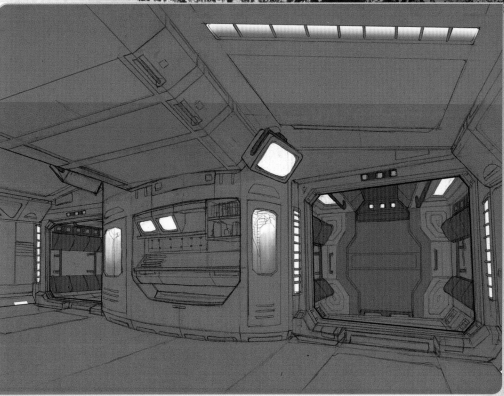

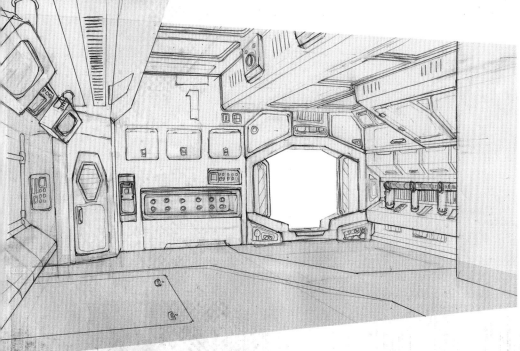

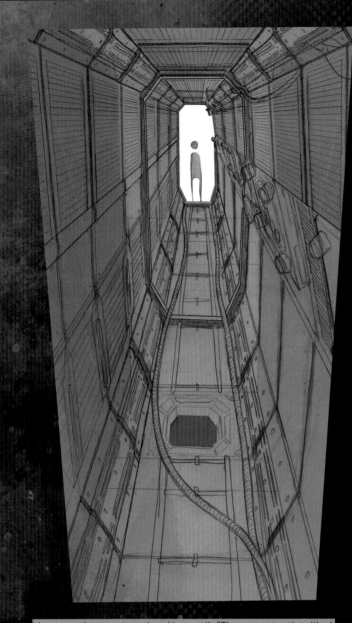

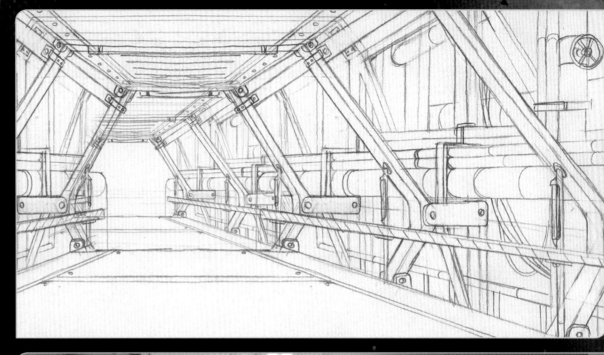

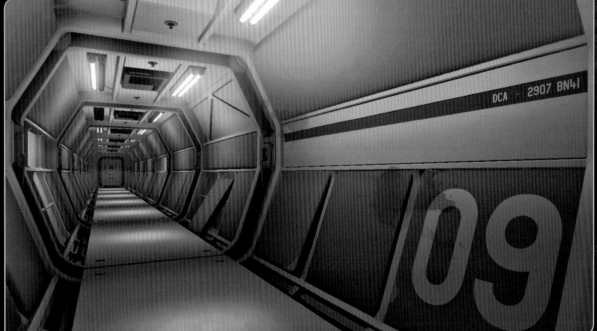

More sample spaces rendered in pencil. "The concept artists liked to get 'into character' and use the media that would have been available at the time," explains Jude Bond.

The vacant corridor to the right references the ALIEN film but also echoes the architecture of the Apollo space mission era. "The removable panels are padded in order to soften this austere bulkhead," says Jude Bond.

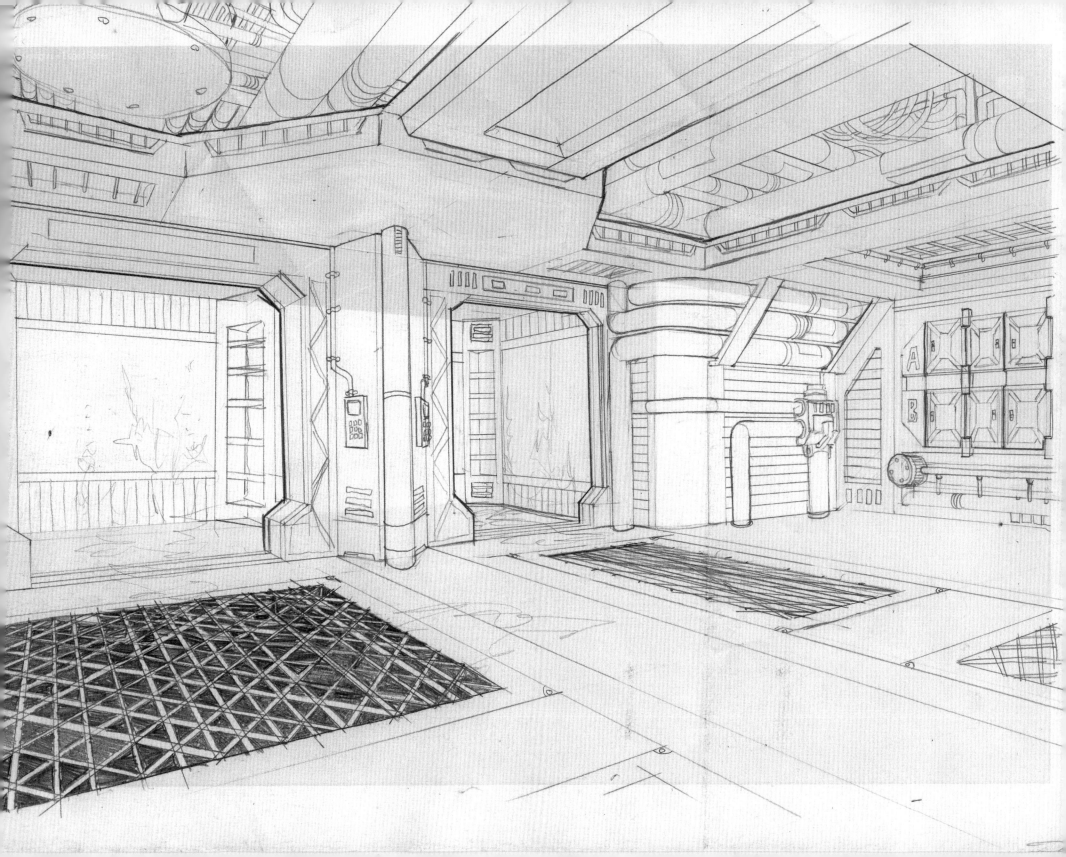

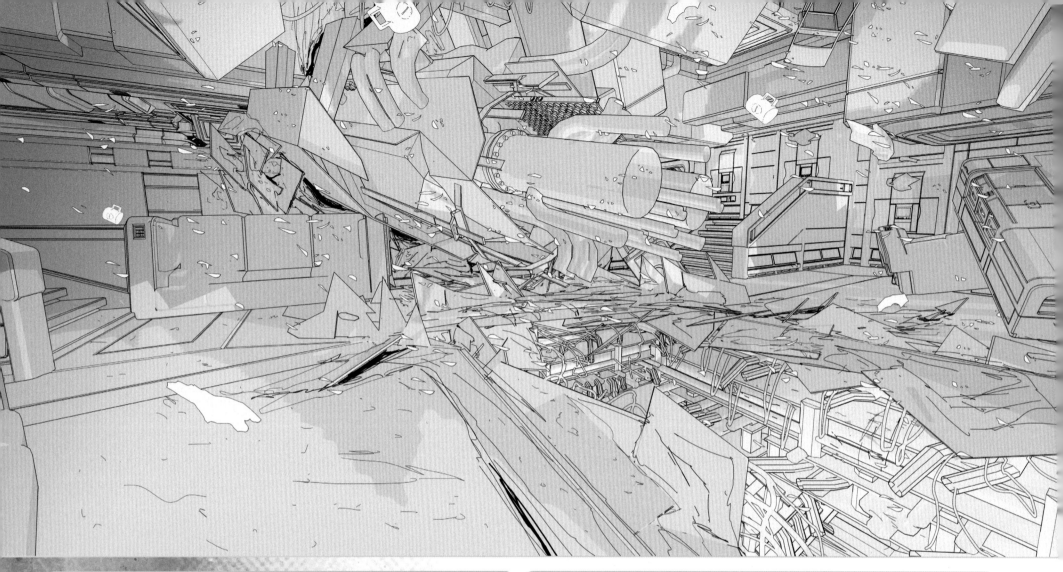

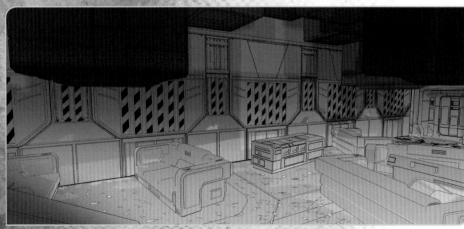

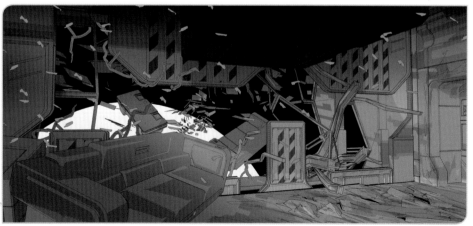

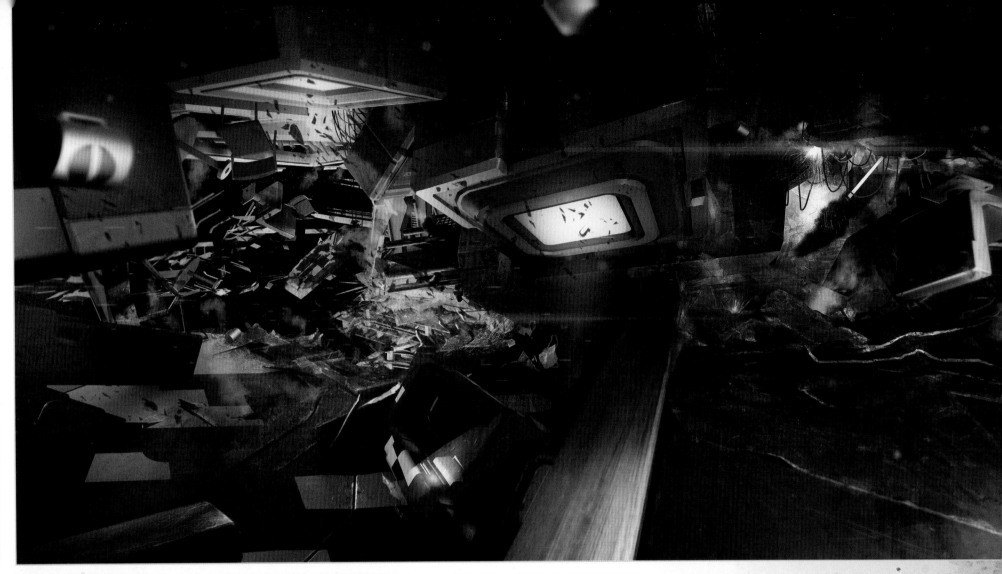

OBLITERATION AND UTTER disarray in the aftermath of a catastrophic loss of pressure. This section of gameplay has since been removed, but it is not hard to imagine the difficulties entailed in negotiating such chaotic scenes – particularly if wearing a spacesuit with a ravenous xenomorph in hot pursuit. "I painted a few images that looked at both the level of destruction needed and how our environments could look if a large piece of debris suddenly ripped itself through an exterior wall and produced a massive depressurization blowout," says Bradley Wright.

LEFT: A collection of images that explore the details of large cutting-panels and an early concept for smaller access panels.

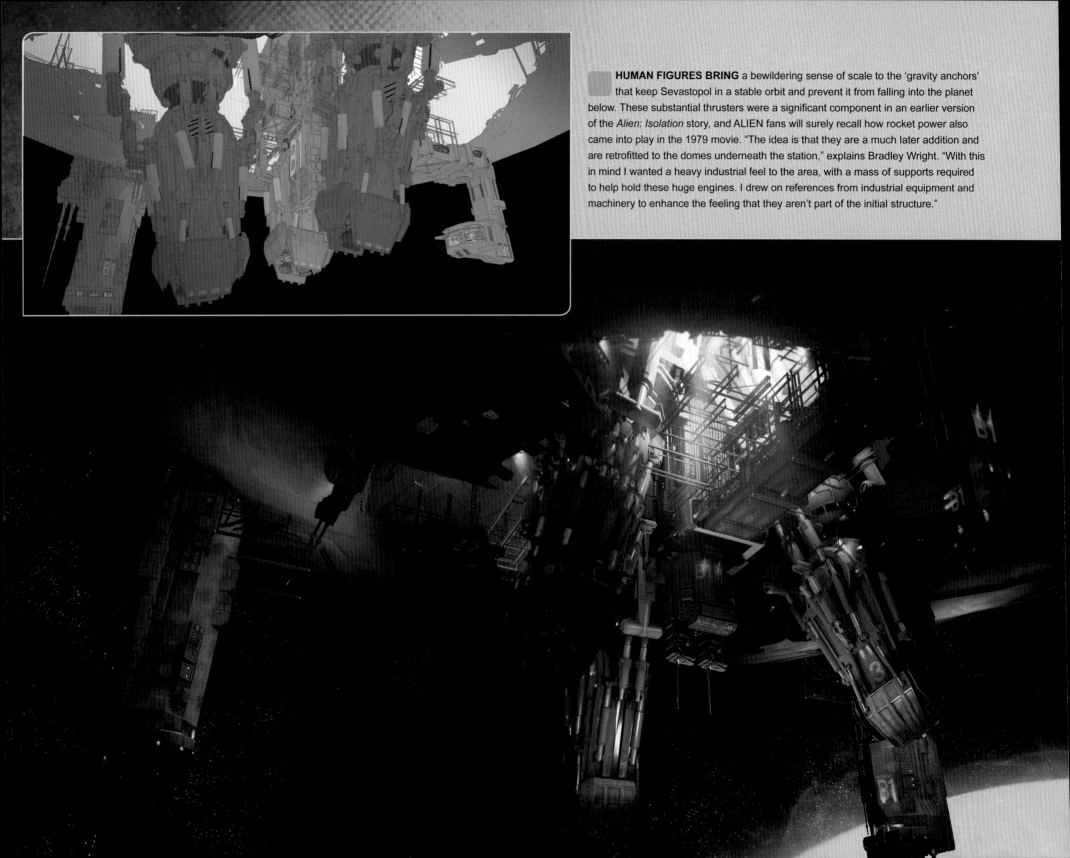

HUMAN FIGURES BRING a bewildering sense of scale to the 'gravity anchors' that keep Sevastopol in a stable orbit and prevent it from falling into the planet below. These substantial thrusters were a significant component in an earlier version of the *Alien: Isolation* story, and ALIEN fans will surely recall how rocket power also came into play in the 1979 movie. "The idea is that they are a much later addition and are retrofitted to the domes underneath the station," explains Bradley Wright. "With this in mind I wanted a heavy industrial feel to the area, with a mass of supports required to help hold these huge engines. I drew on references from industrial equipment and machinery to enhance the feeling that they aren't part of the initial structure."

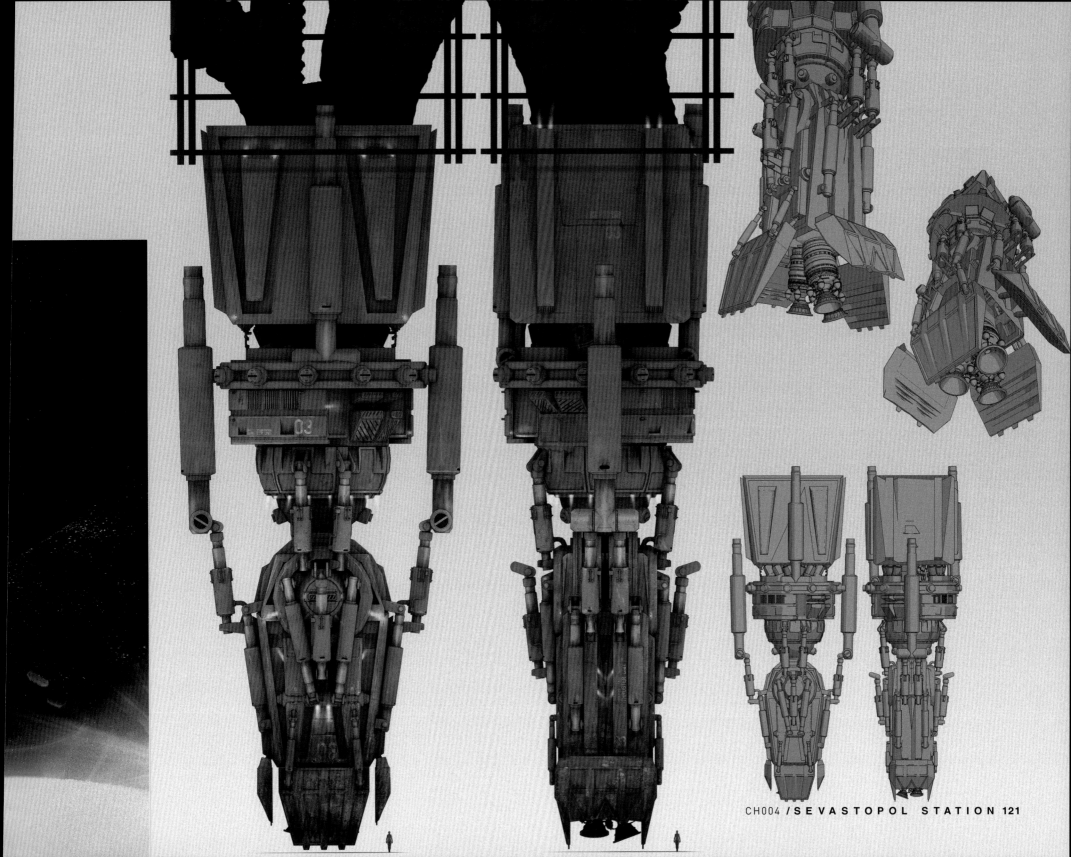

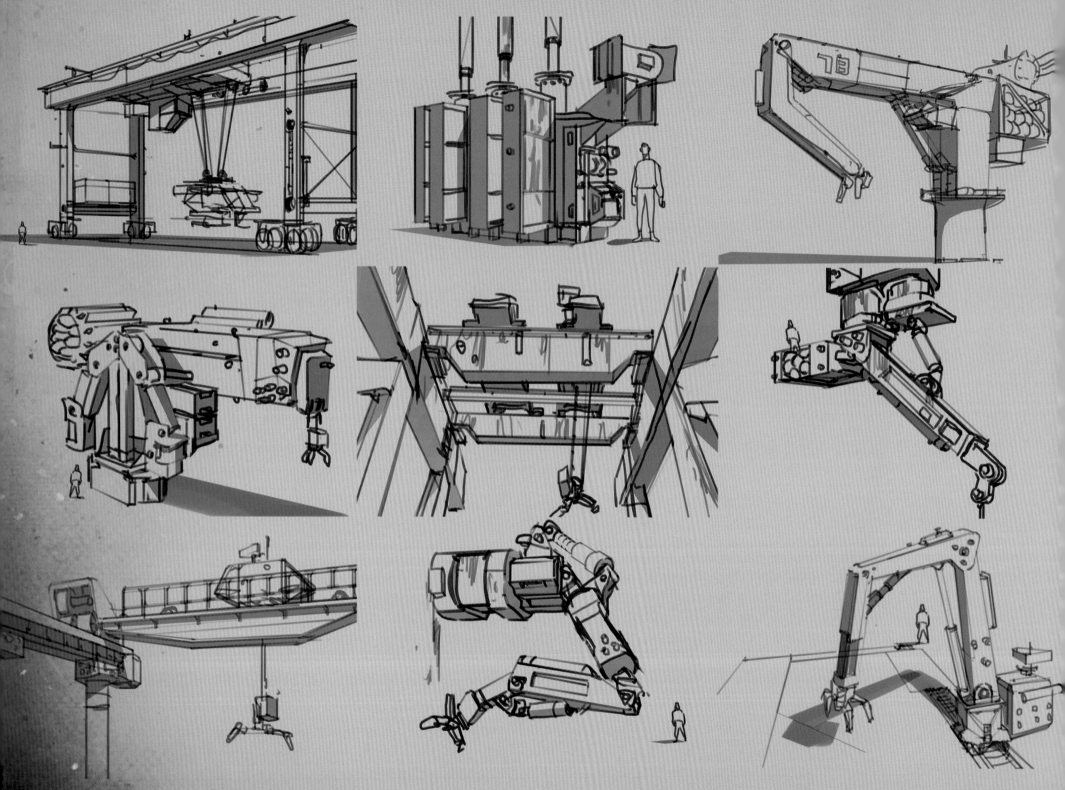

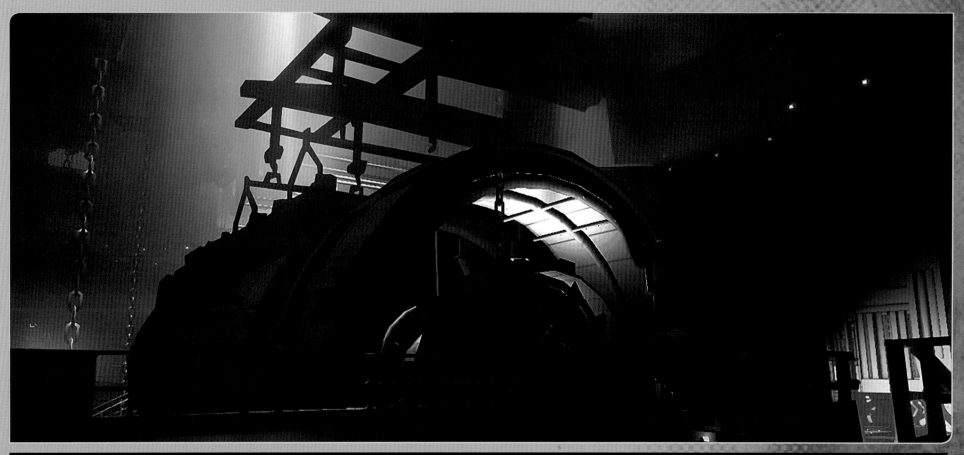

LEFT: Monochrome sketches of cranes and industrial equipment, much of which never made the final build of the game. "I was trying to keep this feeling of heavy machinery from the ALIEN movie," explains Concept Artist Edouard Caplain. "It was fun for me to let the pencil go and then kick the bad ones out at the end."

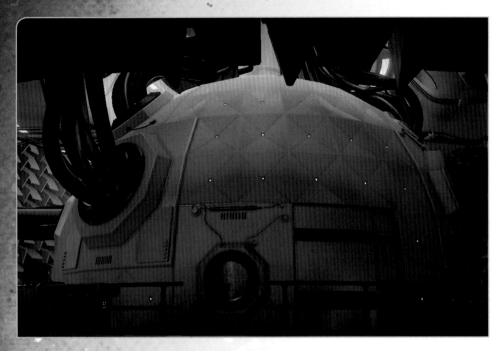

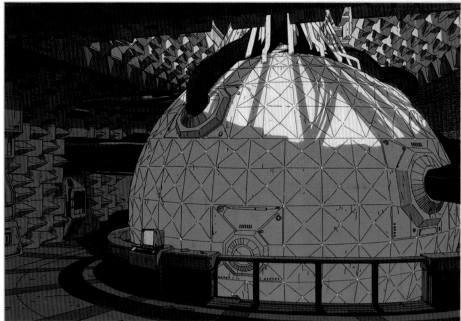

ANDROID AUTHORITY

THE APOLLO CORE controls Sevastopol's synthetic workforce, the name being an acronym for Artificial Personality Overseeing Lifestyle & Logistics Operations. APOLLO monitors the station's security system and dispatches Working Joe androids within short notice of a repair required or a problem occurring. "Our initial inspiration came from the idea of inverting the MU-TH-UR 6000 computer from the ALIEN movie. This turned into a sphere held with cables, like an eye with its nerves," says Edouard Caplain. "This mix of geometrical and organic shapes is always disorientating and ties back to some of the treatments in the movie. In this room you can't really tell what could start moving and what could be a threat."

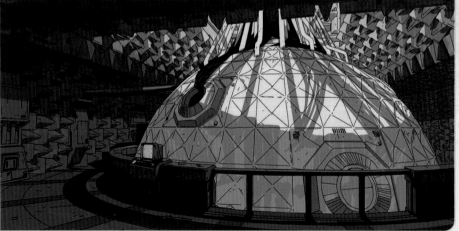

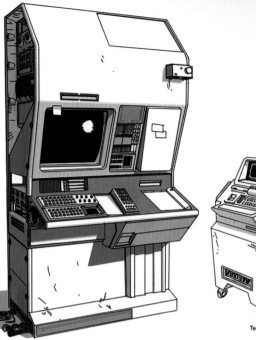

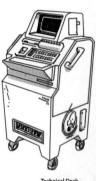

Technical Deck

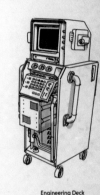

Engineering Deck

HEFTY STANDALONE CONSOLES and banks of computers are another indication of the laudable adherence to lo-fi sci-fi principles and are imagined to be assembled from components that would have been available at the time of the movie. "These sketches are directly inspired by Ron Cobb's work on the original film," explains Edouard Caplain. "Line drawings are quick to produce and are very helpful for the 3D artists. They are straight to the point and the forms are easily readable. For me that's what concept art is all about. It doesn't always have to be nice looking; it has to be clear and usable for the guys that are going to work from it. They knew it 40 years ago and I'm happy that we worked the same way for the game."

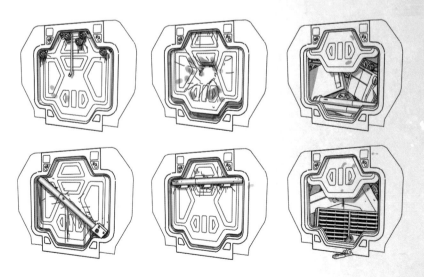

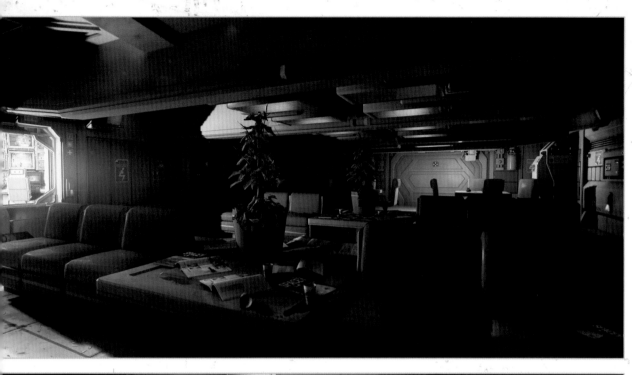

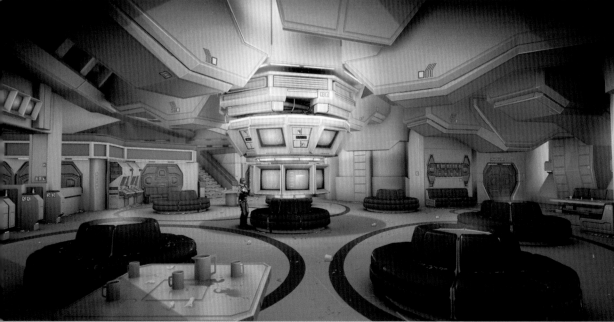

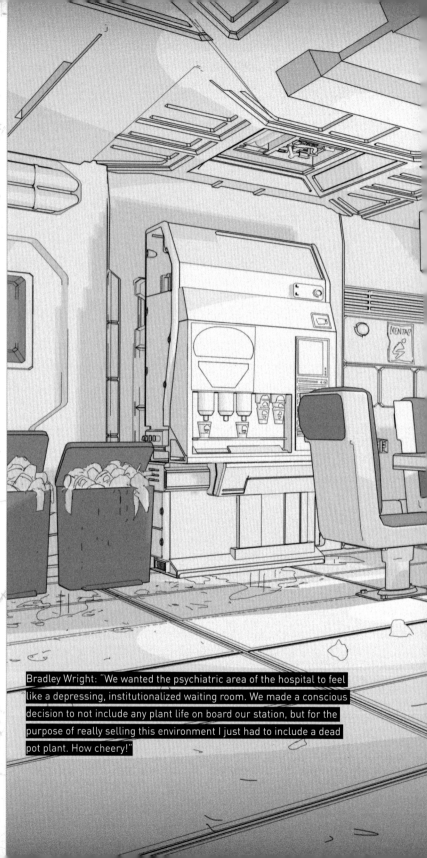

Bradley Wright: "We wanted the psychiatric area of the hospital to feel like a depressing, institutionalized waiting room. We made a conscious decision to not include any plant life on board our station, but for the purpose of really selling this environment I just had to include a dead pot plant. How cheery!"

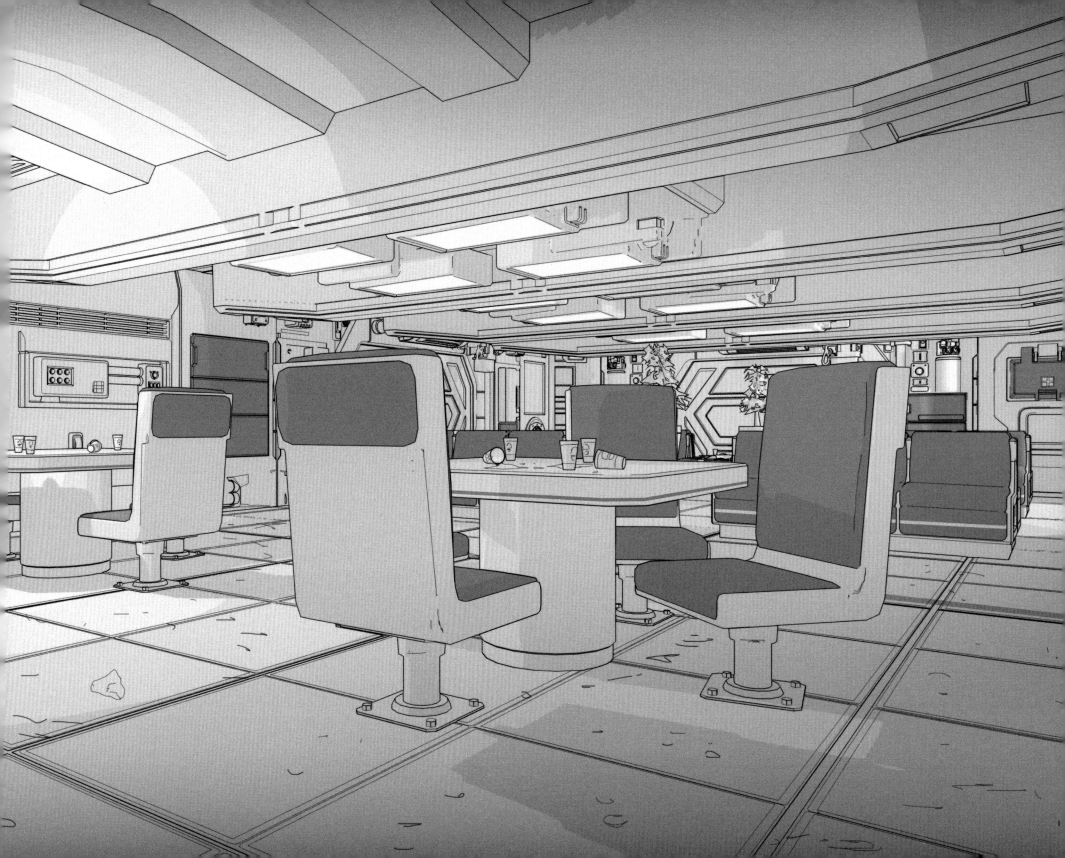

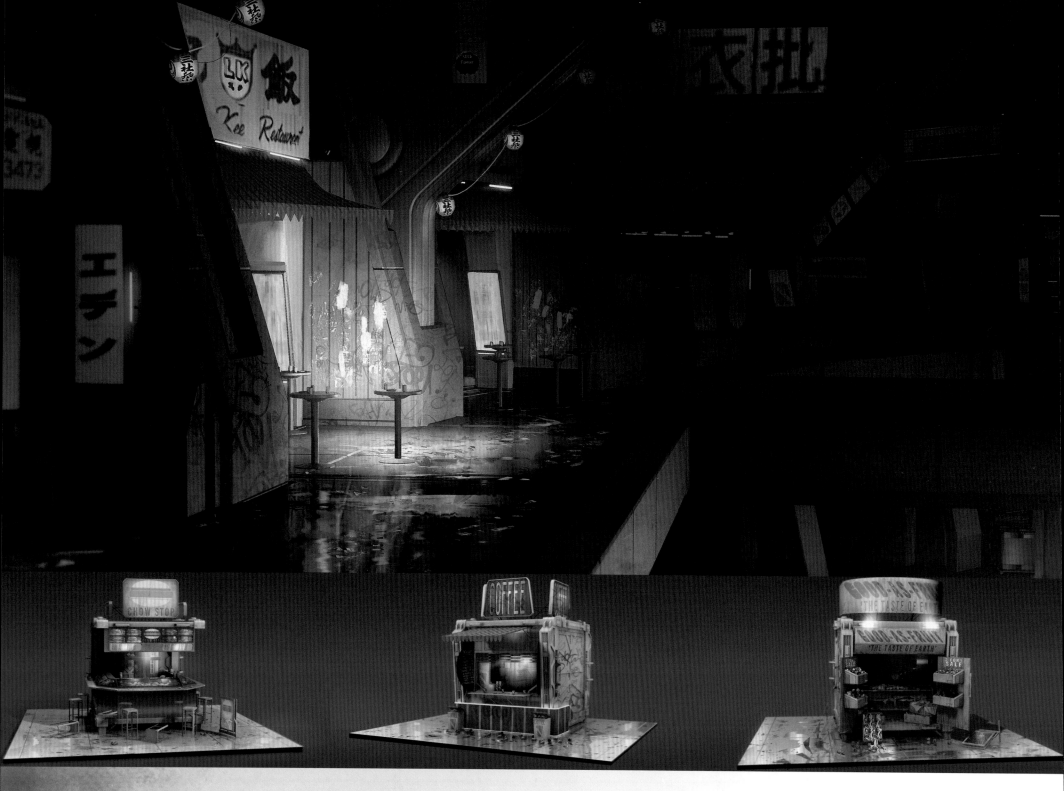

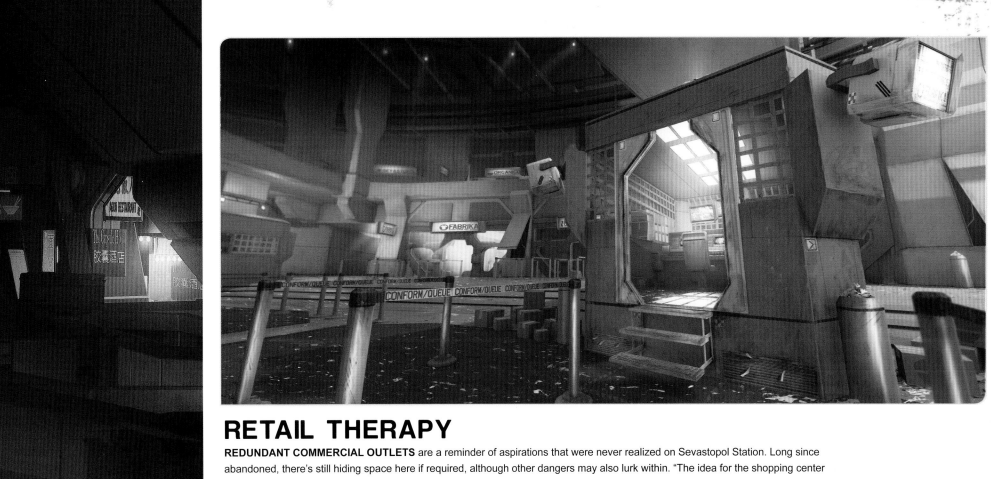

RETAIL THERAPY

REDUNDANT COMMERCIAL OUTLETS are a reminder of aspirations that were never realized on Sevastopol Station. Long since abandoned, there's still hiding space here if required, although other dangers may also lurk within. "The idea for the shopping center was to rent out the spaces. This allowed us a chance to add a variety of contradictory colors that wouldn't have fit anywhere else in the game," says Bradley Wright. "I drew on the organized chaos of Chinese markets filled with contrasting colors and textures. As well as shops, I had to design little stalls (*below*). Nothing more than cargo containers, retrofitted into shops. The friendly and colorful nature of the shopping center is thrown into contrast by the graffiti and looting that happened after evacuation."

Clink. Glug. Ahhh - Oh.

Some things are too good to be savoured. Buy two bottles.

Souta Lager

ORBITAL LOVE

The **Know**

Who's in The **Know**?
Are You?

What we Left Behind

If you could go back, what would you change?

The new romantic time-twister novel from acclaimed author Adrianne Carter.

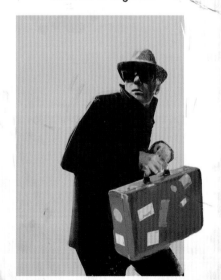

Beware of bag theft

Thieves and pickpockets operate in this area. Protect your belongings. Report any crimes or suspicious activites to Colonial Marshal Bureau.

WEYLAND-YUTANI CORP

BUILDING BETTER WORLDS

SEEGSON

Seegson. Tomorrow, Together.

We don't forget the little details when seeing the big picture.

Law has no boundary.

Stay Focused. Distraction Can Be Hazardous

Keep VIGILANT for SPILLS

Report them immediately!

GRAPHICS

BACKGROUND DETAILS SUCH as these advertisements are easily overlooked during fraught moments of gameplay, but imagine how much more desolate Sevastopol Station would look without them. "Hundreds of individual images were created to support and enhance the story and the universe we had created," explains Bradley Wright. "These posters reference print material published in the 1970's, using ideas, styles, and colors that would have been commonplace. They were just pure fun to create and let loose on."

Before they breed...TRACK and EXTERMINATE.

Vermin cause diseases, don't let them spread!

CAUTION

Observe moving trains at all times

WEYLAND-YUTANI CORP

BUILDING BETTER WORLDS

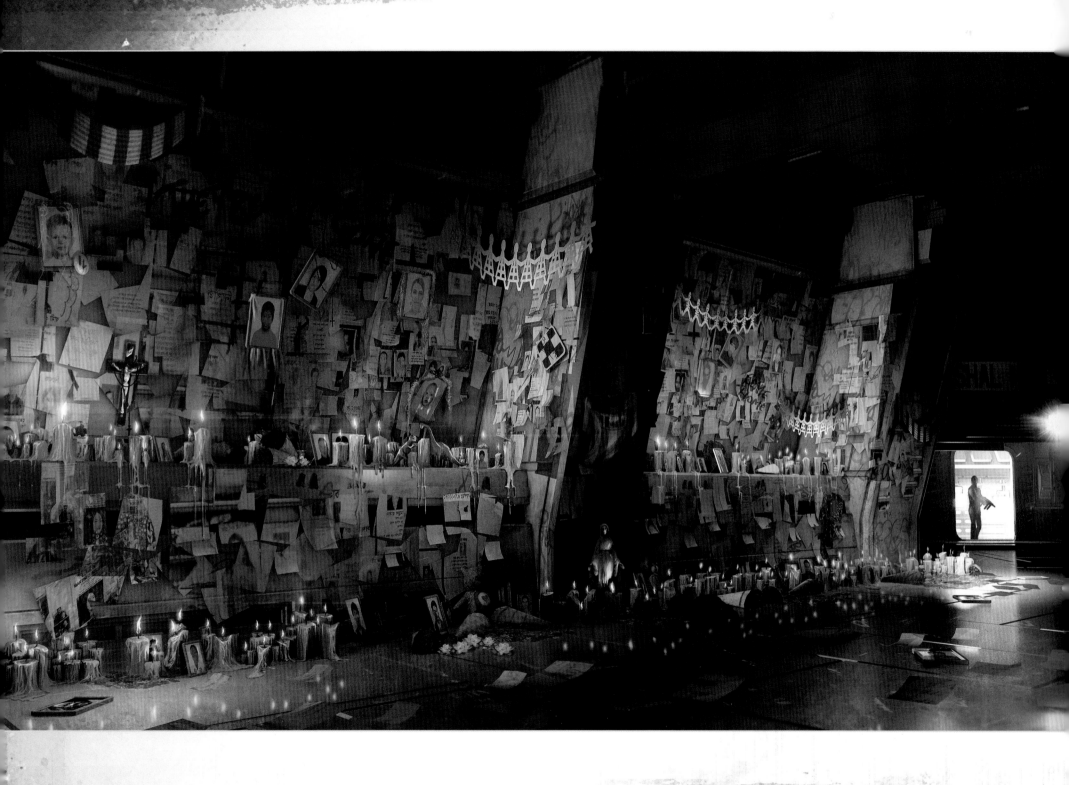

More signs of the trials endured by Sevastopol citizens and poignant reminders of friends and family now lost or departed. "For numerous concepts I tried to add hints to the downfall of the station," explains Bradley Wright. "The personal struggles that people had to go through to survive. Whether it be a back room of a shop turned into a secure home, or a memorial wall. These images document the hardship that they must have experienced as loved ones went missing."

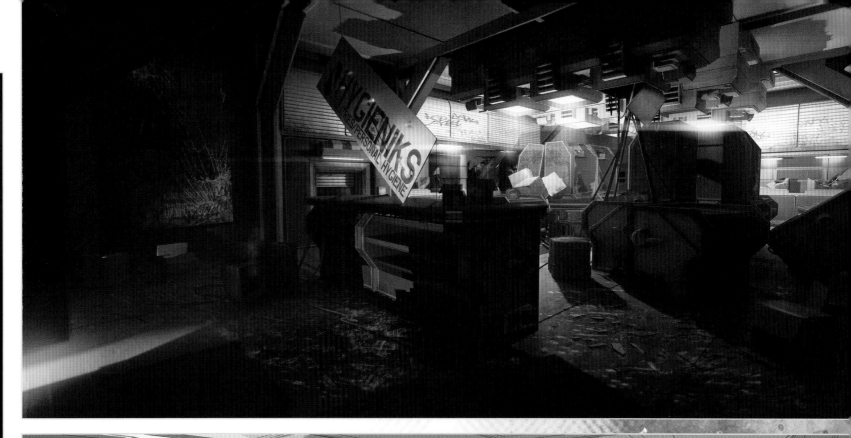

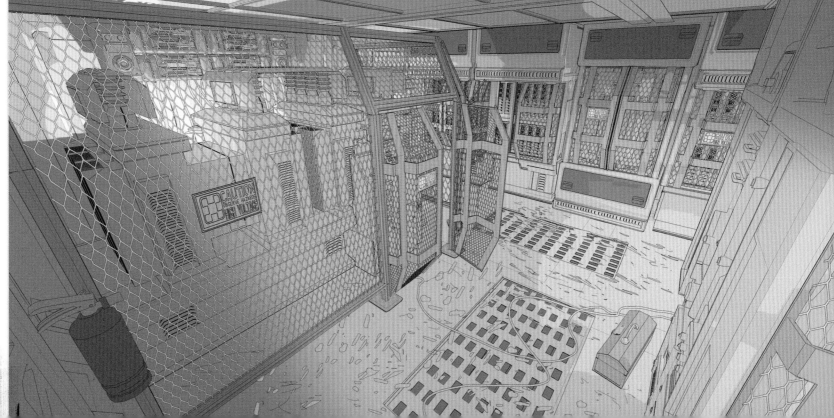

// "The original creature did a brilliant job of capturing people's imagination because it taps into deep rooted primal and cultural fears. The creature design is beautiful and terrifying at the same time. As a viewer you want to look, but know you should run. It's threatening and sexual, beautiful and ugly." //
Lead Artist, Jude Bond.

THE EPONYMOUS ALIEN is unpredictable, untameable and utterly inscrutable. Its eyeless gaze and rictus grin mask its savage intent. However, this creature kills not for pleasure but to fulfill its biological imperative, its progeny often displaying certain characteristics of its surrogate hosts with each successive generation – hence its bipedal stance and humanoid morphology in the 1979 movie. Superior speed, strength and cunning make the xenomorph a formidable predator, and its corrosive blood ensures that it remains a threat even when wounded. Some consider the creature to be the perfect organism; the perfect weapon, perhaps. But too few who encounter it, or who try to exploit its fearsome capabilities, ever live to tell the tale.

001	031	061
002	032	062
003	033	063
004	034	064
005	035	065
006	036	066
007	037	067
008	038	068
009	039	069

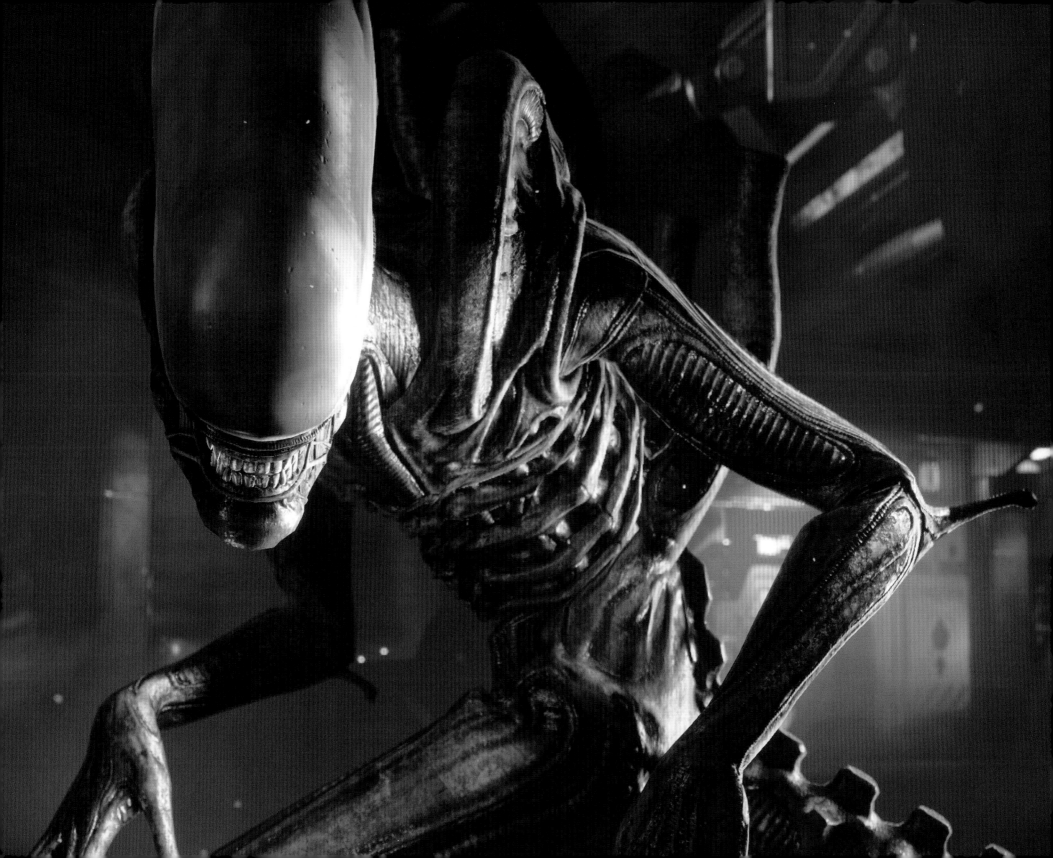

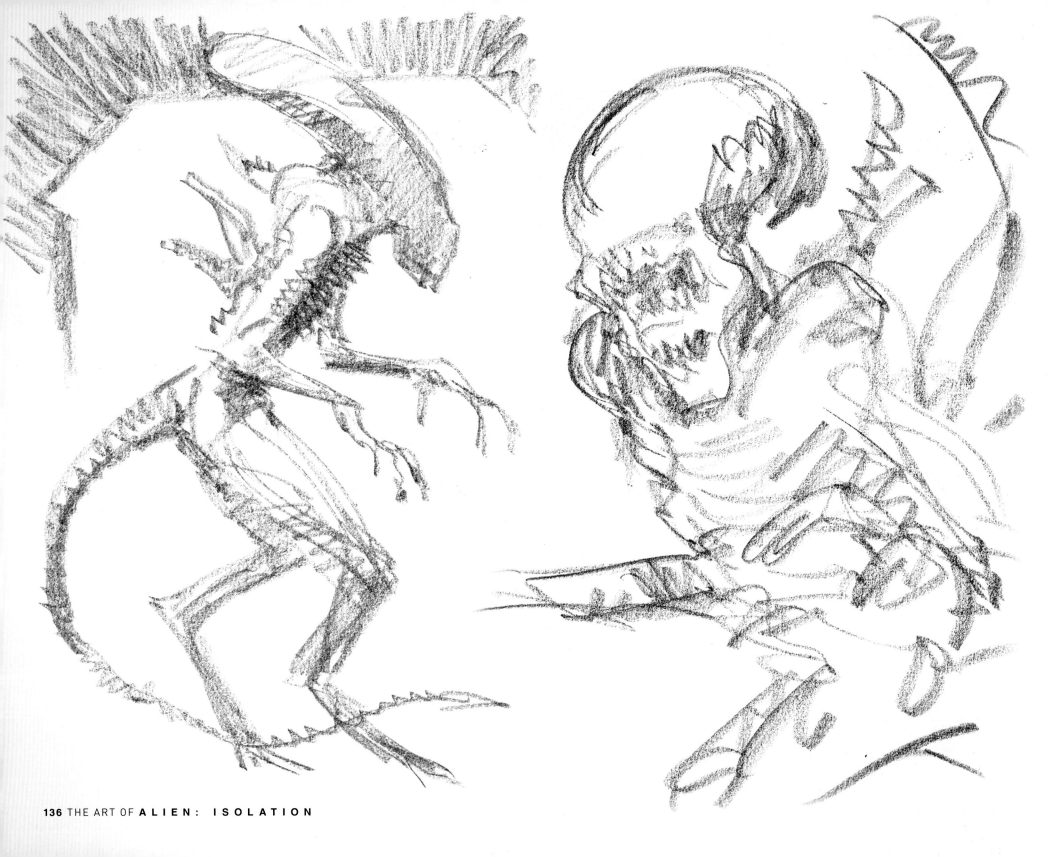

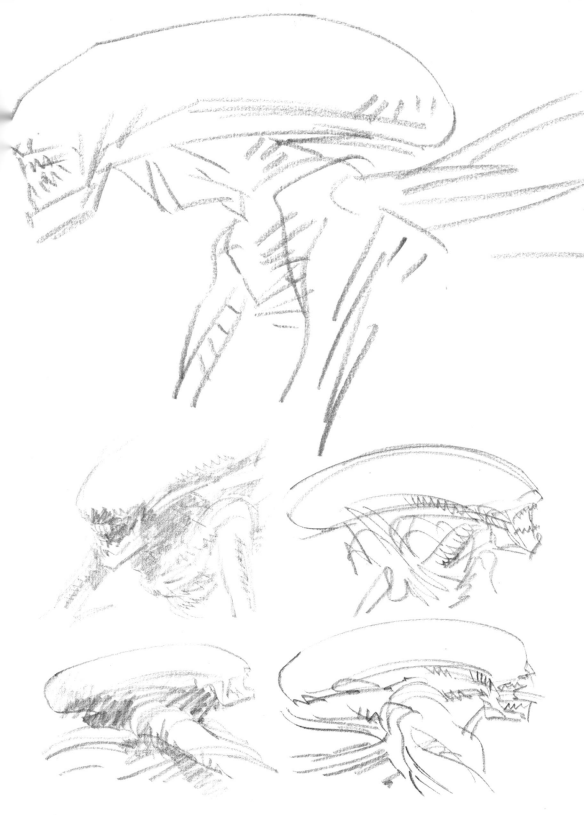

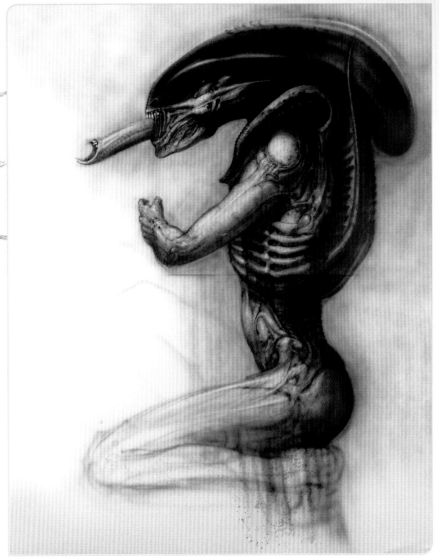

BRIEF ENCOUNTER

THE ROUGH PENCIL sketches to the *left* are the results of a tricky brief for Concept Artist Calum Watt, where he was required to imagine how a character within the game might draw the xenomorph, perhaps only having glimpsed the creature in a panicked effort to escape. "These illustrations are supposed to be by Mike Tanaka, a Japanese worker who documents his brief visit to the space station," he begins. "The challenge was to create images of the Alien that would have been drafted under duress, possibly with a mortal wound. I started out drawing digitally, as I do with all my work, but decided to swap to traditional pencil and paper to reflect that urgency. Creature design is usually out of my comfort zone, but it was an absolute joy to work from H.R. Giger's designs (*above*)."

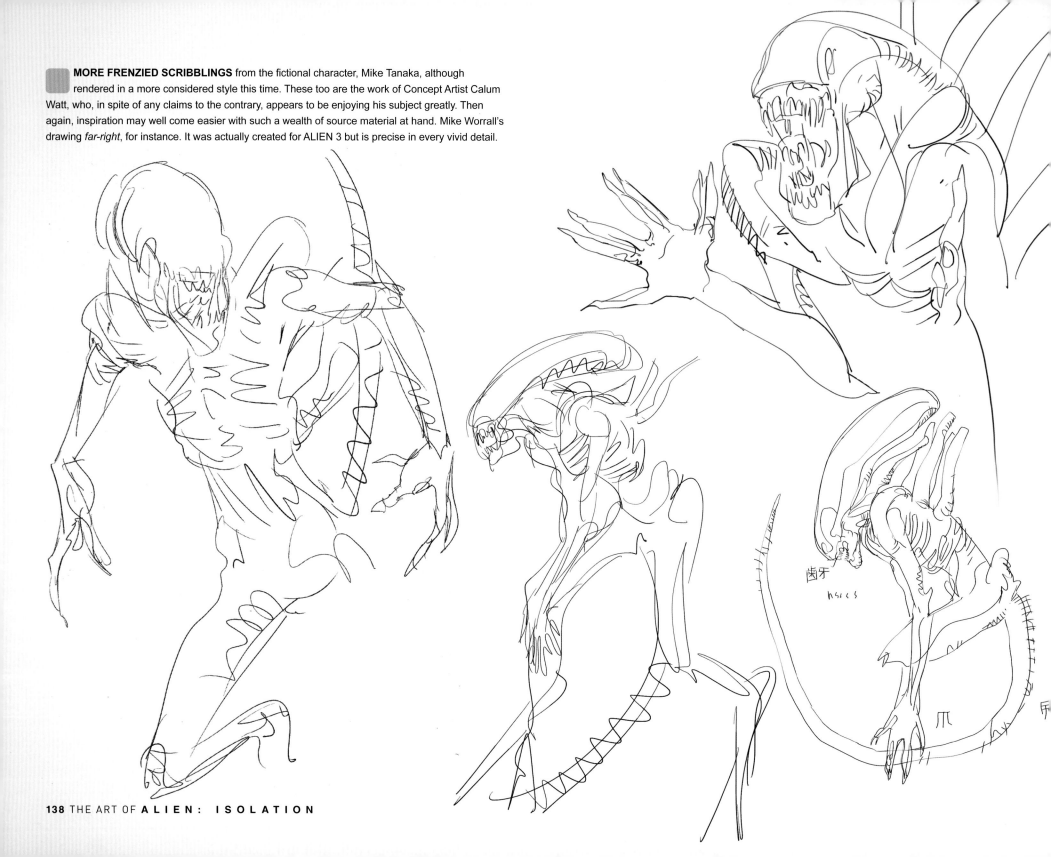

MORE FRENZIED SCRIBBLINGS from the fictional character, Mike Tanaka, although rendered in a more considered style this time. These too are the work of Concept Artist Calum Watt, who, in spite of any claims to the contrary, appears to be enjoying his subject greatly. Then again, inspiration may well come easier with such a wealth of source material at hand. Mike Worrall's drawing *far-right*, for instance. It was actually created for ALIEN 3 but is precise in every vivid detail.

歯牙

爪

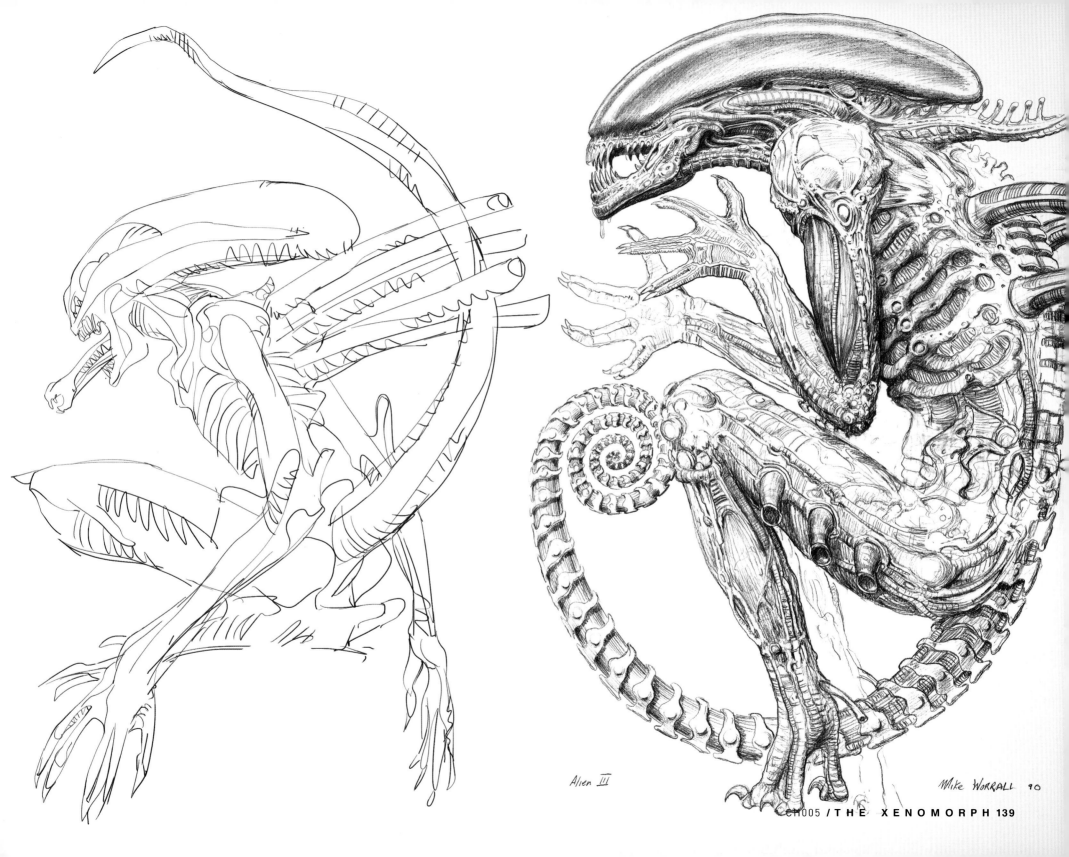

Alien III

Mike Worrall '90

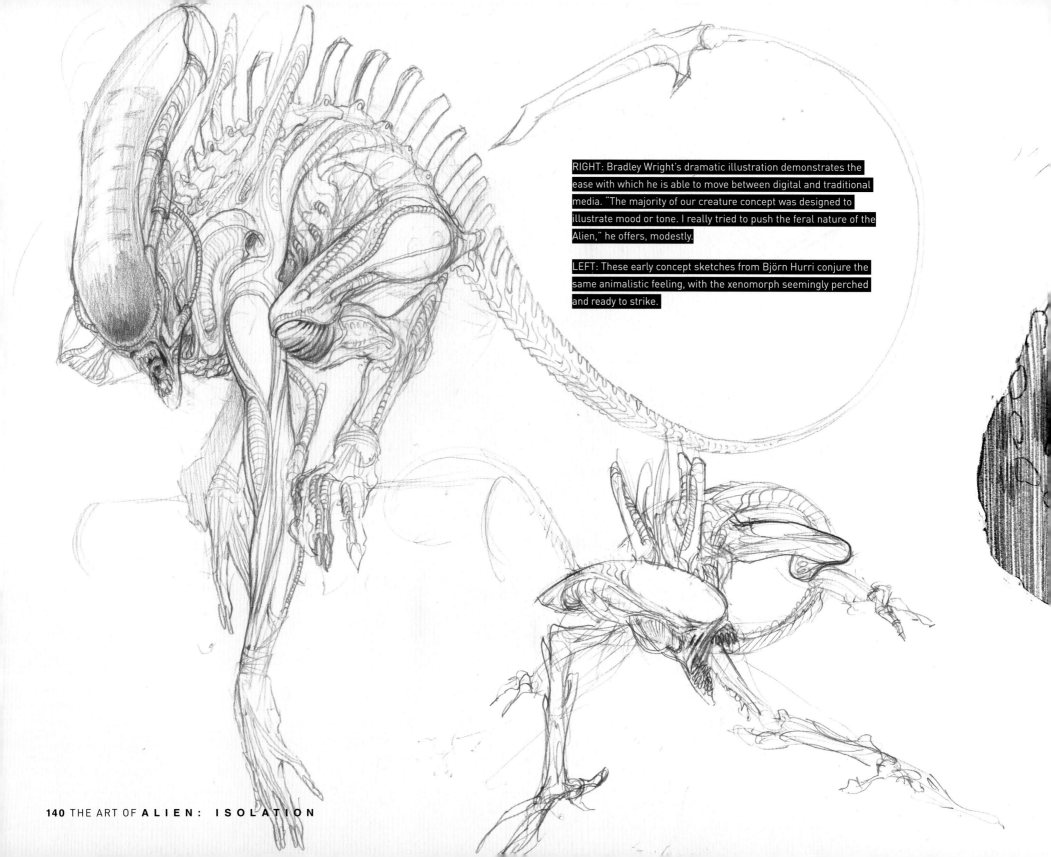

RIGHT: Bradley Wright's dramatic illustration demonstrates the ease with which he is able to move between digital and traditional media. "The majority of our creature concept was designed to illustrate mood or tone. I really tried to push the feral nature of the Alien," he offers, modestly.

LEFT: These early concept sketches from Björn Hurri conjure the same animalistic feeling, with the xenomorph seemingly perched and ready to strike.

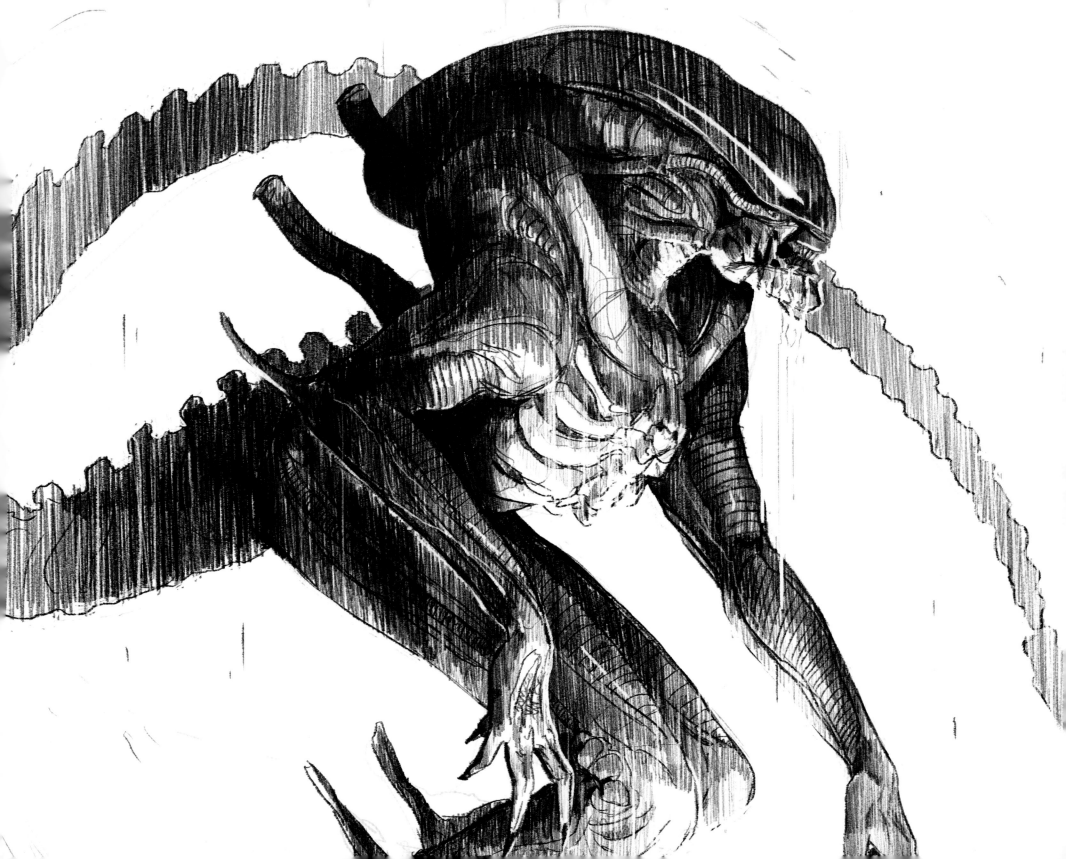

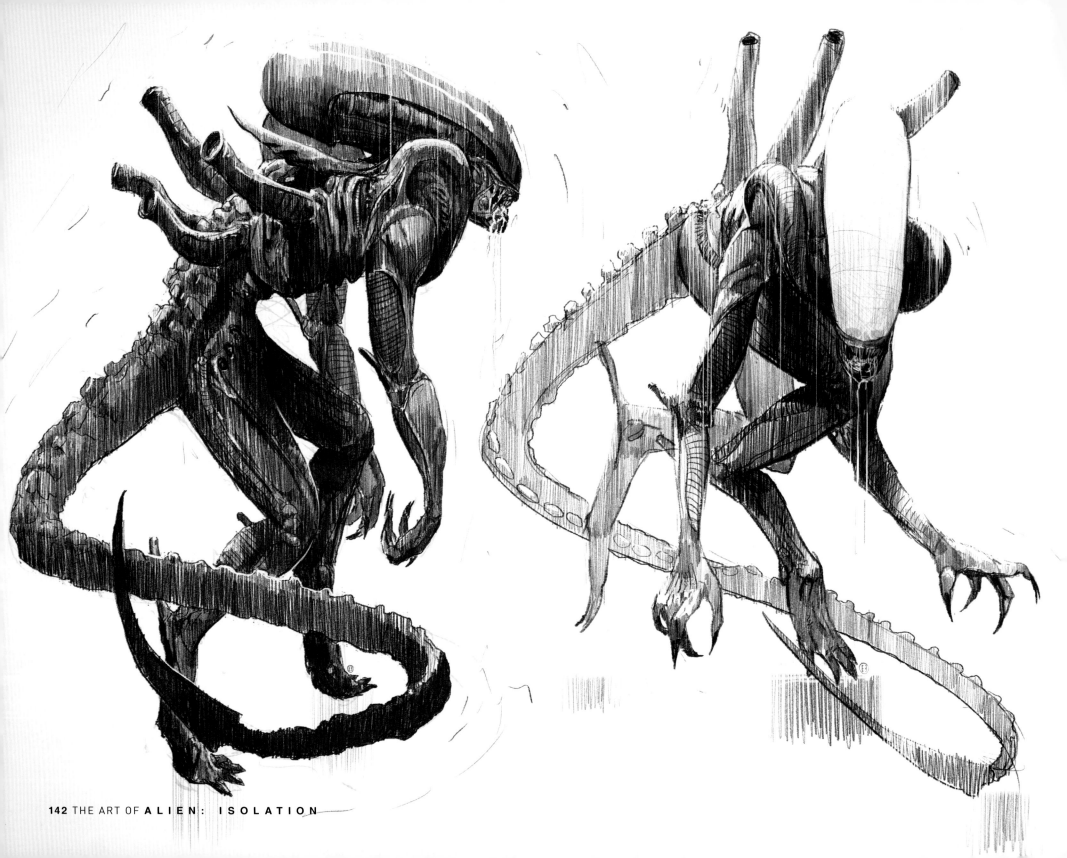

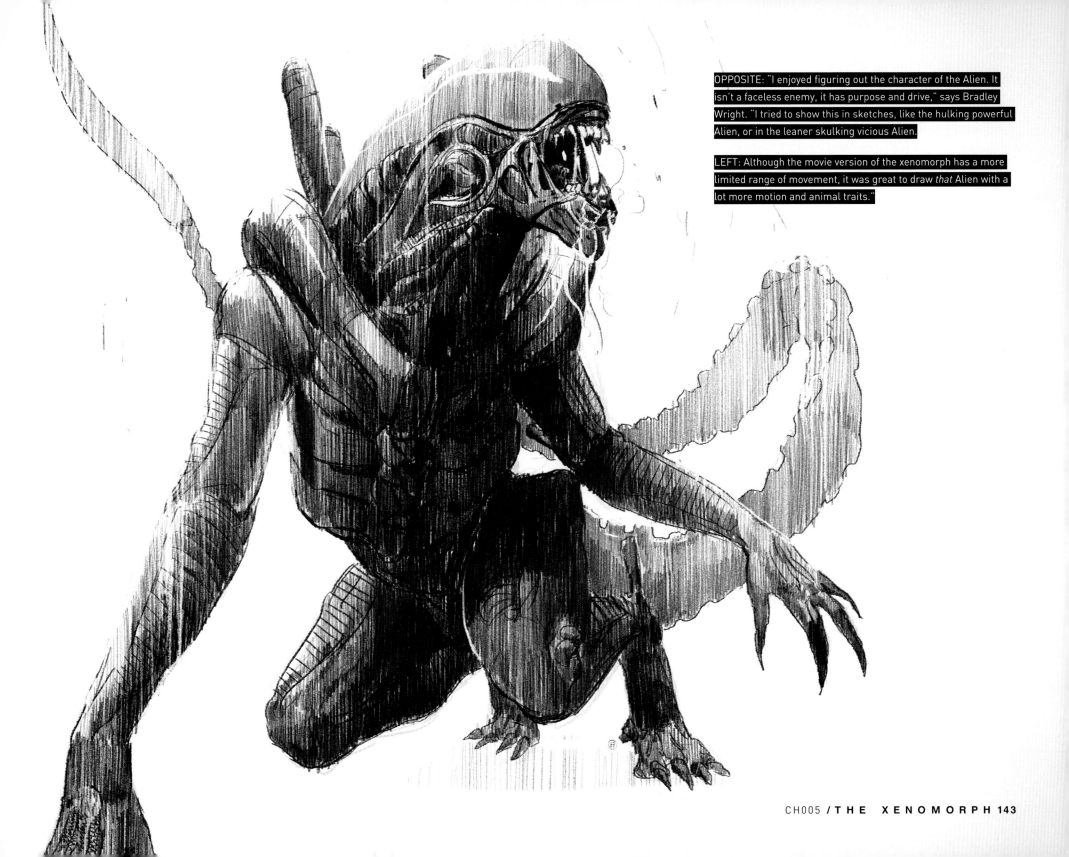

OPPOSITE: "I enjoyed figuring out the character of the Alien. It isn't a faceless enemy, it has purpose and drive," says Bradley Wright. "I tried to show this in sketches, like the hulking powerful Alien, or in the leaner skulking vicious Alien.

LEFT: Although the movie version of the xenomorph has a more limited range of movement, it was great to draw *that* Alien with a lot more motion and animal traits."

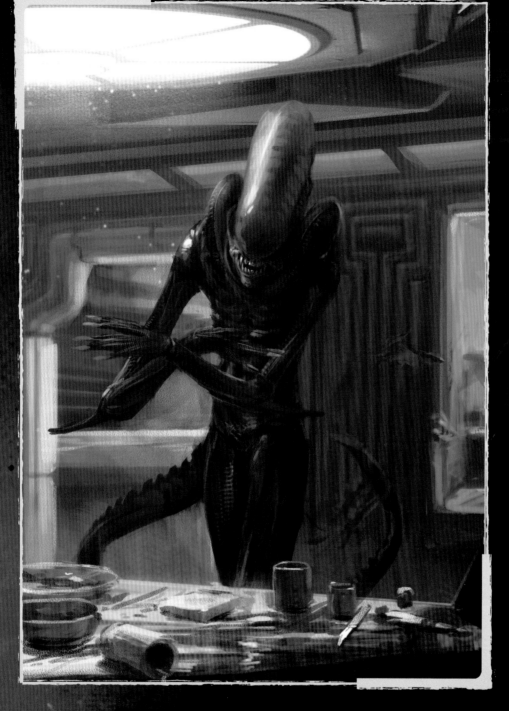

KNOW YOUR ENEMY

LEARNING THE WAY that the Alien moves, behaves and learns is the key to surviving encounters with a creature that is not only difficult to kill, but which also seems to become smarter as gameplay progresses. Creative Lead Alistair Hope explains further: "The Alien will react to its own interpretation of the world around it, so over the course of development we've been able to play with the sensitivity of how the creature responds to different events. Balancing is an important step in our development. We don't want the experience to be unrelentingly oppressive as it just wouldn't be fun, so *Alien: Isolation* is very much a game about tension and release. We want the player to have small moments where they can breathe again before heading into the unknown."

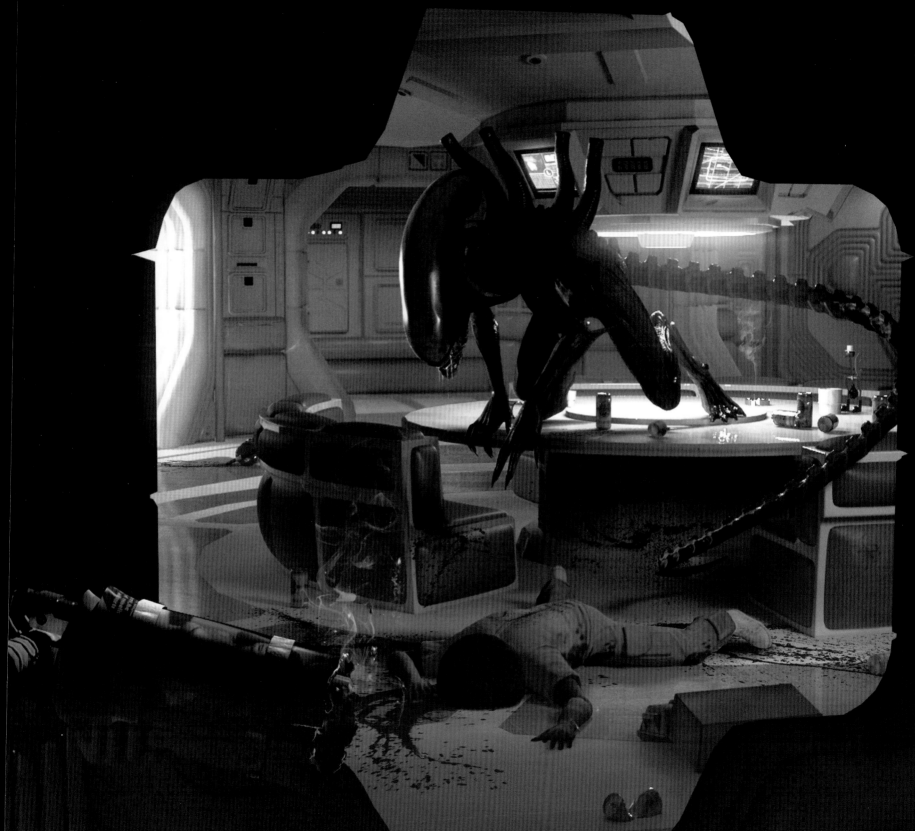

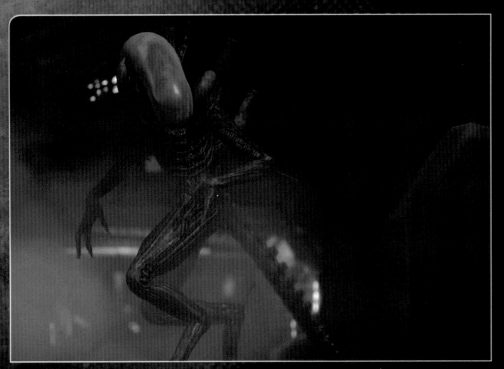

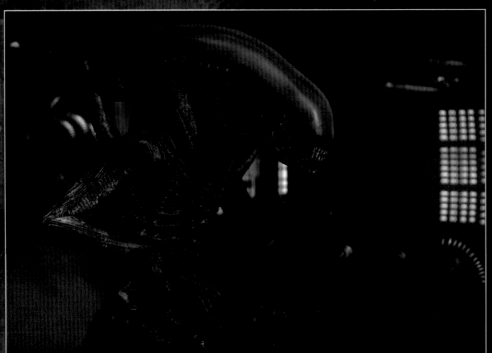
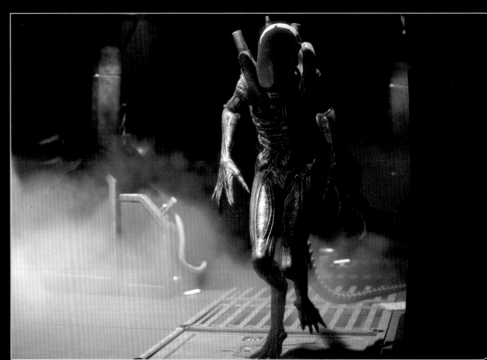

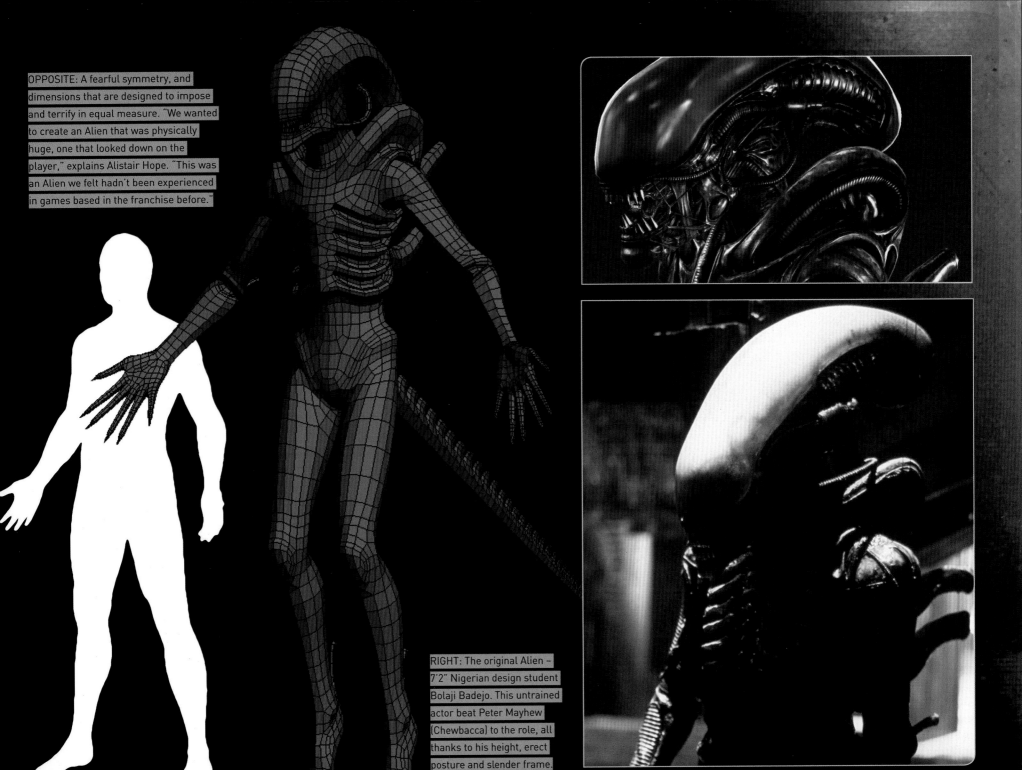

OPPOSITE: A fearful symmetry, and dimensions that are designed to impose and terrify in equal measure. "We wanted to create an Alien that was physically huge, one that looked down on the player," explains Alistair Hope. "This was an Alien we felt hadn't been experienced in games based in the franchise before."

RIGHT: The original Alien – 7'2" Nigerian design student Bolaji Badejo. This untrained actor beat Peter Mayhew (Chewbacca) to the role, all thanks to his height, erect posture and slender frame.

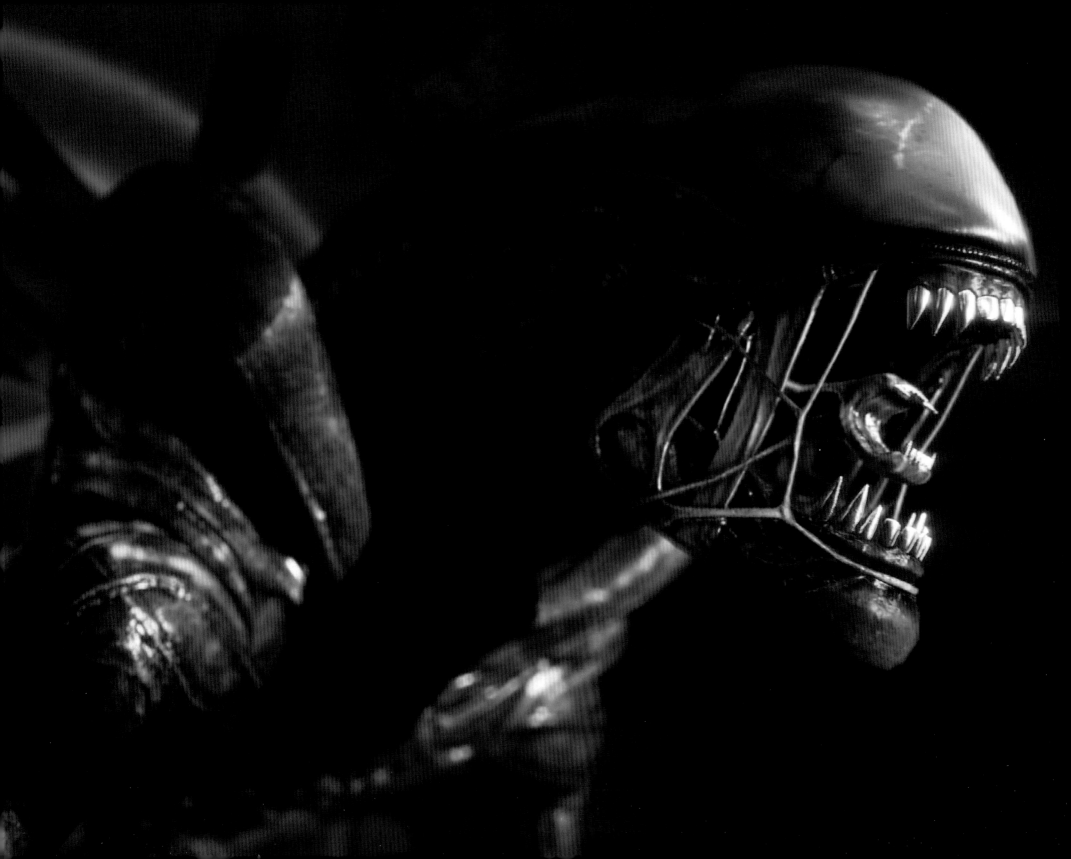

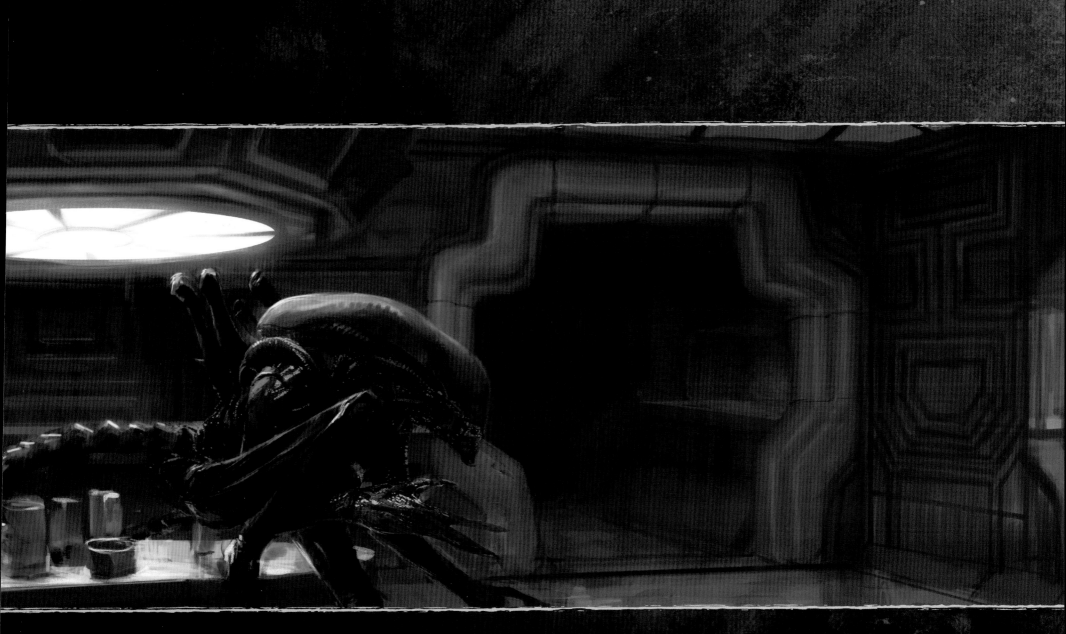

"**THE ALIEN CAN** hear, see light and movement and is aware of multiple targets at once," says Lead Designer Gary Napper. "It starts by exploring an area for any signs of movement or sounds but does not follow a prescribed path. At this point it isn't even searching for the player, just signs of any target. When it hears or sees something, it narrows its search to the area that it has detected something within. From then on it reacts to what it is seeing depending on the target and their actions. This of course is just its low level behavior and any more would spoil the magic!"

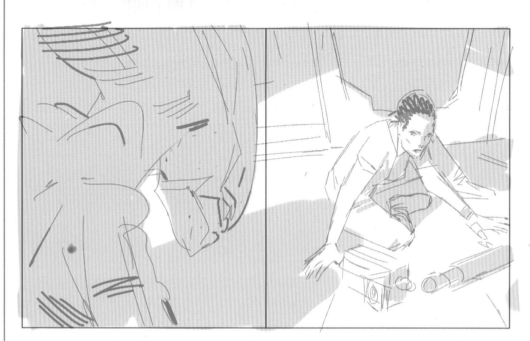
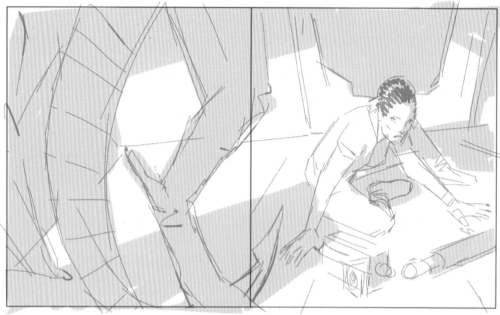

LOCKED AND LOADED

RARELY SEEN AND perhaps much less appreciated is the work that goes into the marketing and promotional materials for a game, which are often prepared well in advance in order that supply can satisfy the eventual demand. The images on these pages are not from gameplay storyboards, as they might appear, but are preliminary concept drawings for double page special features, pull-out sections and potential wrap-around magazine covers. "The interesting thing here was looking at the same composition twice – the page on the right had to work in isolation, but also as a whole piece once it was opened out," says Jude Bond.

"In these line drawings we're trying to communicate as much of the authentic ALIEN atmosphere as we could – for example, the door shape is prominent in all of them," says Jude Bond. "A lot of the images are playing on the same idea too, with the presence of the creature being hinted at rather than explicitly depicted."

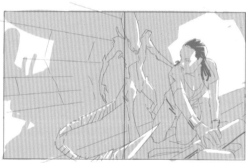
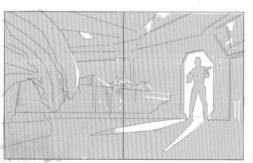
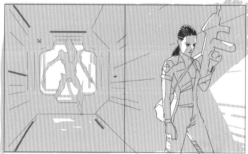

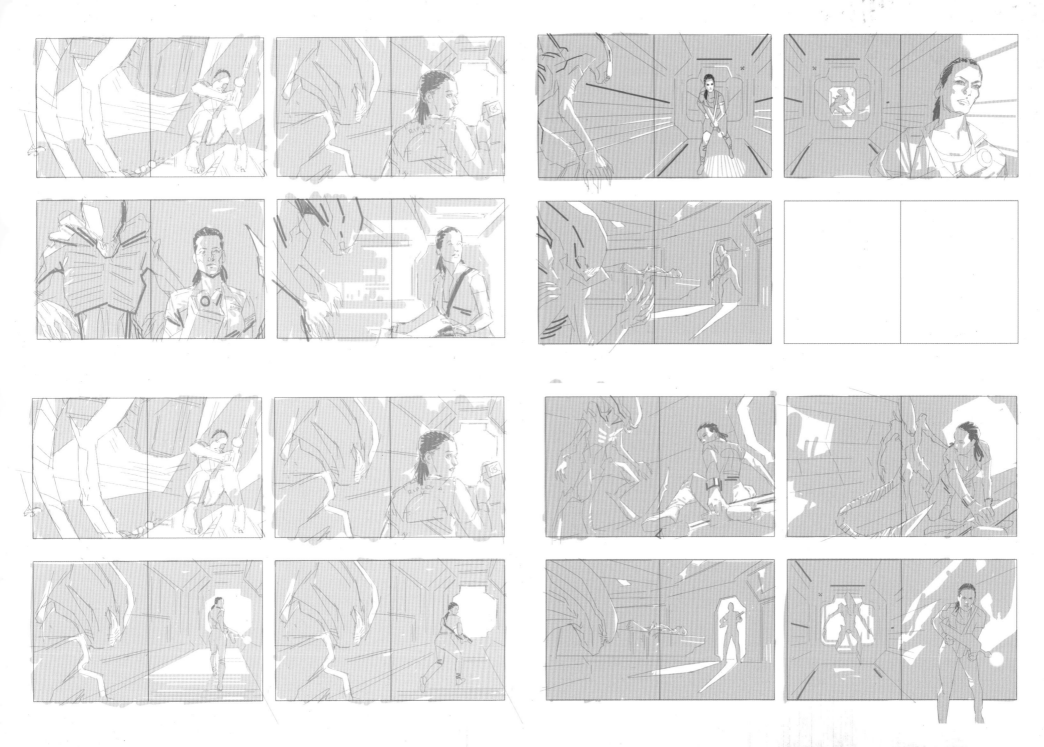

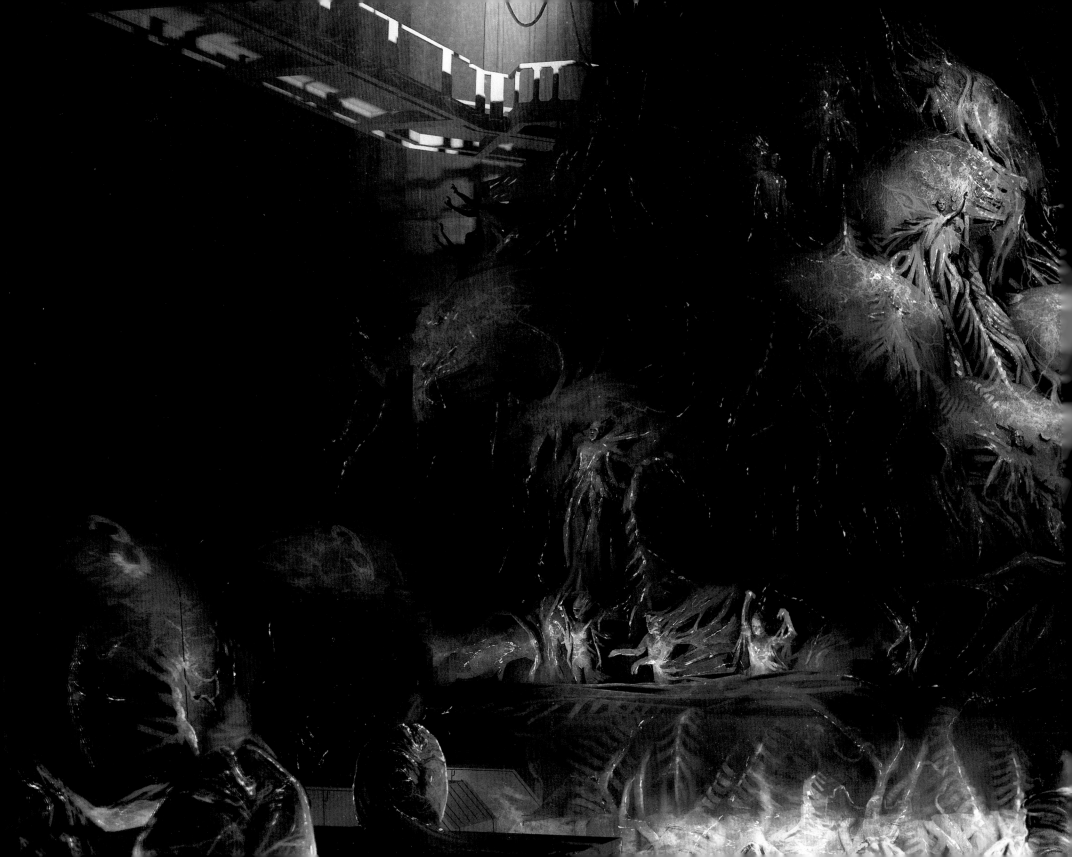

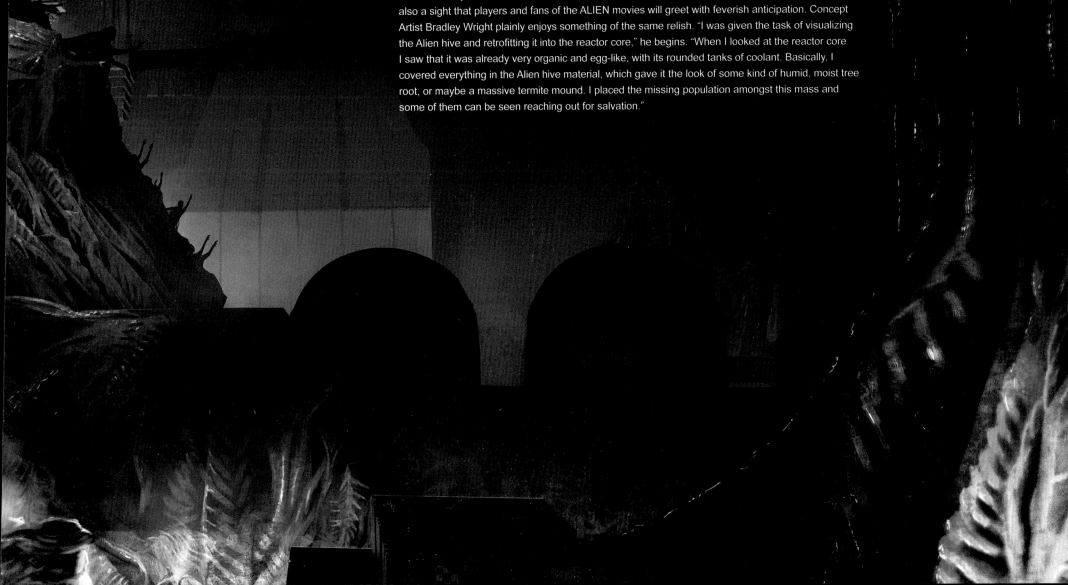

also a sight that players and fans of the ALIEN movies will greet with feverish anticipation. Concept Artist Bradley Wright plainly enjoys something of the same relish. "I was given the task of visualizing the Alien hive and retrofitting it into the reactor core," he begins. "When I looked at the reactor core I saw that it was already very organic and egg-like, with its rounded tanks of coolant. Basically, I covered everything in the Alien hive material, which gave it the look of some kind of humid, moist tree root, or maybe a massive termite mound. I placed the missing population amongst this mass and some of them can be seen reaching out for salvation."

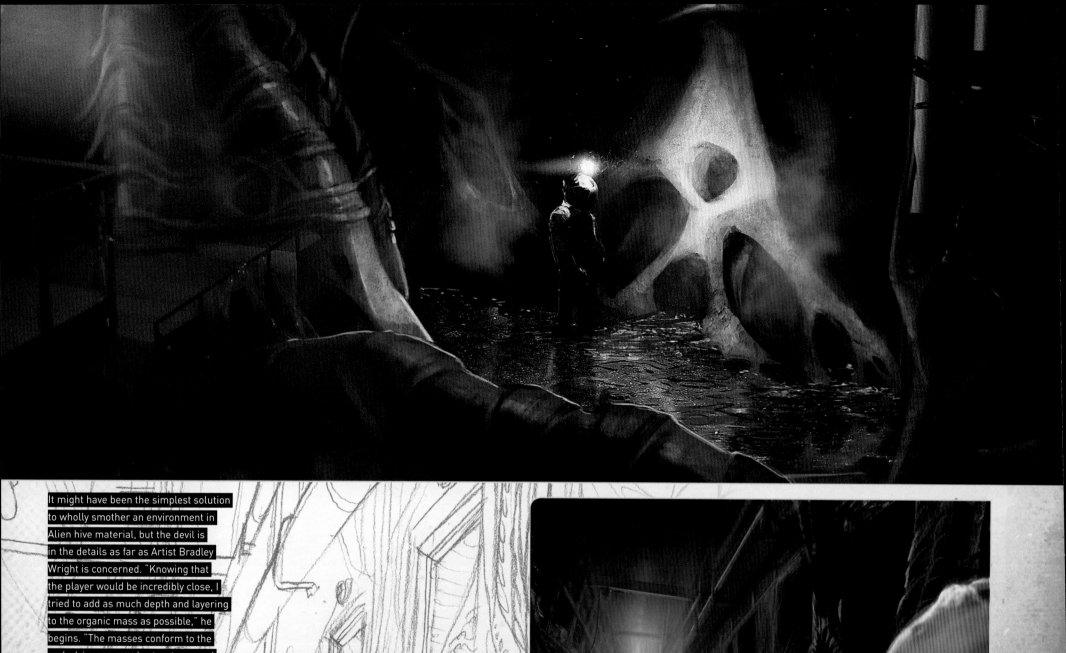

It might have been the simplest solution to wholly smother an environment in Alien hive material, but the devil is in the details as far as Artist Bradley Wright is concerned. "Knowing that the player would be incredibly close, I tried to add as much depth and layering to the organic mass as possible," he begins. "The masses conform to the underlying manmade structures and also have their own growth patterns, so I looked at how this would spiral and contort itself around those structures. I was really aiming to add as much contrast between the two materials."

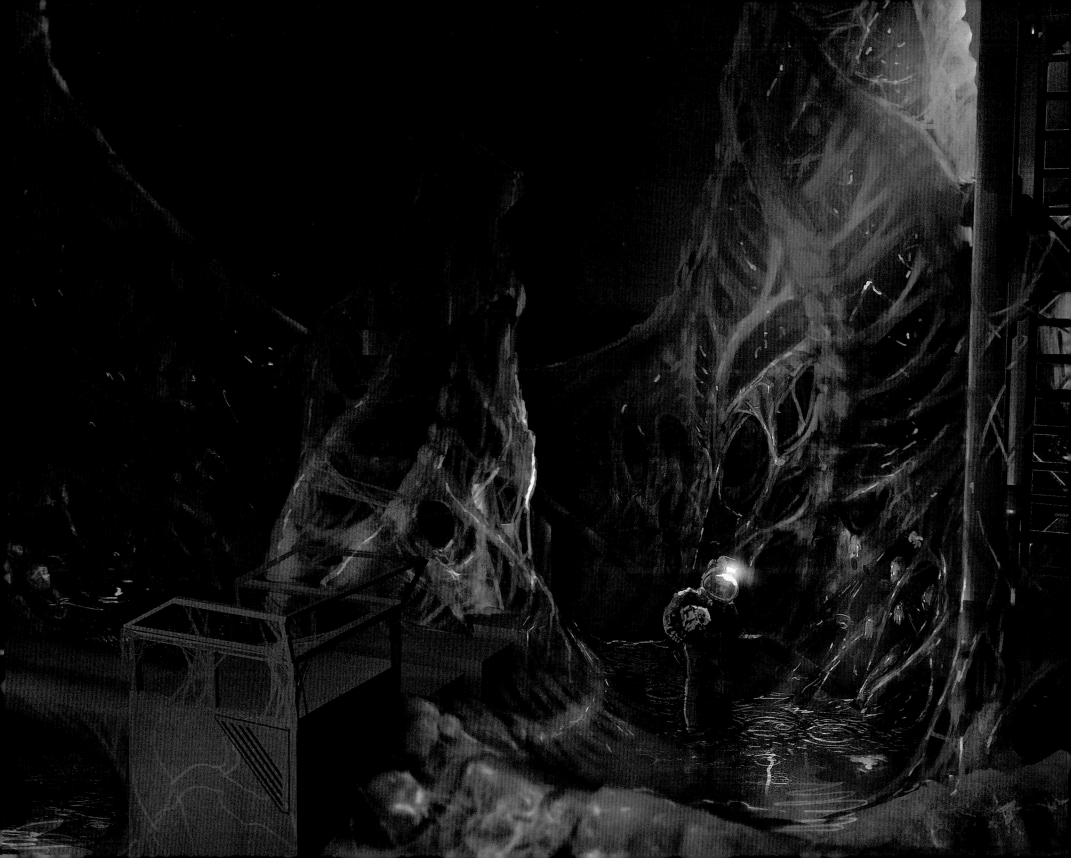

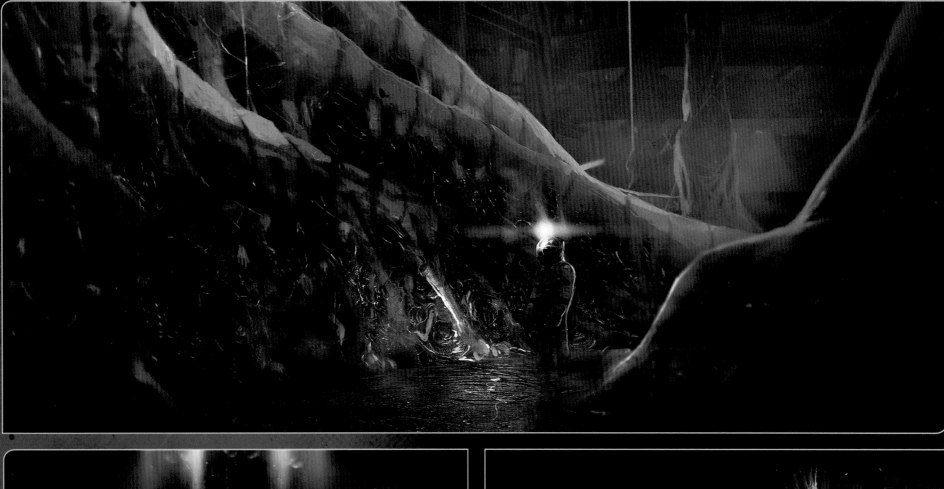
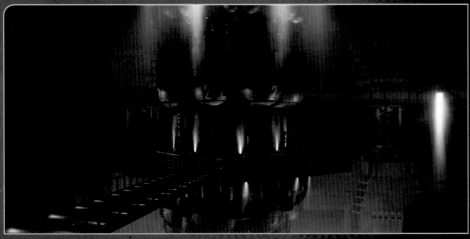
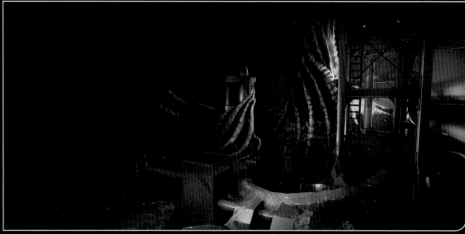

Corporeal inspirations abound in the darkest corners of Sevastopol Station, although not always as nature intended, as Bradley Wright explains. "A great deal of iteration was done in this early design of the hive. Such ideas as spaghetti-like veins and large rainforest tree roots were all looked at. People would be found within the organic structure, so this was explored too. This is much more along the lines of a horrific mass grave, which the player would only discover when close enough."

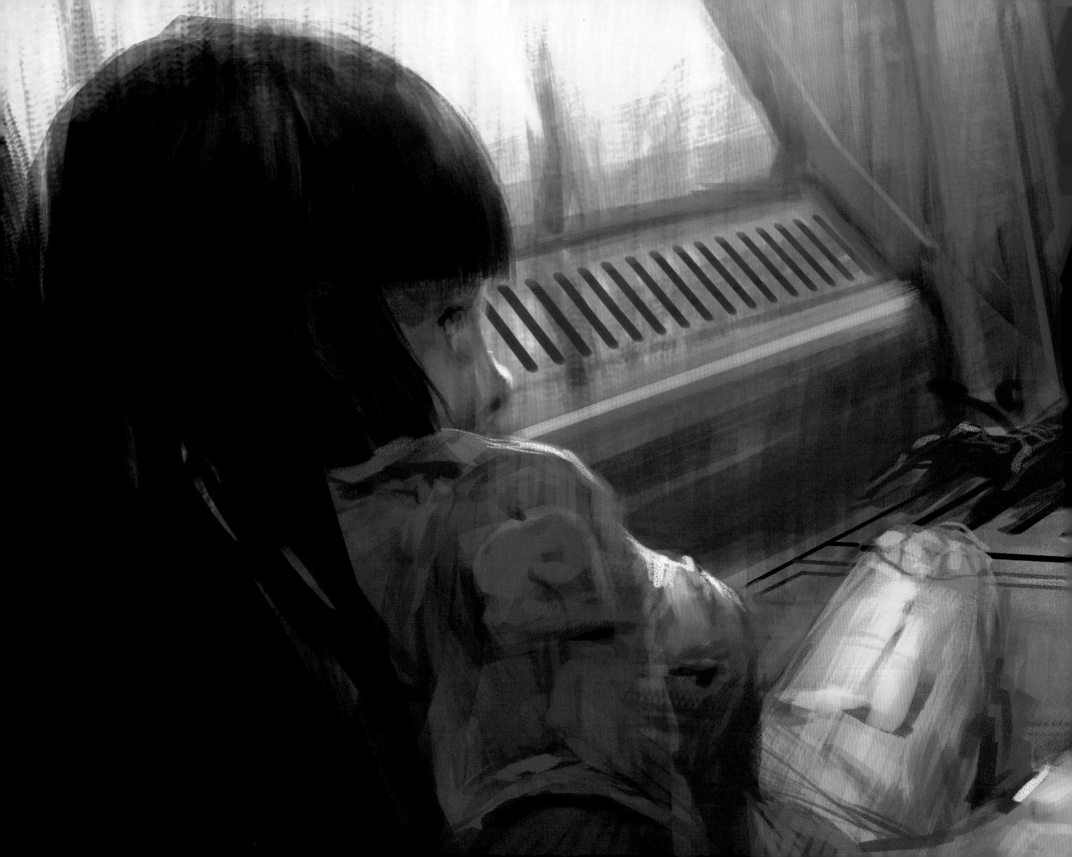

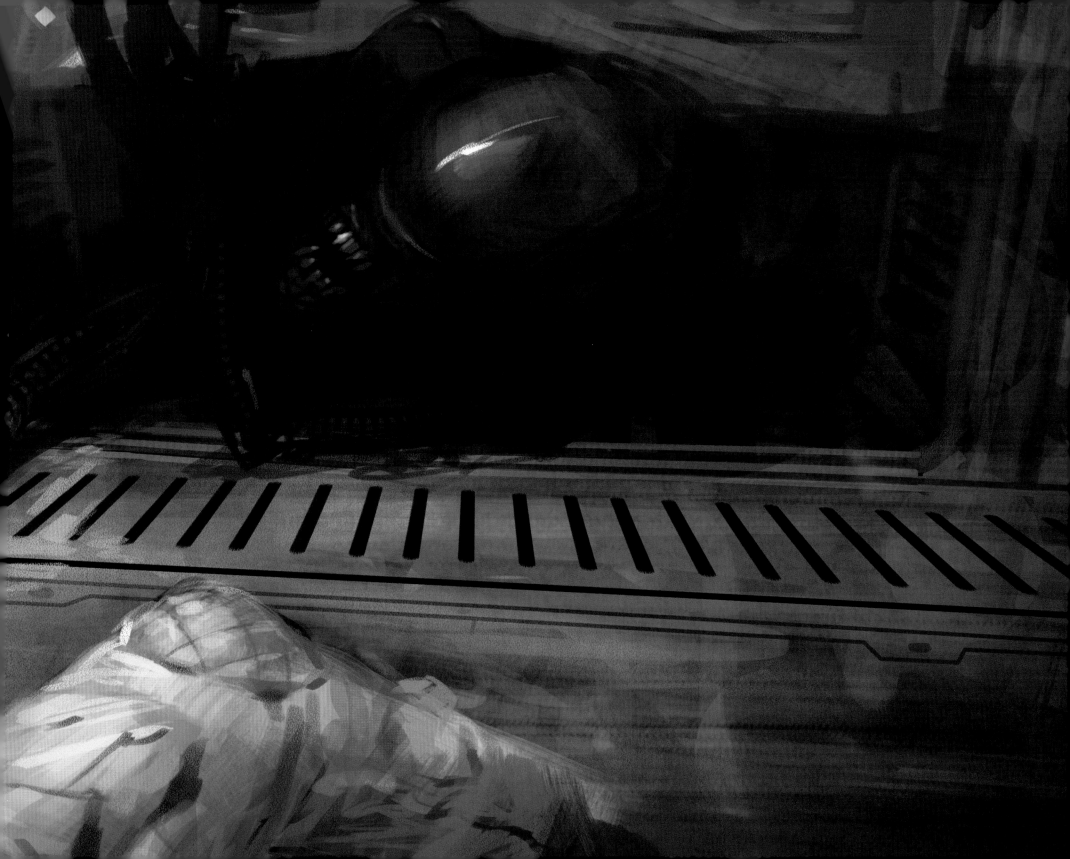

CH006 / STORYBOARDS

// "Ripley. I am awaiting
your signal. Do you read?
Do you read? I repeat,
Ripley, can you hear me?" //
Captain of the Torrens, Diane Verlaine

HAND-DRAWN AND QUICKLY rendered storyboards might be construed as an affectionate tribute to the traditional methods used on the original ALIEN movie. However, they remain a vital component of the development process and are still the quickest way to convey gameplay concepts prior to the prolonged and considerably more expensive undertaking of constructing them for real. The pages that follow tell their own story for the most part, while some are only meant to serve as an inspiration for the game's artists and animators. These are the first indicators of Creative Assembly's original intent – their mission to discover what it would be like to face the creature of Ridley Scott's iconic film and to create the definitive survival horror game based on what is certainly the *definitive* survival horror movie. Here's a final glimpse at that vision before you experience it for yourselves...

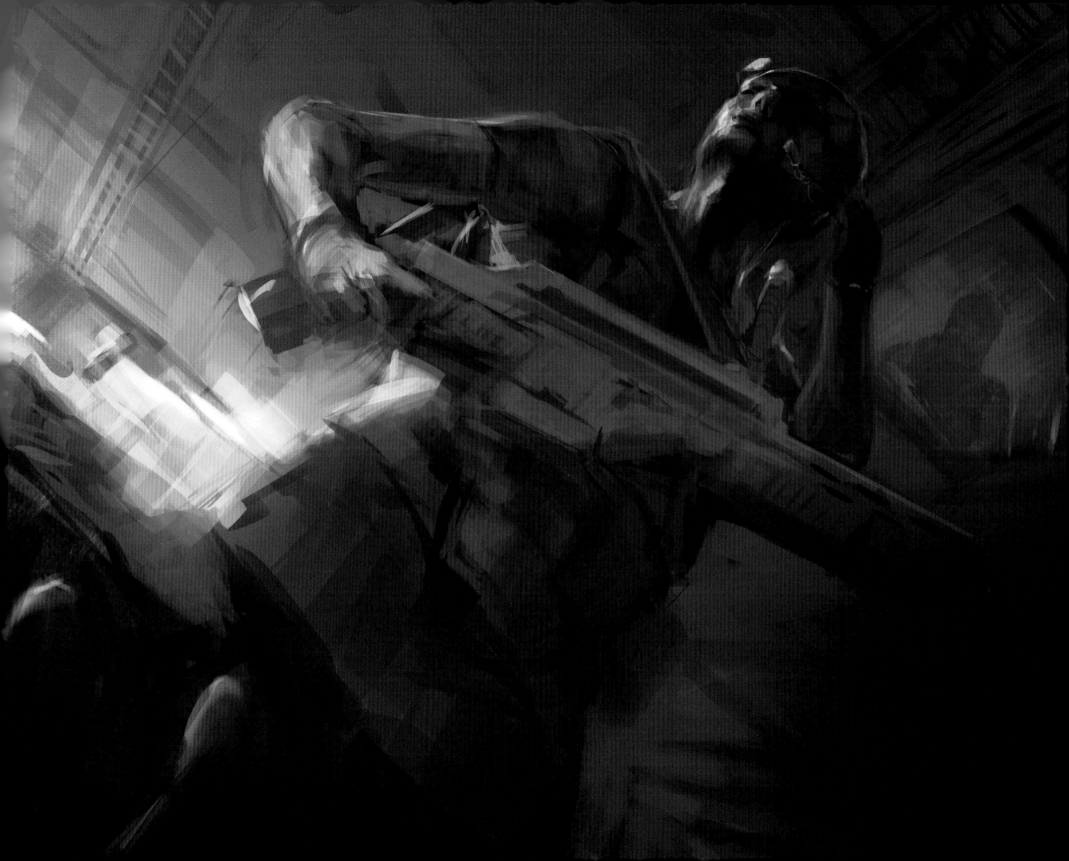

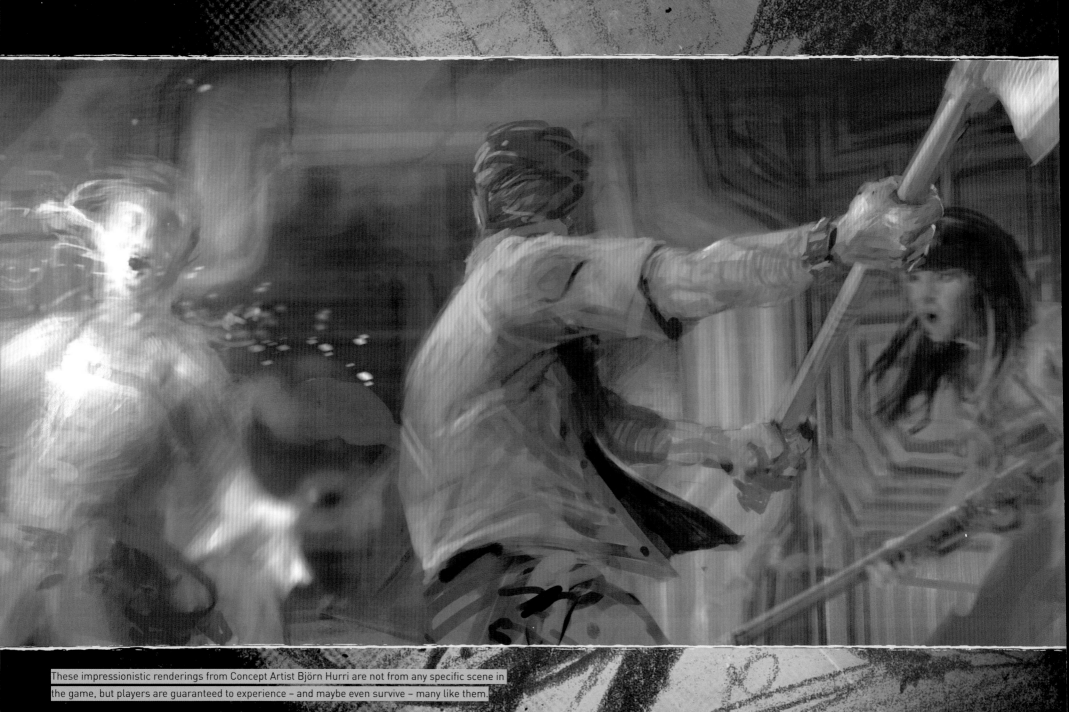

These impressionistic renderings from Concept Artist Björn Hurri are not from any specific scene in the game, but players are guaranteed to experience – and maybe even survive – many like them.

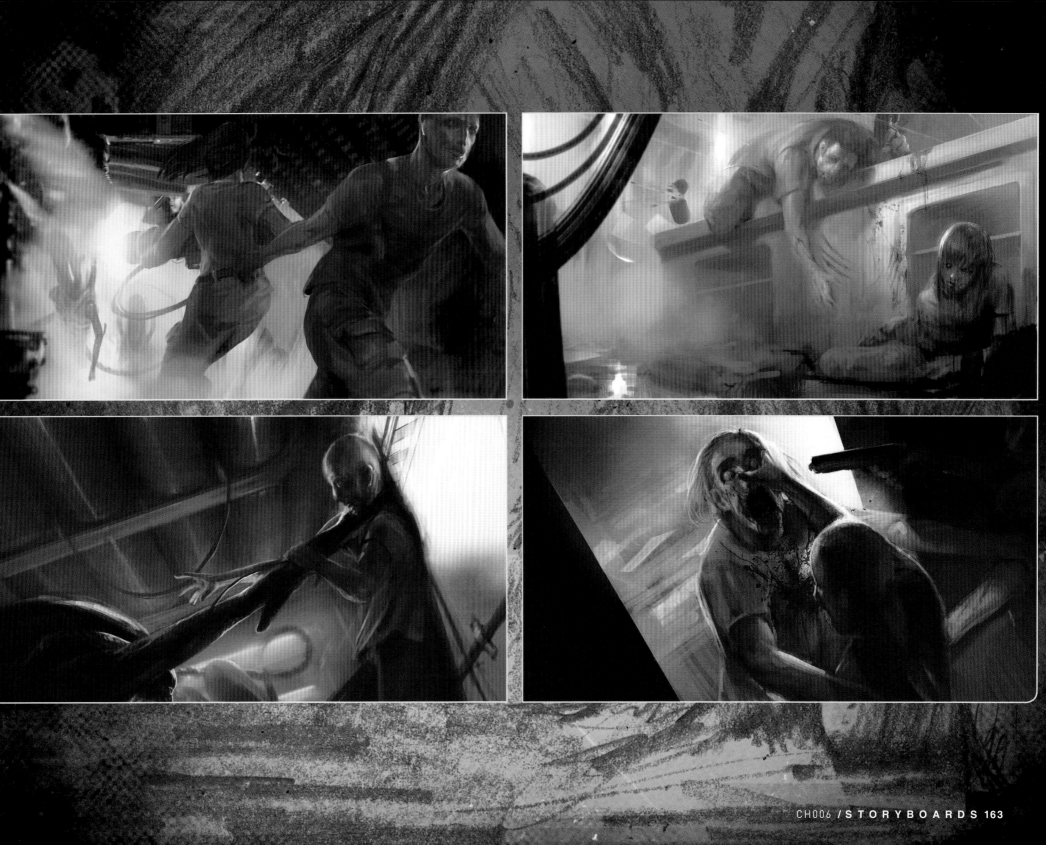

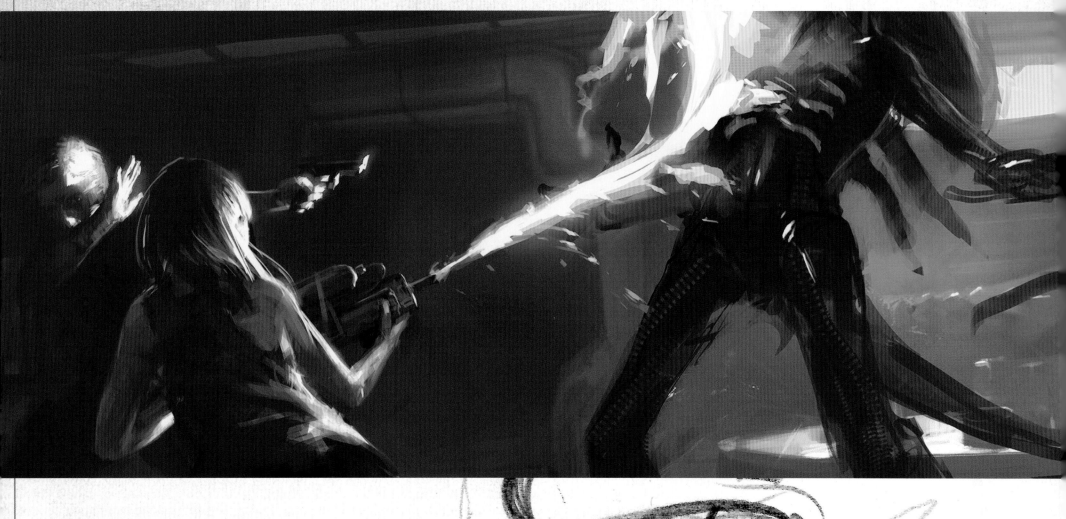

THE HEAT IS ON

"THESE PENCIL SKETCHES are from a very early concept for a scene in which Amanda finds herself caught in a vent, unaware that the Alien is heading her way. She escapes through an exit and runs off to hide, swiftly followed by the Alien," says Senior Animator Ben Potts. "Although the scene is simple to explain, sketching it out revealed various animation and camera issues. Timing became a key issue to convey the feeling of utter panic. I think I even created a timed 'animatic' (a simplified animation built on a series of still images) using these drawings, just to suggest the pacing of the scene. However, it was cut from the game in the end, due to a level mission change."

Björn Hurri's dramatic sketch *above*, meanwhile, needs little in the way of explanation.

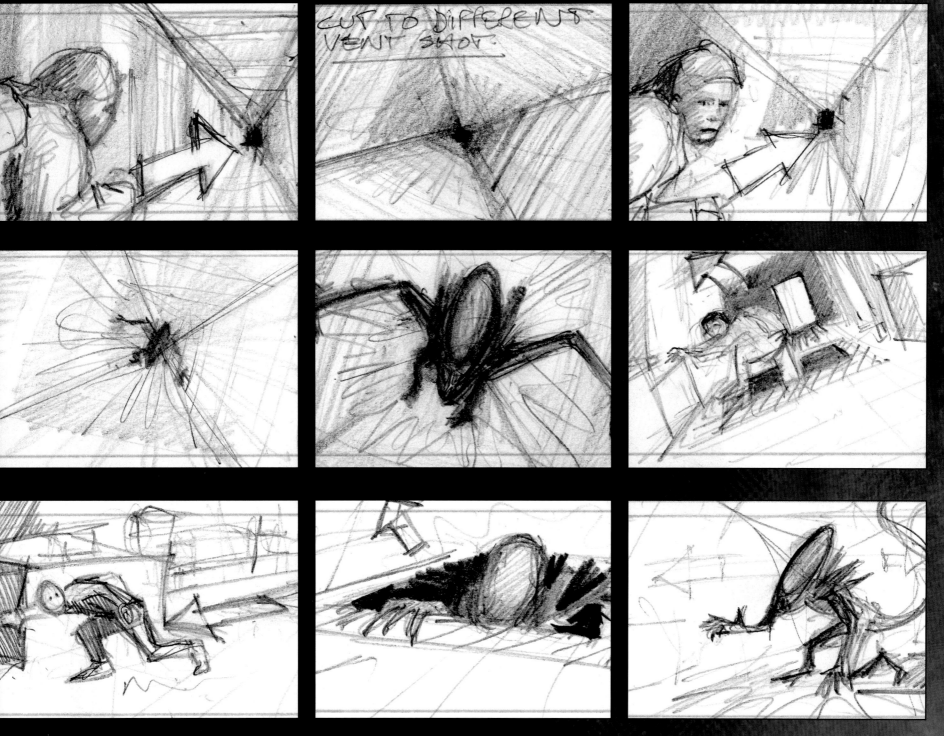

CUT TO DIFFERENT
VENT SHOT:

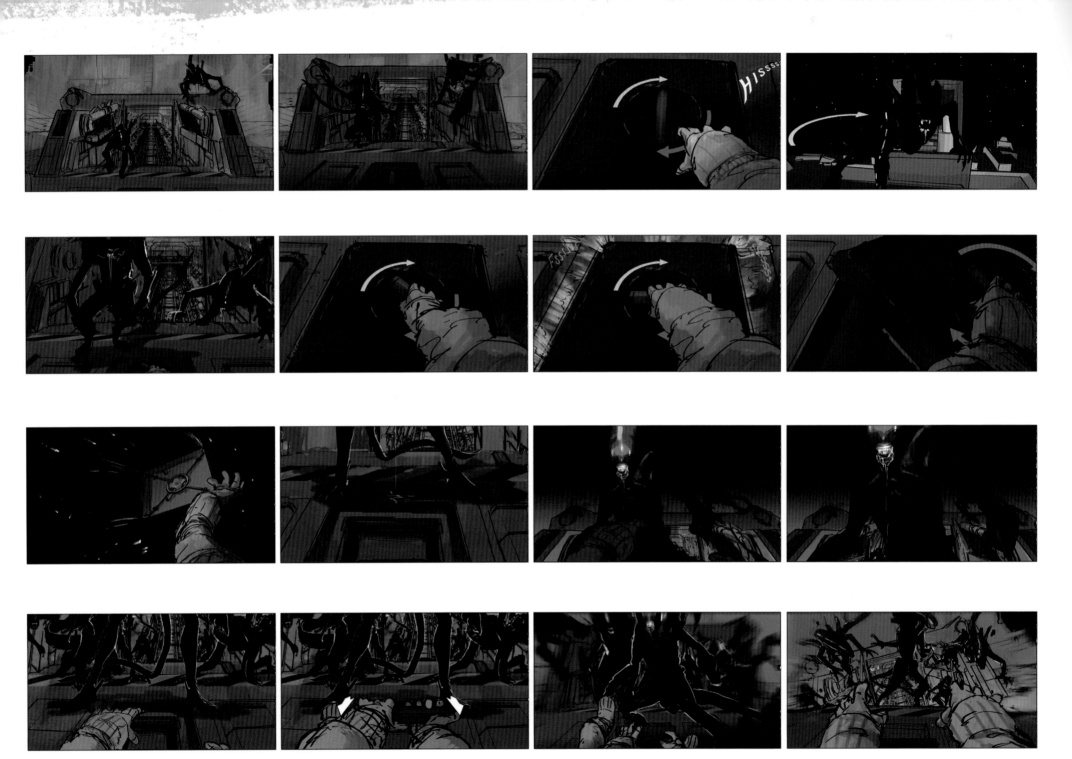

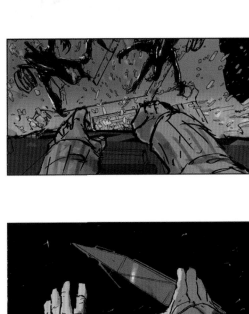
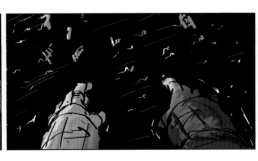
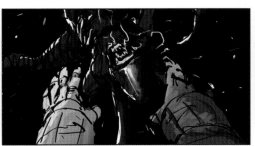
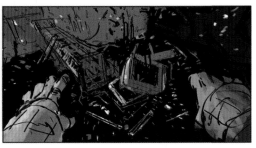
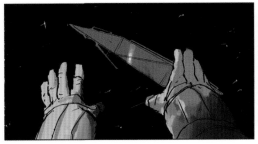
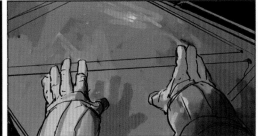
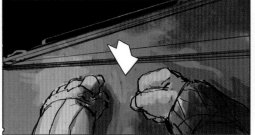
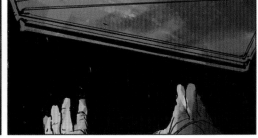

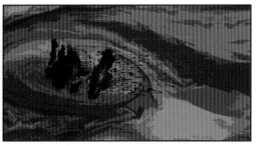

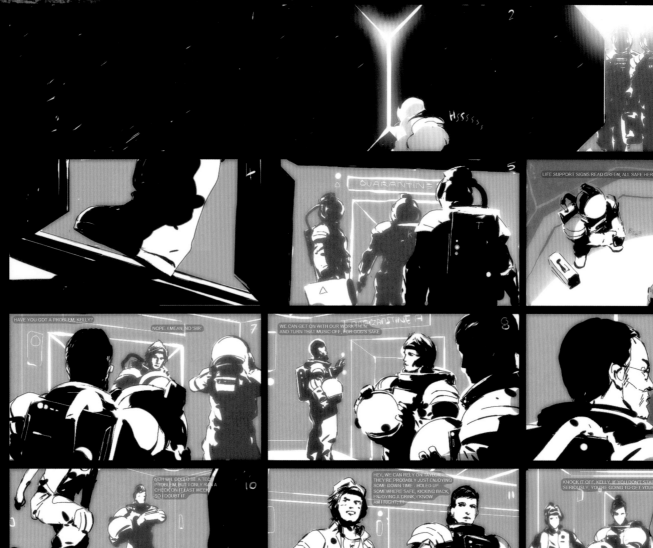

Storyboards are often produced as roughly sketched scenarios by and for the game's animators, or more detailed sequences used for pitching and storytelling purposes. Calum Watt's drawings to the *right* and *opposite* describe the opening and closing scenes of a very early gameplay demo. All were later turned into an animated storyboard as part of the original pitch to SEGA, although the characters seen here were later cut from the game.

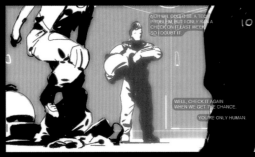
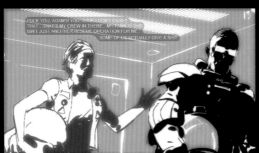
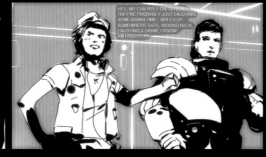
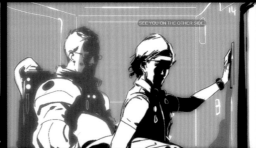
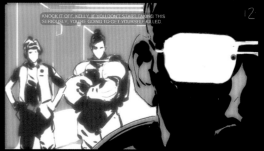
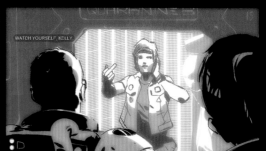

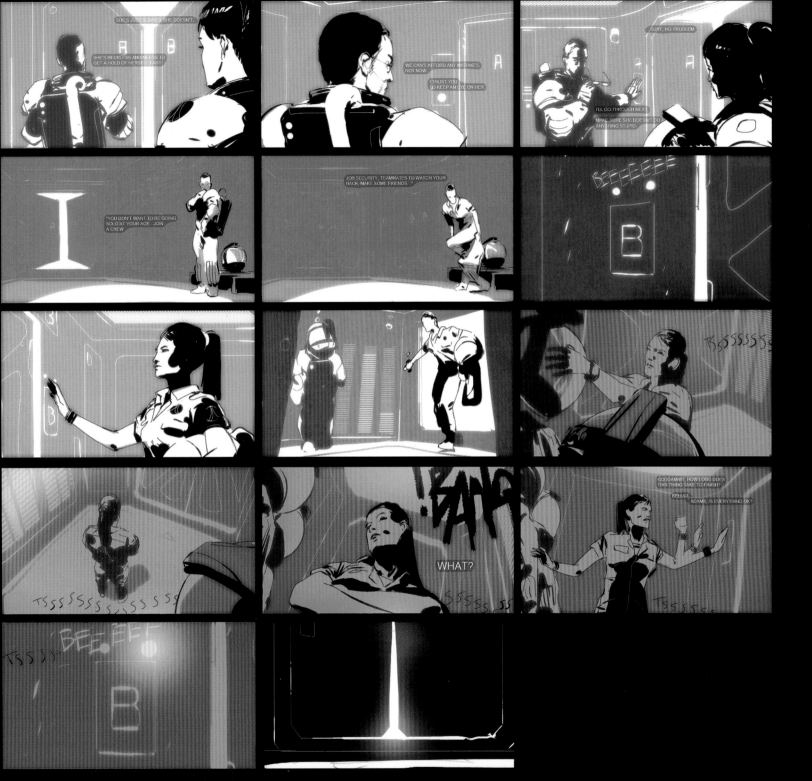

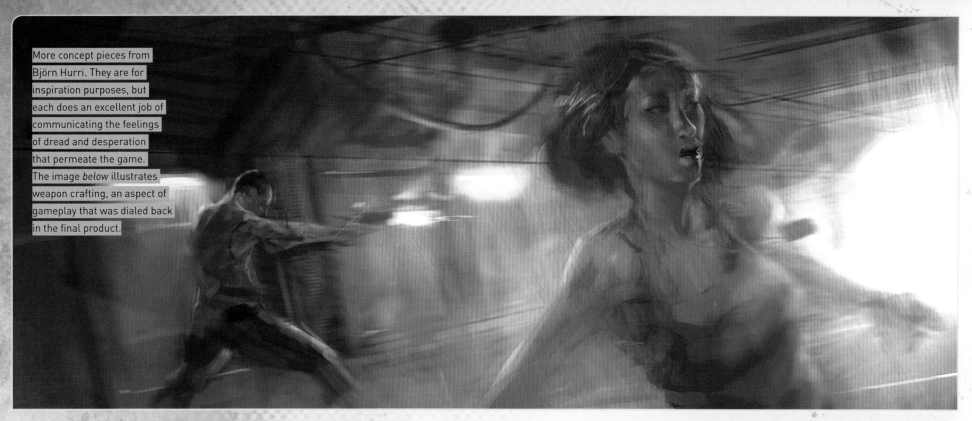

More concept pieces from Björn Hurri. They are for inspiration purposes, but each does an excellent job of communicating the feelings of dread and desperation that permeate the game. The image *below* illustrates weapon crafting, an aspect of gameplay that was dialed back in the final product.

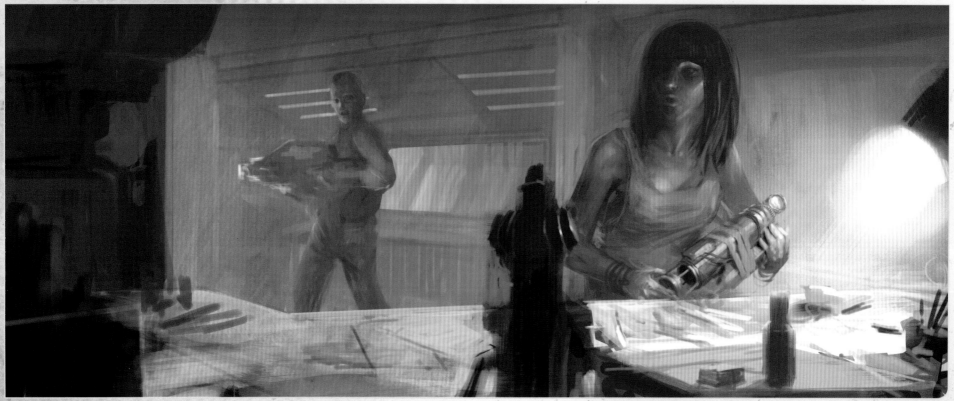

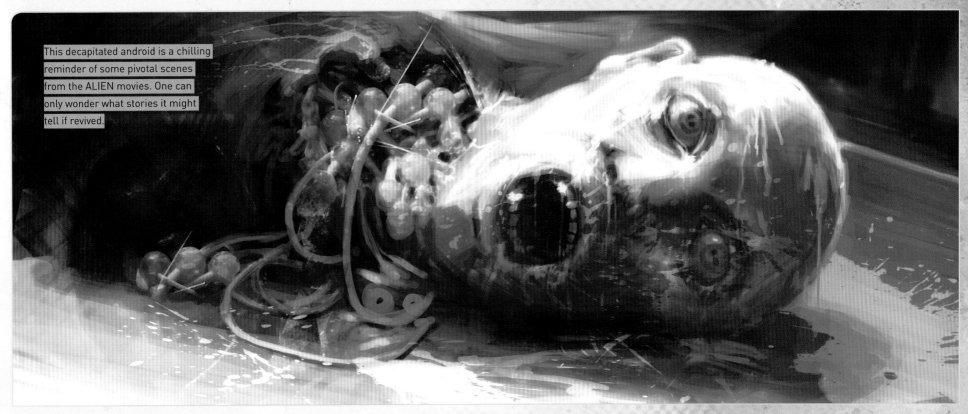

This decapitated android is a chilling reminder of some pivotal scenes from the ALIEN movies. One can only wonder what stories it might tell if revived.

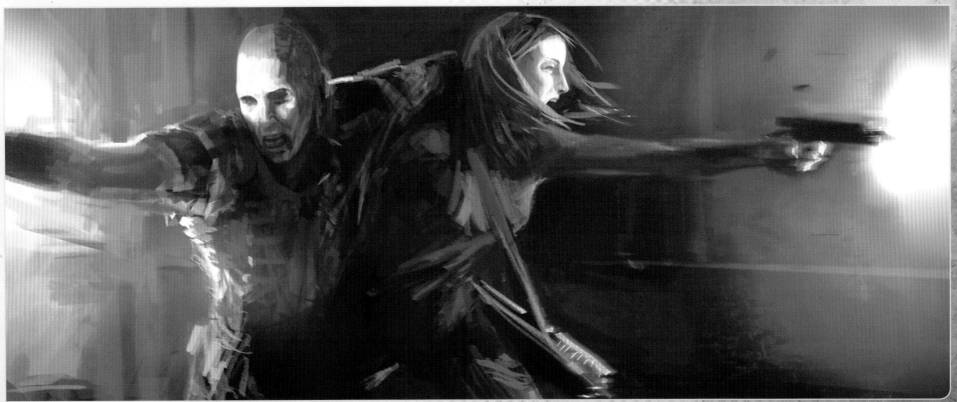

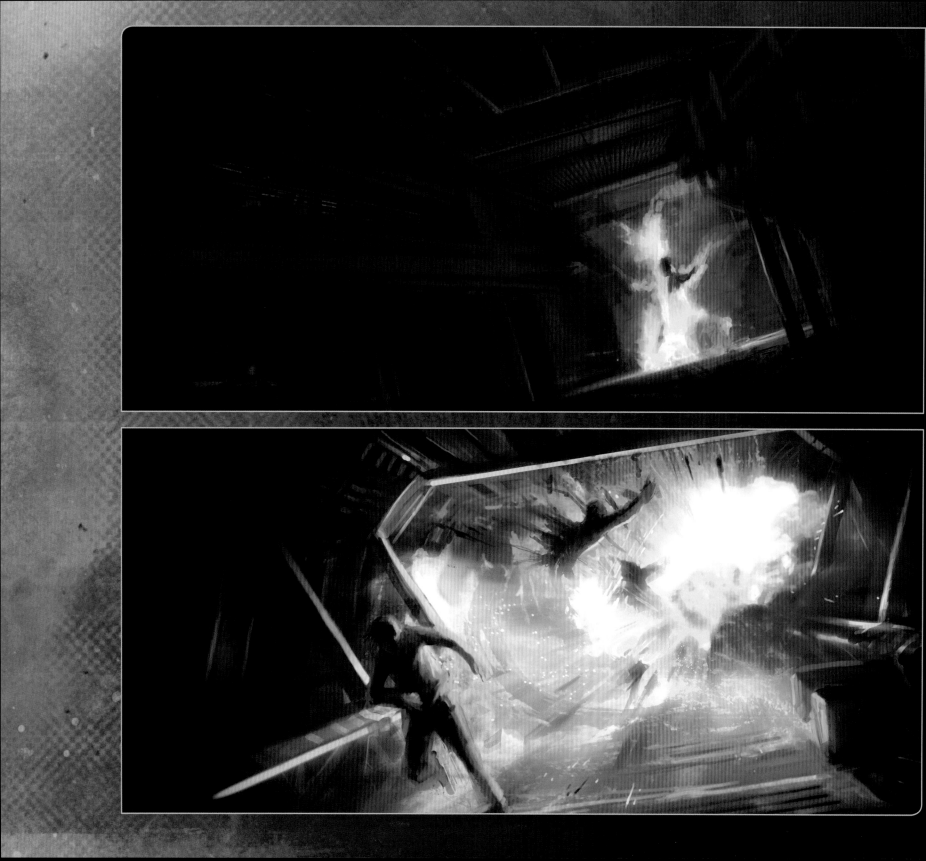

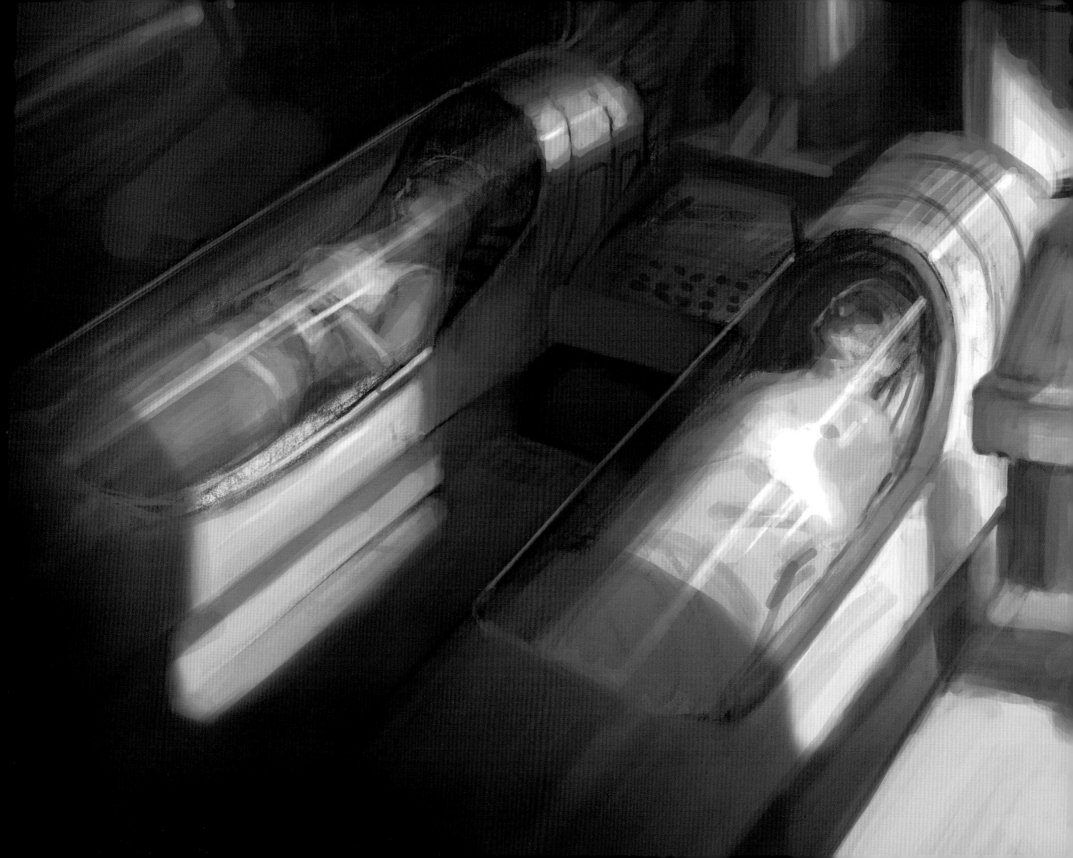

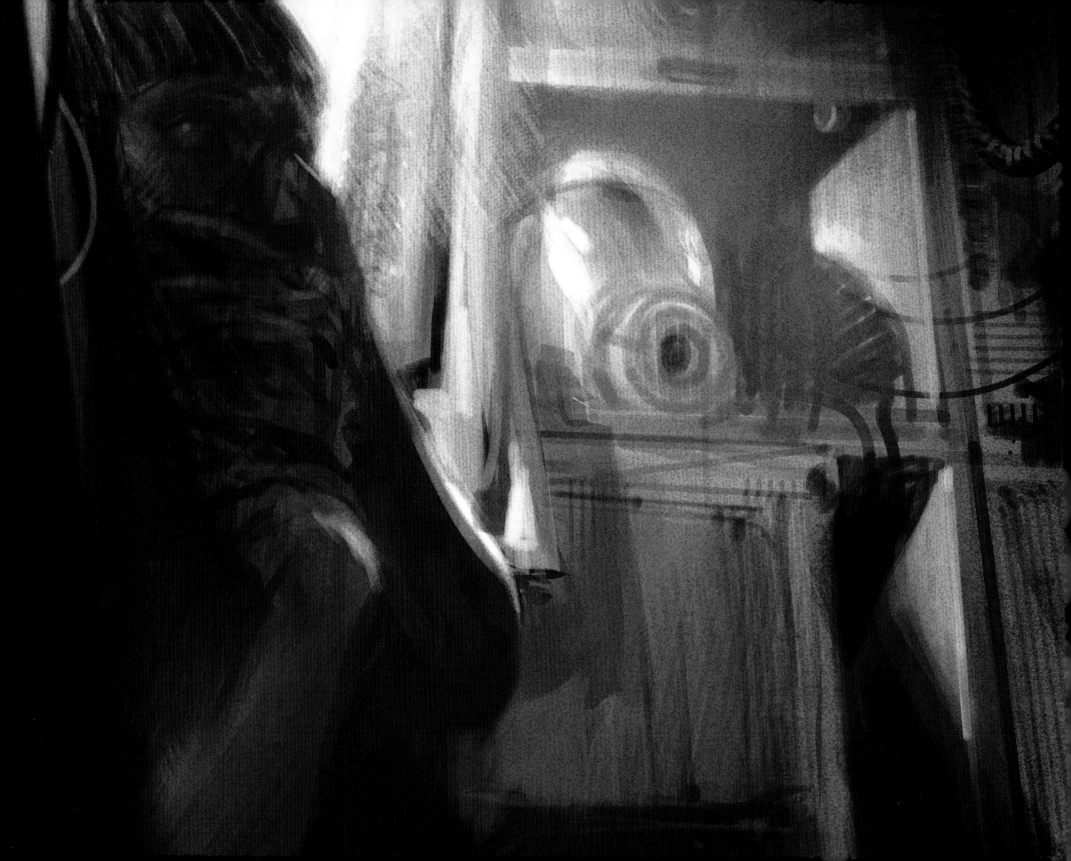

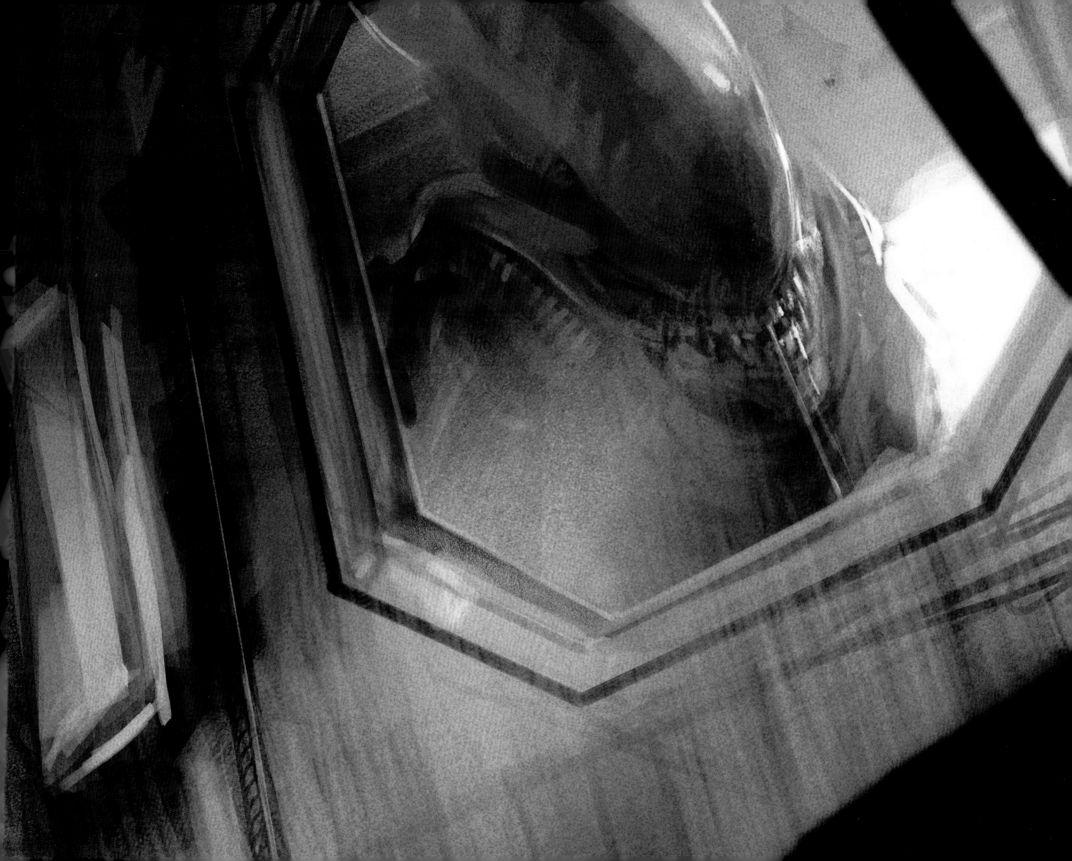

APOLLO

Guiding our synthetics. Ensuring your safety.

THE ART OF ALIEN:ISOLATION
ISBN: 9781781169315

Published by Titan Books
A division of Titan Publishing Group Ltd.
144 Southwark St.
London SE1 0UP

First edition: October 2014
10 9 8 7 6 5 4 3 2

ACKNOWLEDGMENTS

We would like to say a special thank you to the following people for making this book possible:

Alistair Hope
Creative Lead

Jude Bond
Lead Artist

Stefano Barolo
Assistant Brand Manager

Art Team:

Alexandra Trocea
Andrew Oakley
Andrew Pollington
Andrew Sawers
Ben Hutchings
Ben Potts
Ben Matthews
Ben Stevens
Bjorn Hurri
Bradley Wright
Calum Watt
Carl Allen
Carl Keeler
Chris le Roux
Chris Southall

David Foss
Edouard Caplain
Gerard Muntés Mulero
Graham Hopkins
Guy Davies
Helen Cranston
Howard Rayner
Jack Perry
Jon McKellan
Kelly Ford
Liam Tart
Mark Perry
Mark Radcliffe
Mark Sneddon
Nathan Dearsley

Nic Frath
Oriol Sans Gomez
Paul Allison
Paul Abbot
Pete Norris
Ranulf Busby
Ricardo Chamizo
Rob Blight
Roman Pajdlhauser
Rowan Clarke
Simon Ridge
Stefano Tsai
Thomas Armer
Tunde Glover
Vincent Chai

Book design by Amazing15.com

To receive advance information, news,
competitions, and exclusive offers online,
please sign up for the Titan newsletter on our
website: www.titanbooks.com

Did you enjoy this book? We love to hear from
our readers. Please e-mail us at:
readerfeedback@titanemail.com or write to
Reader Feedback at the above address.

A CIP catalogue record for this title is
available from the British Library.

Printed and bound in China.

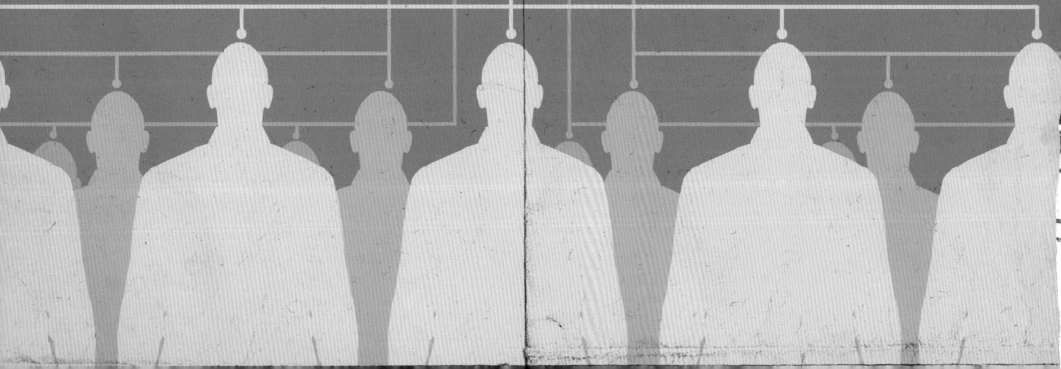